An Outline of 19th Century European Painting

Also by Lorenz Eitner

AN OUTLINE OF 19TH CENTURY EUROPEAN PAINTING
Volume I: Text

An
Outline of 19th Century
European Painting

From David Through Cézanne

Lorenz Eitner

Volume II: Plates

ICON EDITIONS

1817

HARPER & ROW, PUBLISHERS, New York
Grand Rapids, Philadelphia, St. Louis, San Francisco
London, Singapore, Sydney, Tokyo, Toronto

Photograph credits appear at the end of the book.

Designed by C. Linda Dingler

LIBRARY OF CONGRESS CATALOG CARD NUMBER: 82-48690
ISBN: 0-06-432977-1
ISBN: 0-06-430173-7 (pbk.)

90 91 92 CC/MPC 10 9 8 7 6 5 4

Note to the Reader

This second volume of *An Outline of 19th Century European Painting*, published some time after the first, supplies illustrations of most of the paintings discussed in Volume I. The relatively large number of plates that I considered necessary had to be accommodated within relatively few pages. It was therefore not possible to offer them as a feast for the eye. Their purpose, rather, had to be the modest one of providing a serviceable pictorial accompaniment to the text.

The sequence of the illustrations closely follows that of the discussion of the corresponding paintings in Volume I. To make it as easy as possible to relate text and plates, references to the pertinent page numbers in Volume I have been included in all the plate captions. (In addition, the index of Volume I identifies those works of art illustrated here.)

In the amazingly laborious work of procuring these 418 pictures, I was greatly helped by Mrs. Elizabeth Martin of the Stanford University Department of Art—for this I give her my warmest thanks.

LORENZ EITNER
Stanford University

List of Illustrations

The number in *italics* refers to the page on which the illustration appears.

A NOTE ABOUT THE PLATE CAPTIONS

The numbers in parentheses refer to discussion in Volume I. A number in *italics* indicates discussion of the specific work of art.

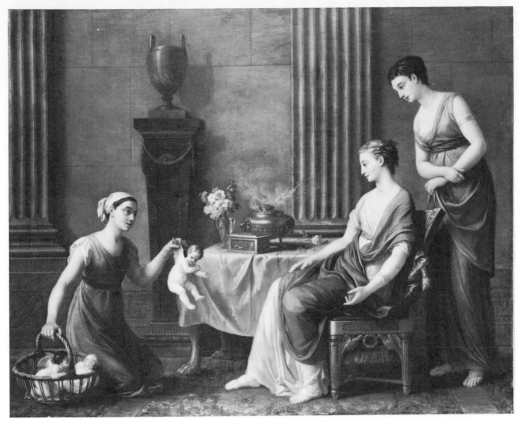

1. J.-M. Vien, *The Cupid Seller,* 1763, Fontainebleau, Château (p. 6)

2. J.-M. Vien, *Portrait of J.-L. David as an Adolescent,* ca. 1766, Angers, Musée des Beaux-Arts (pp. 5; 17)

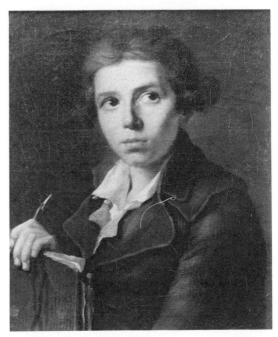

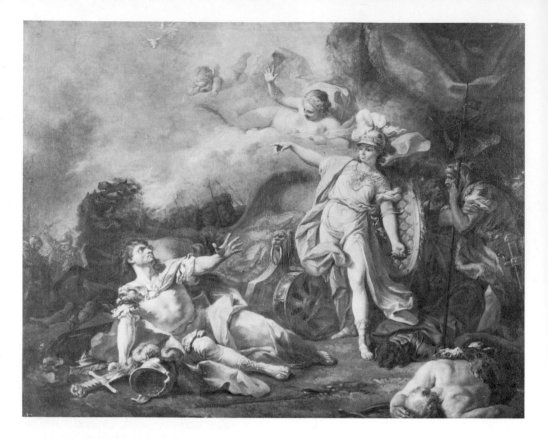

3. J.-L. David, *Battle Between Mars and Minerva*, 1771, Paris, Louvre (p. *18*)

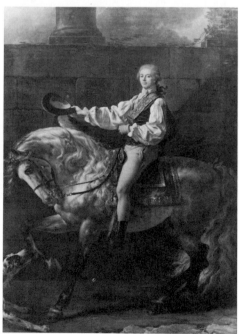

4. J.-L. David, *Equestrian Portrait of Count Potocki*, 1779, Warsaw, National Museum (pp. *18; 27*)

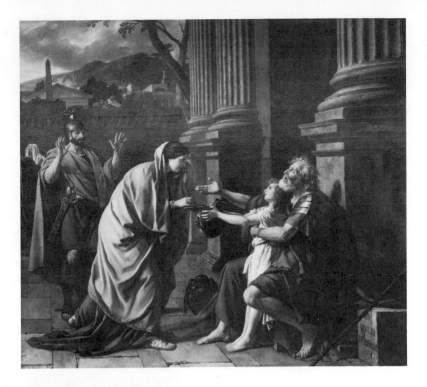

5. J.-L. David, *Belisarius Begging Alms,*
1780, Lille, Musée des Beaux-Arts (pp. *19;*
45)

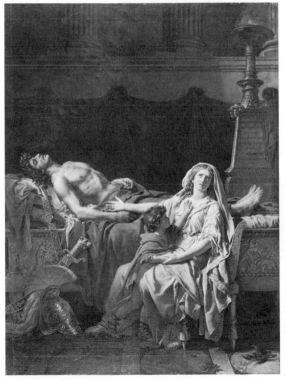

6. J.-L. David, *Andromache Mourning Hec-
tor,* 1783, Paris, Ecole Nationale Supérieure
des Beaux-Arts (pp. *19;* 45)

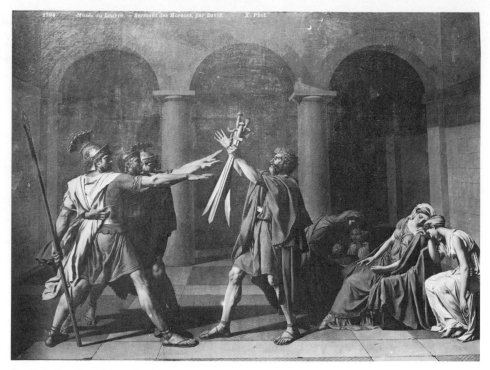

7. J.-L. David, *The Oath of the Horatii,* 1784, Paris, Louvre (pp. *19–21;* 78)

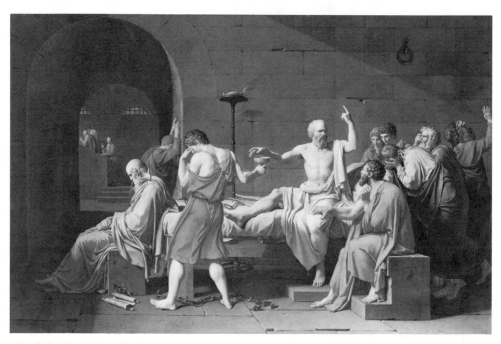

8. J.-L. David, *Death of Socrates,* 1787, New York, Metropolitan Museum of Art, Wolfe Fund (pp. *21;* 25)

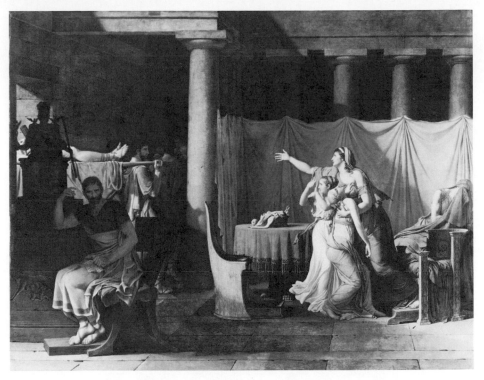

9. J.-L. David, *Brutus in the Atrium of His House, After the Execution of His Sons,* 1789, Paris, Louvre (pp. *21;* 25, 45)

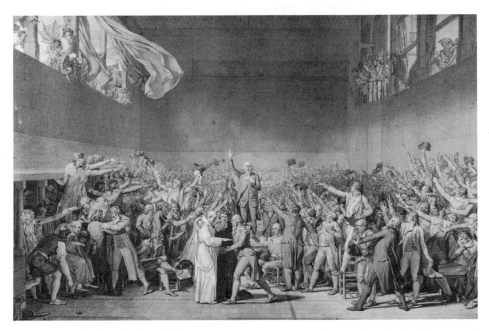

10. J.-L. David, *The Oath in the Tennis Court,* pen-and-wash drawing, 1790–91, Paris, Louvre (p. *23*)

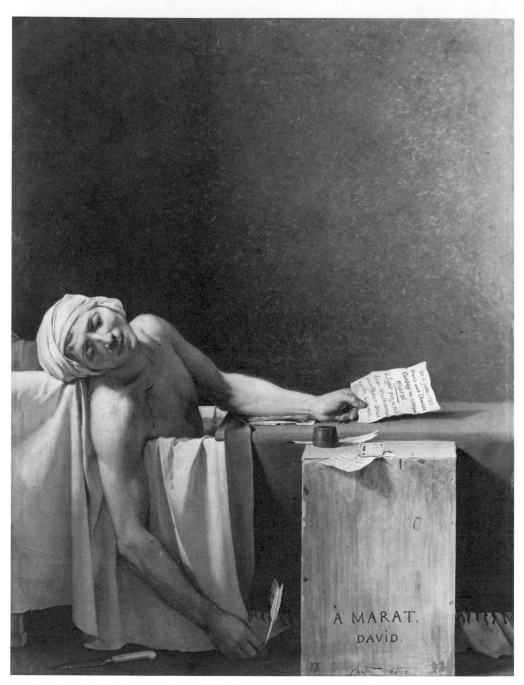

11. J.-L. David, *The Death of Marat,* 1793, Brussels, Musées Royaux (p. *24*)

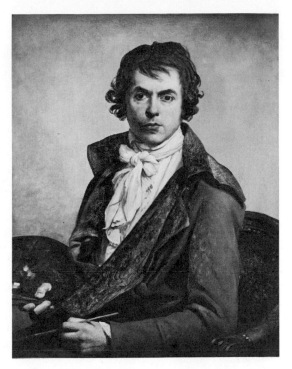

12. J.-L. David, *Self-Portrait,* 1794, Paris, Louvre (p. *24*)

13. J.-L. David, *View of the Luxembourg Gardens,* 1794, Paris, Louvre (p. *25*)

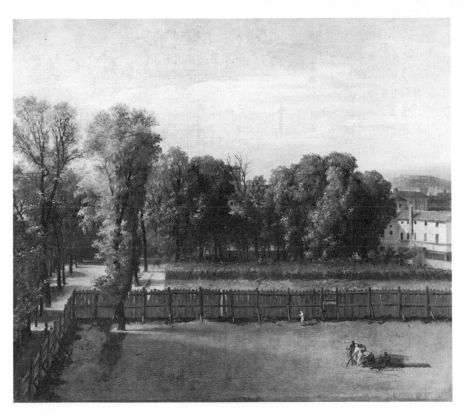

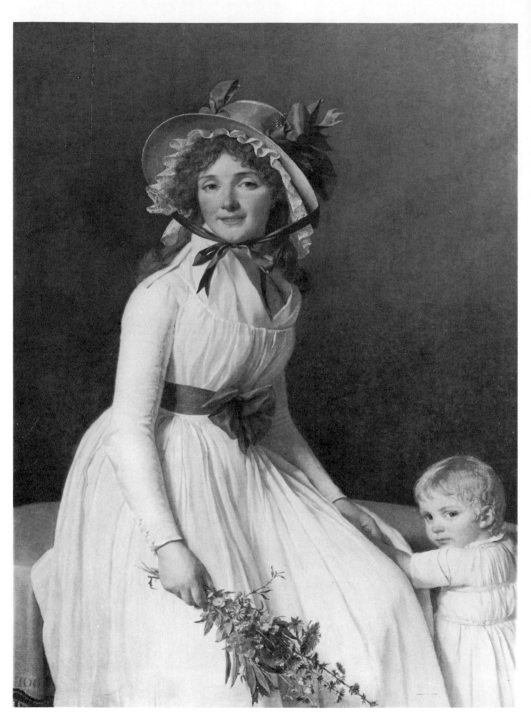

14. J.-L. David, *Mme Sériziat,* 1795, Paris, Louvre (pp. *25;* 160)

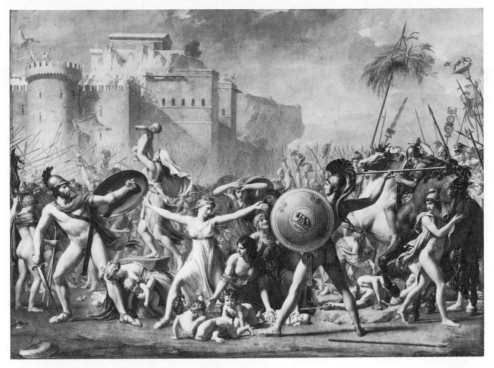

15. J.-L. David, *The Sabine Women Stopping the Battle Between Romans and Sabines,* 1795–99, Paris, Louvre (pp. *25;* 40, 318)

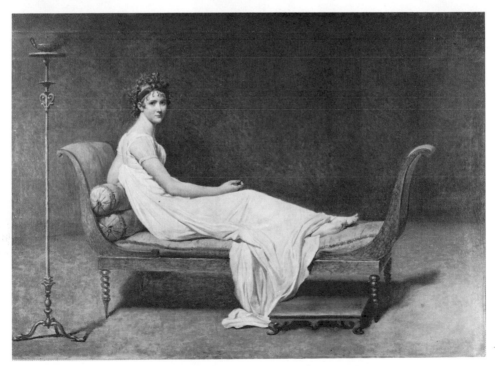

16. J.-L. David, *Mme Récamier,* 1800, Paris, Louvre (pp. *26;* 43, 163)

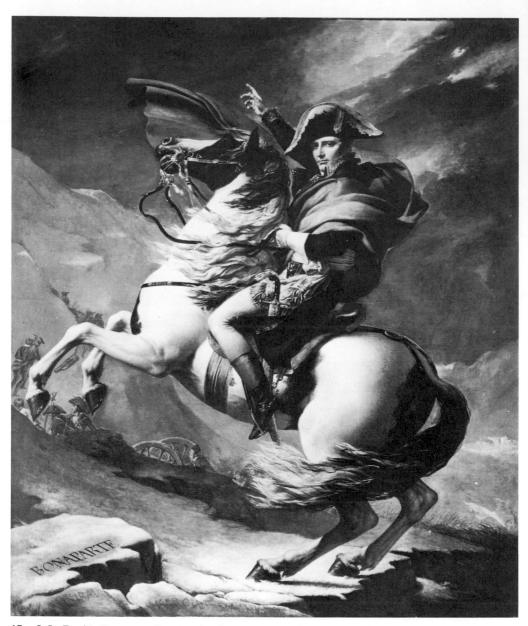

17. J.-L. David, *Bonaparte Crossing the Great St. Bernard,* 1801, Versailles, Musée (pp. *27; 34*)

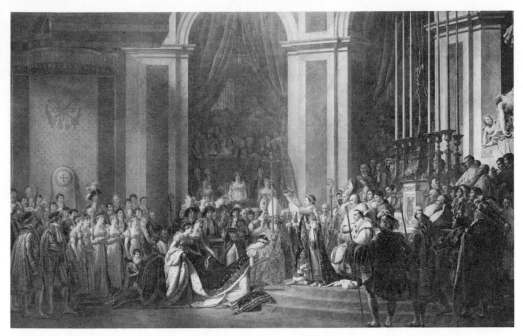

18. J.-L. David, *Coronation,* 1805–8, Paris, Louvre (pp. *27–28:* 36)

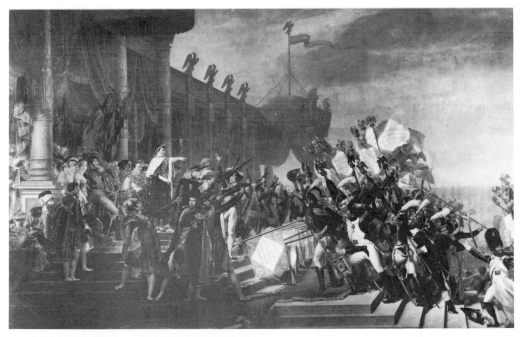

19. J.-L. David, *Presentation of the Eagle Standards,* 1808–10, Versailles, Musée (pp. *27–29;* 35, 41)

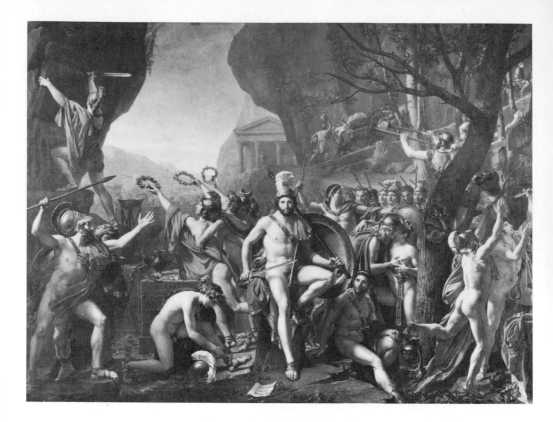

20. J.-L. David, *Leonidas at the Pass of Thermopylae,* begun ca. 1800, executed 1812–14, Paris, Louvre (pp. *29;* 26–27)

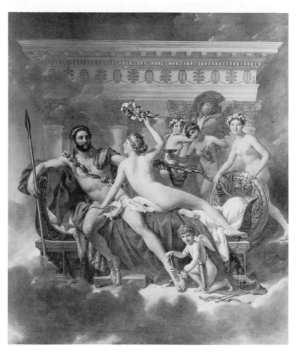

21. J.-L. David, *Mars Disarmed by Venus and the Graces,* 1824, Brussels, Musées Royaux (p. *30*)

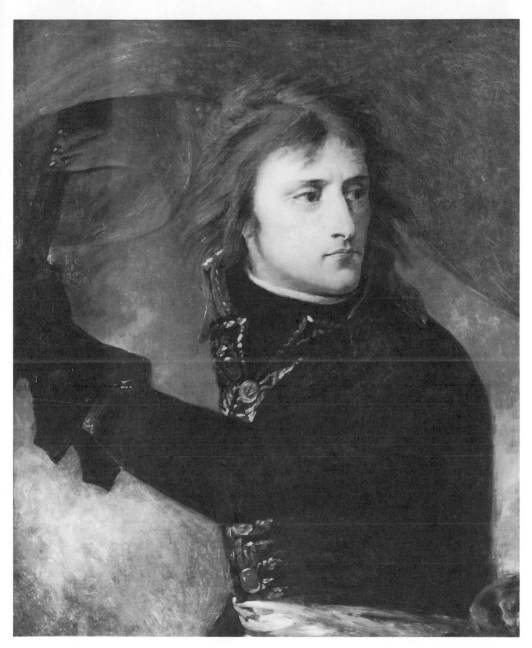

22. A.-J. Gros, *Napoleon at the Battle of Arcola,* 1797, Paris, Louvre (p. *34*)

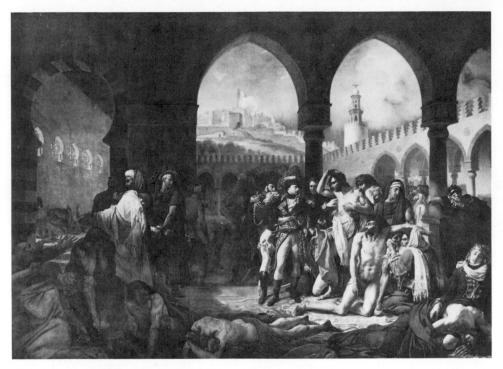

23. A.-J. Gros, *Napoleon Visiting the Plague Hospital at Jaffa,* 1804, Paris, Louvre (pp. *35;* 36)

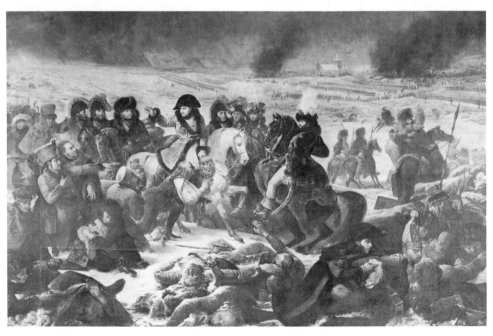

24. A.-J. Gros, *Napoleon at the Battle of Eylau,* 1808, Paris, Louvre (p. *36*)

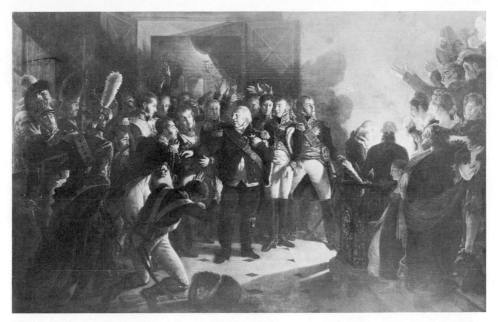

25. A.-J. Gros, *Louis XVIII Leaving the Tuileries on Napoleon's Return from Elba,* 1817, Versailles, Musée (p. *37*)

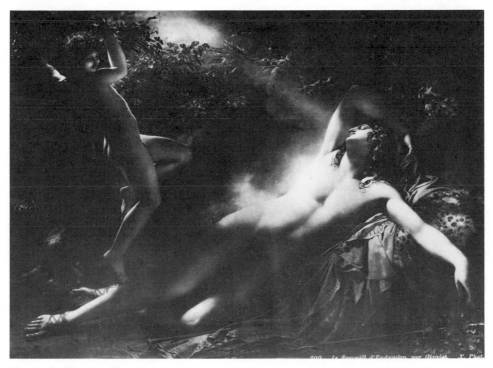

26. A.-L. Girodet, *The Sleep of Endymion,* 1791, Paris, Louvre (pp. *38;* 39, 40, 46)

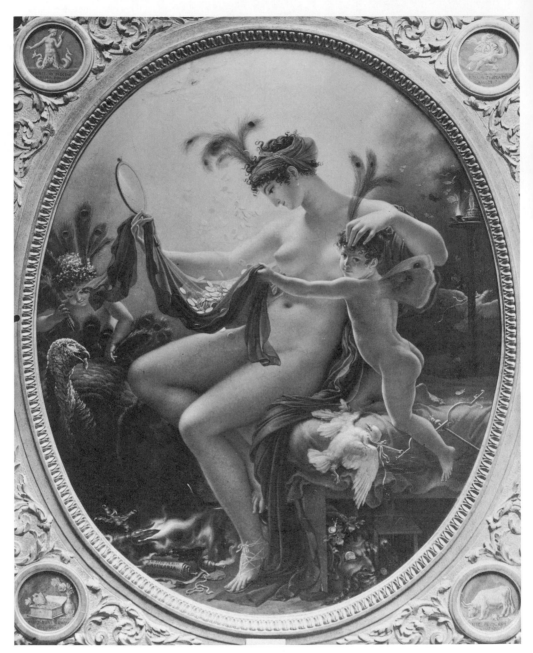

27. A.-L. Girodet, *Satirical Portrait of Mlle Lange as Danaë,* 1799, Minneapolis Institute of Arts, William Hood Dunwoody Fund (p. *39*)

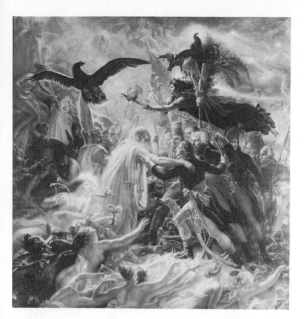

28. A.-L. Girodet, *Ossian Receiving the Shades of French Heroes,* 1802, Château of La Malmaison (pp. *39–40*)

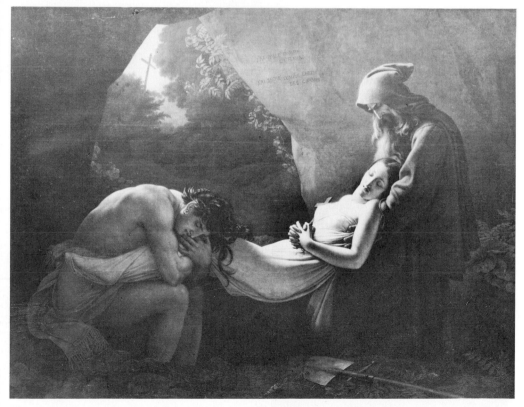

29. A.-L. Girodet, *The Entombment of Atala,* 1808, Paris, Louvre (pp. *40;* 53)

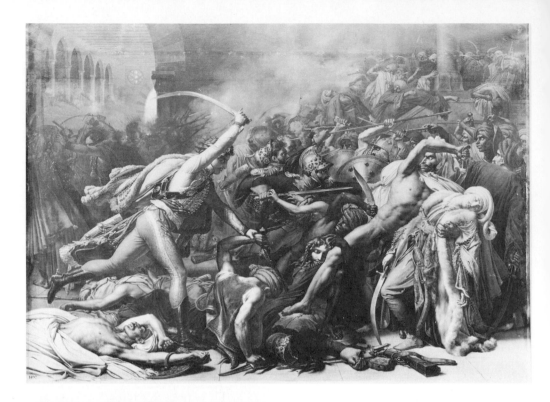

30. A.-L. Girodet, *The Revolt of Cairo,* 1810, Versailles, Musée (pp. *40;* 68)

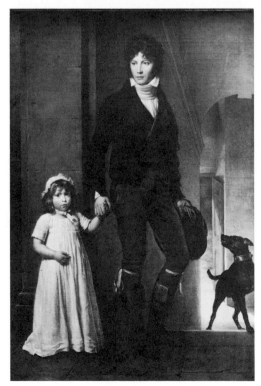

31. F.-P. Gérard, *Jean-Baptiste Isabey and His Daughter,* 1795, Paris, Louvre (p. *42*)

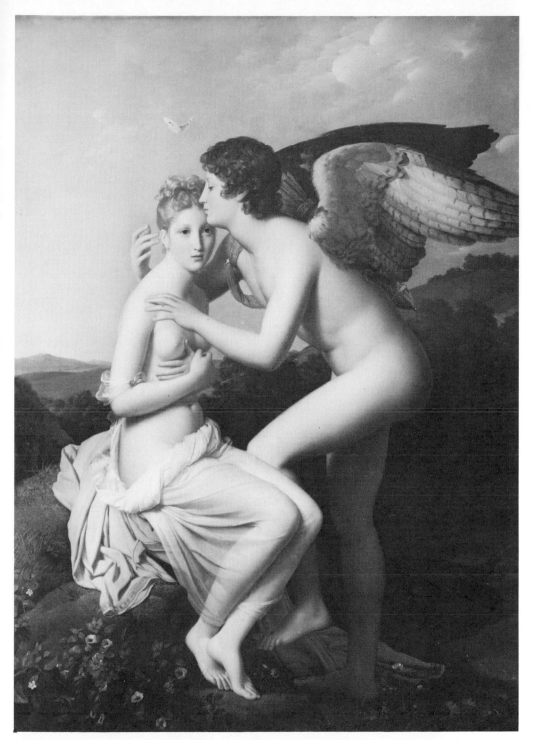

32. F.-P. Gérard, *Psyche Receiving Cupid's First Kiss,* 1797–98, Paris, Louvre (p. *42*)

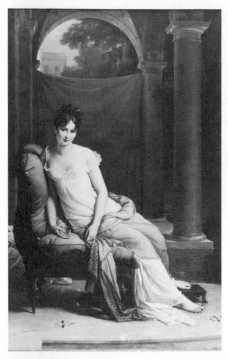

33. F.-P. Gérard, *Mme Récamier,* 1802, Paris, Louvre (p. *43*)

34. P.-N. Guérin, *The Return of Marcus Sextus,* 1799, Paris, Louvre (p. *45*)

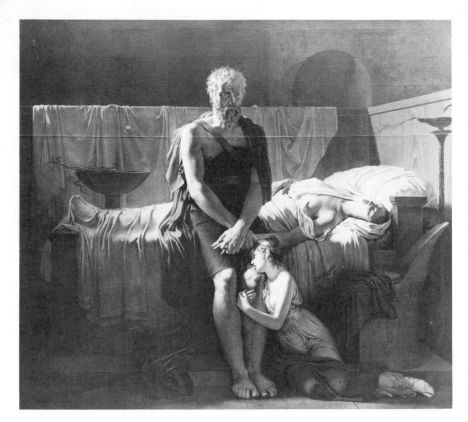

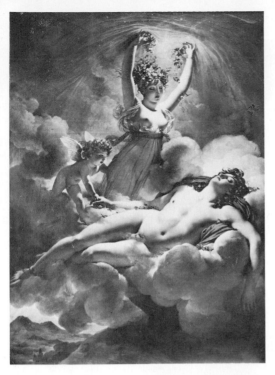

35. P.-N. Guérin, *Aurora and Cephalus,* 1810, Paris, Louvre (p. *46*)

36. P.-N. Guérin, *Clytemnestra Contemplating the Murder of Agamemnon,* 1817, Paris, Louvre (p. *46*)

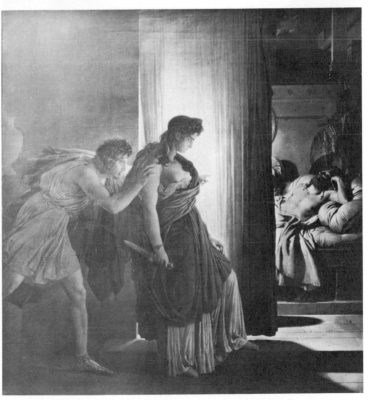

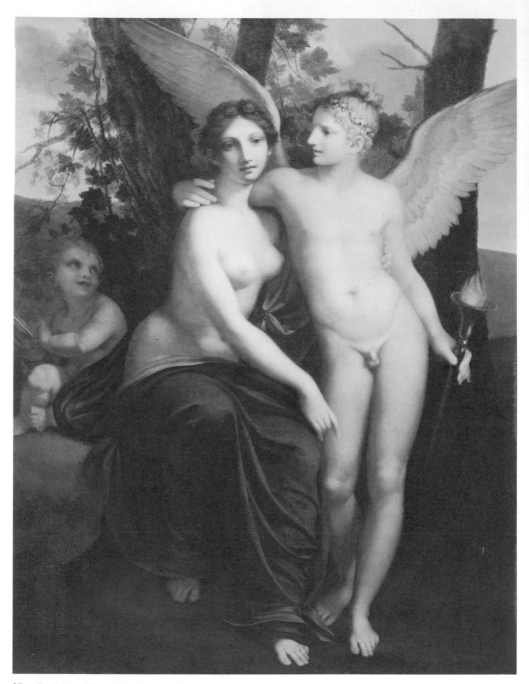

37. P.-P. Prud'hon, *The Union of Love and Friendship,* 1793, Minneapolis Institute of Arts, William Hood Dunwoody Fund (p. *50*)

38. P.-P. Prud'hon, *Portrait of Constance Mayer,* chalk drawing, ca. 1806, Paris, Louvre (p. *52*)

39. P.-P. Prud'hon, *Portrait of the Empress Josephine,* 1805, Paris, Louvre (p. *52*)

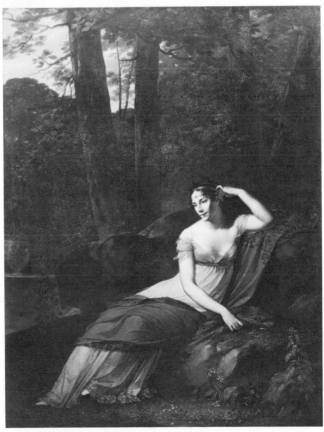

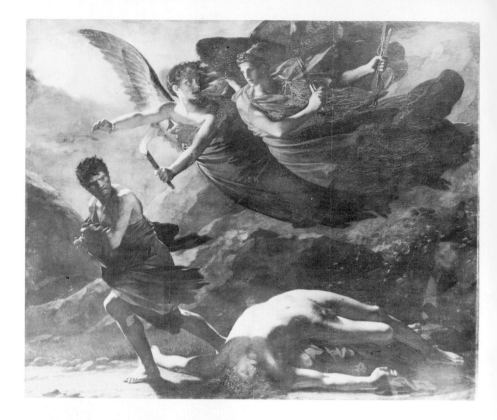

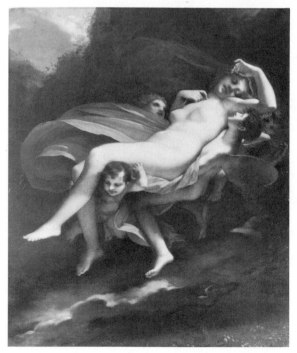

40. P.-P. Prud'hon, *Justice and Divine Vengeance Pursuing Crime,* 1808, Paris, Louvre (p. *52*)

41. P.-P. Prud'hon, *Psyche Carried Off by Zephyr,* 1808, Paris, Louvre (p. *53*)

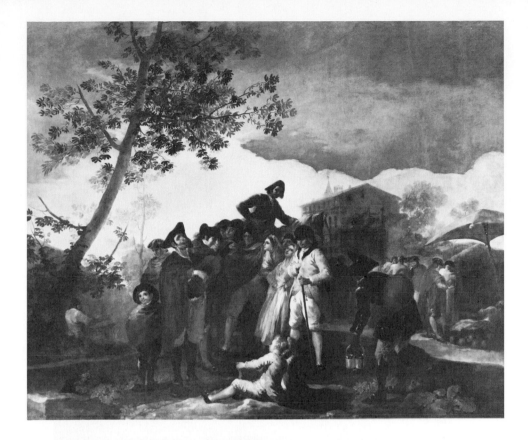

42. F. Goya, *The Blind Guitar Player,* tapestry cartoon, 1778, Madrid, Prado (p. 59)

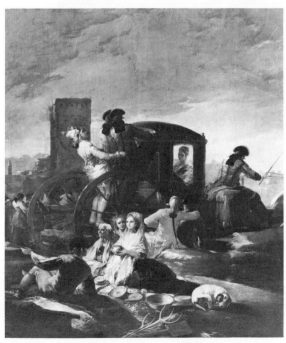

43. F. Goya, *The Coach in the Crockery Market,* tapestry cartoon, 1778–80, Madrid, Prado (p. 59)

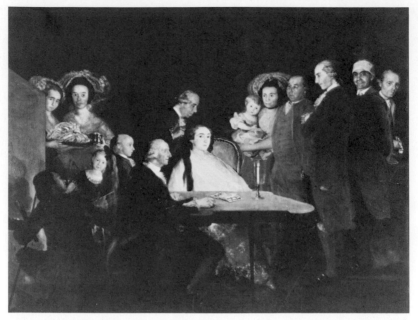

44. F. Goya, *The Family of the Infante Don Luis,* 1783 (formerly Florence, Ruspoli Collection), Corte di Mamiano, Fondazione Magnani-Rocca (p. *61*)

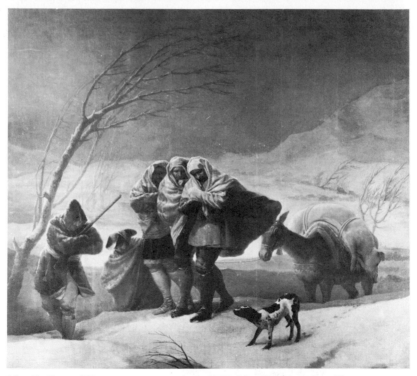

46. F. Goya, *Winter,* tapestry cartoon, 1787, Madrid, Prado (p. *61*)

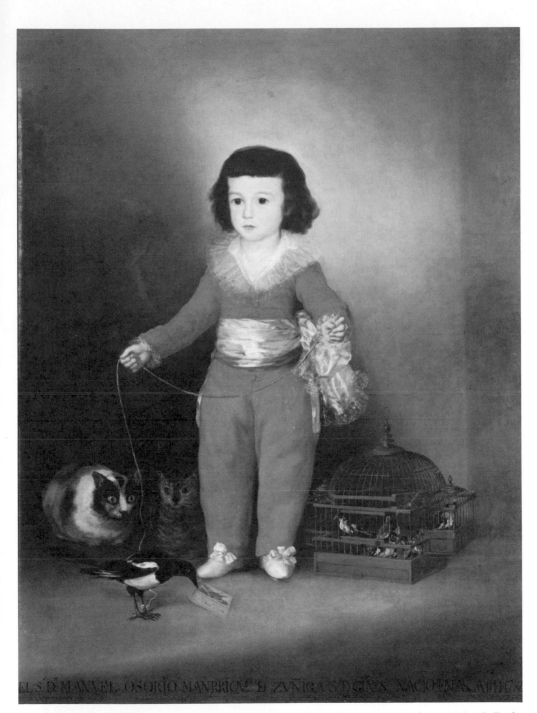

45. F. Goya, *Don Manuel Osorio*, 1788, New York, Metropolitan Museum of Art, Jules S. Bache Collection (pp. *61;* 300)

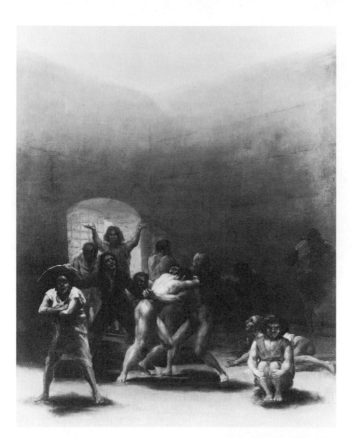

47. F. Goya, *Yard of a Lunatic Asylum,*
1794, Dallas, Meadows Museum, Algour
H. Meadows Collection (p. *62*)

48. F. Goya, *Marquesa de la Solana,*
1794–95, Paris, Louvre (p. *63*)

49. F. Goya, *The Duchess of Alba Dressed as Maja,* 1797, New York, Hispanic Society of America (p. *63*)

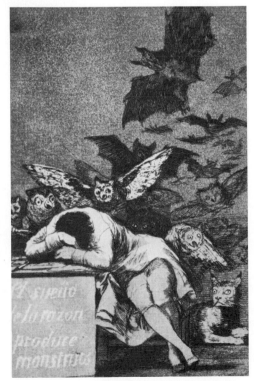

50. F. Goya, *The Dream of Reason* (plate 43 of the *Caprichos*), etching and aquatint, 1797–98, private collection (p. *64*)

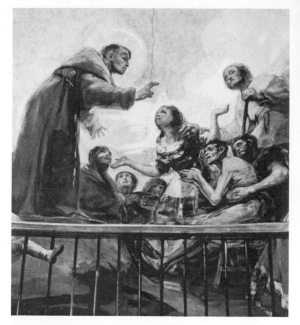

51. F. Goya, *St. Anthony Resurrecting a
Dead Man,* dome fresco, 1798, Madrid, San
Antonio de la Florida (p. *64*)

52. F. Goya, *The Family of Charles IV,*
1800, Madrid, Prado (p. *65*)

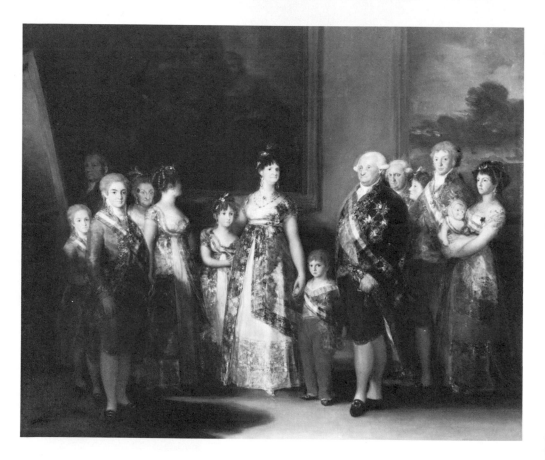

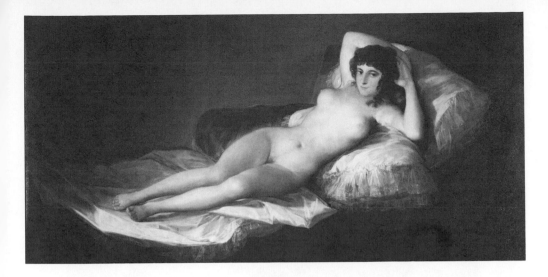

53. F. Goya, *The Naked Maja,* ca. 1800–1802, Madrid, Prado (pp. *65–66; 69,* 298)

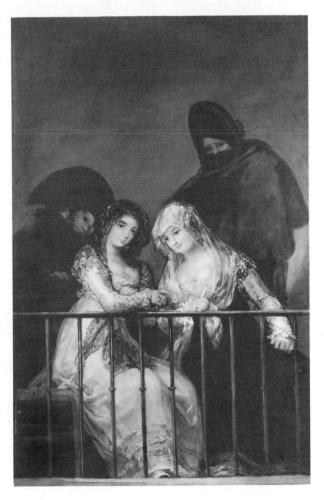

54. F. Goya, *Majas on a Balcony,* 1808–10, New York, Metropolitan Museum of Art, Bequest of H. O. Havemeyer (pp. *65;* 302)

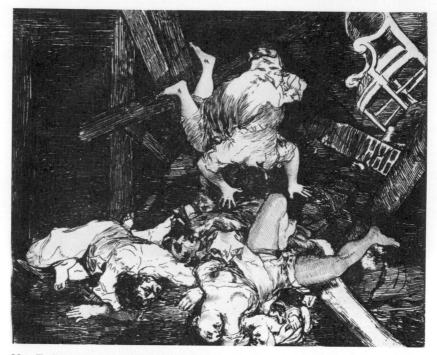

55. F. Goya, *Ravages of War* (plate 30 of *Los desastros de la guerra*), etching, 1809–13, Stanford University Museum (p. *67*)

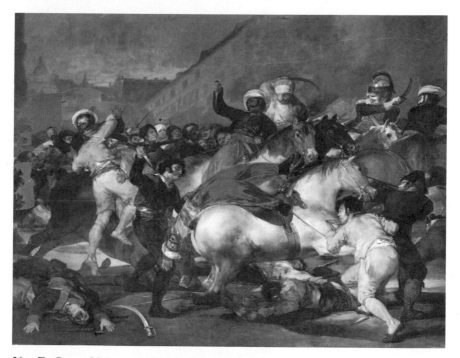

56. F. Goya, *Massacre of the Mamelukes (The Second of May, 1808),* 1814, Madrid, Prado (p. *68*)

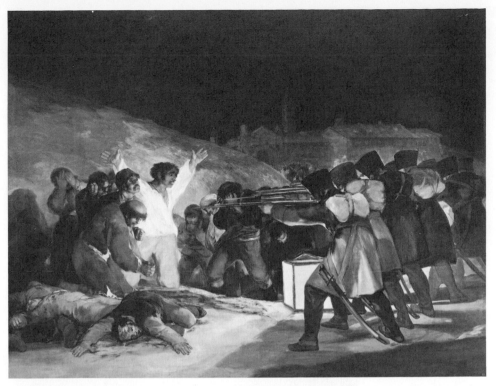

57. F. Goya, *The Execution of the Hostages (The Third of May, 1808)*, 1814, Madrid, Prado (pp.· *68;* 301)

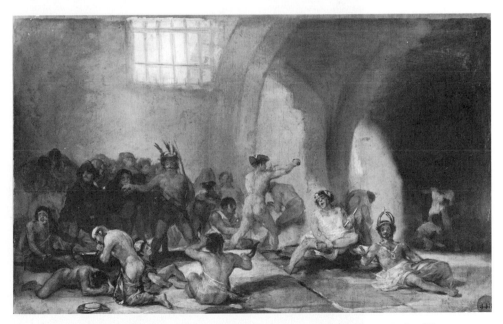

58. F. Goya, *The Madhouse*, ca. 1812–15, Madrid, Academy of San Fernando (p. *68*)

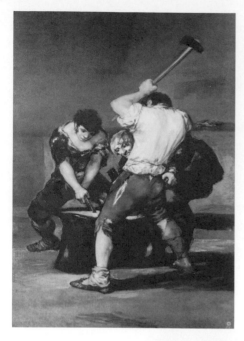

59. F. Goya, *The Forge,* ca. 1812–15, New York, Frick Collection (p. *69*)

60. F. Goya, *The Colossus* (or *Panic*), 1808–12, Madrid, Prado (p. *69*)

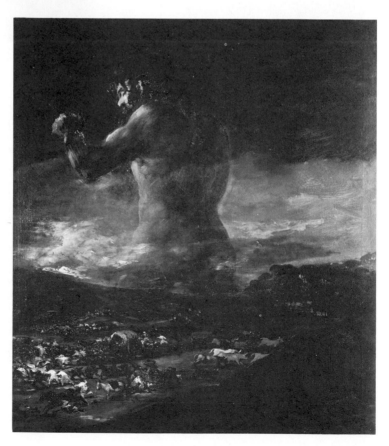

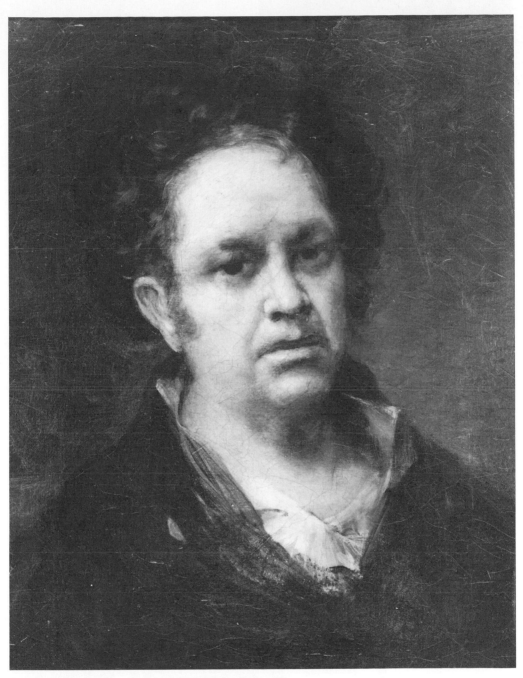

61. F. Goya, *Self-Portrait,* 1815, **Madrid, Prado** (p. *69*)

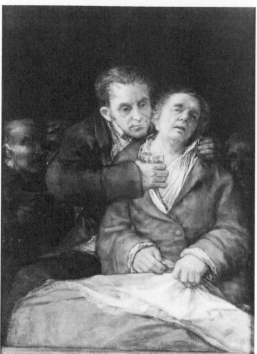

62. F. Goya, *Goya and Doctor Arrieta,* 1820, Minneapolis Institute of Arts, Ethel Morrison Van Derlip Fund (p. *70*)

63. F. Goya, *Folly of Fear* (plate 2 of *Los disparates,* also known as *Proverbios*), etching and aquatint, 1820–23, Stanford University Museum (p. *70*)

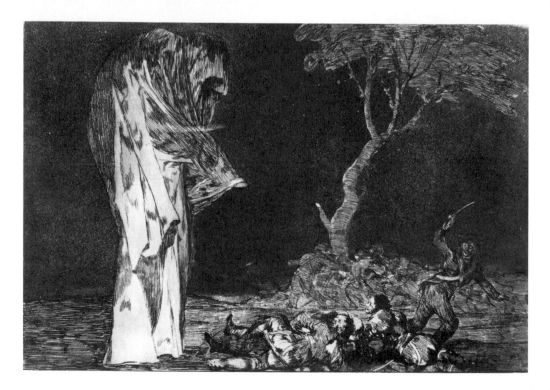

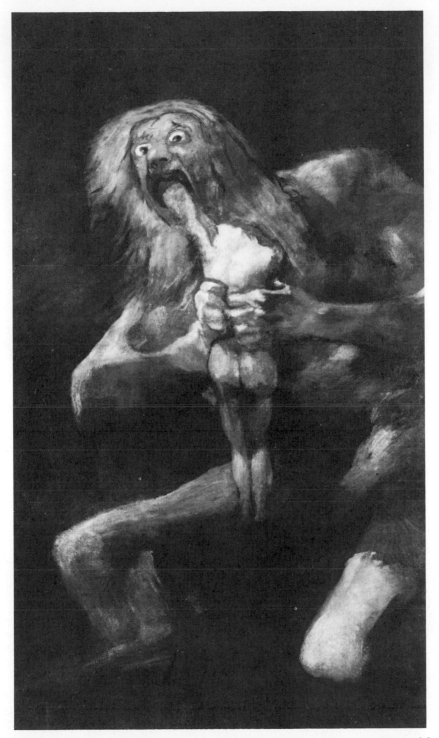

64. F. Goya, *Saturn Eating One of His Children,* wall painting from the *Quinta del Sordo,* 1820–23, Madrid, Prado (p. *71*)

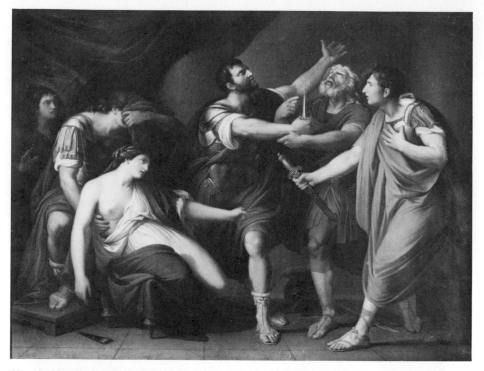

65. G. Hamilton, *Brutus Swearing to Avenge the Death of Lucretia,* ca. 1763, London, Theatre Royal, Drury Lane (p. *78*)

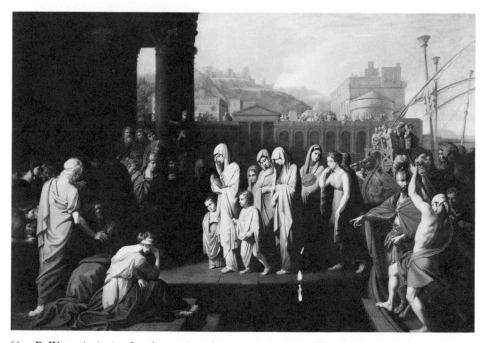

66. B. West, *Agrippina Landing at Brundisium with the Ashes of Germanicus,* 1768, New Haven, Yale University Art Gallery, Paul Mellon Collection (p. *78*)

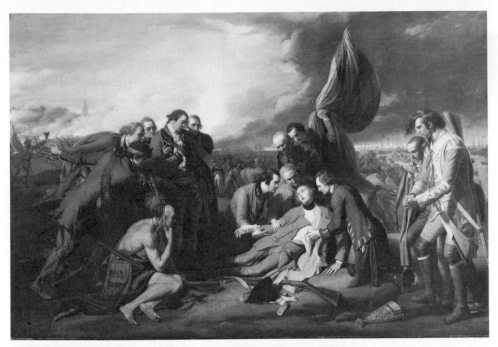

67. B. West, *Death of General Wolfe,* 1770, Ottawa, National Gallery of Canada, Gift of the Duke of Westminster (p. 79)

68. J. Barry, *The Triumph of the Thames (Commerce),* a section of the wall paintings in the Adelphi, 1777–83, London, Royal Society of Arts (p. 80)

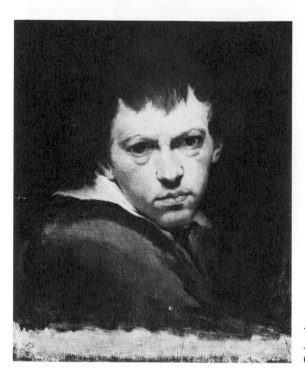

69. J. Barry, *Self-Portrait (A Sketch),* ca. 1780, London, Victoria and Albert Museum (p. 79)

70. J. Barry, *King Lear Weeping Over the Body of Cordelia,* 1787, London, Tate Gallery (p. *81*)

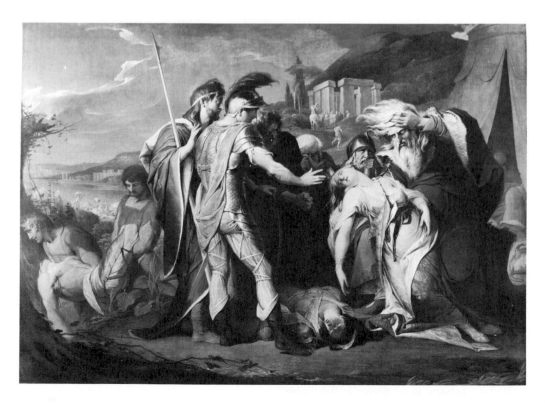

71. H. Fuseli, *The Artist in Conversation with Johann Jakob Bodmer,* 1778–81, Zurich, Kunsthaus (p. 81)

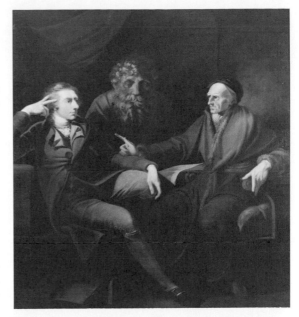

72. H. Fuseli, *Nightmare,* 1781, Detroit Institute of Arts, Gift of Mr. and Mrs. Bert L. Smokler and Mr. and Mrs. Lawrence A. Fleischman (p. *82*)

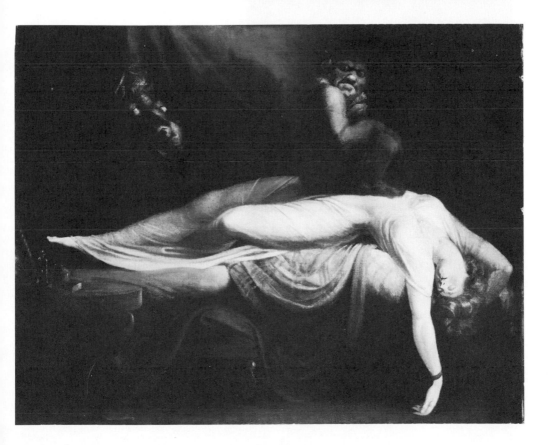

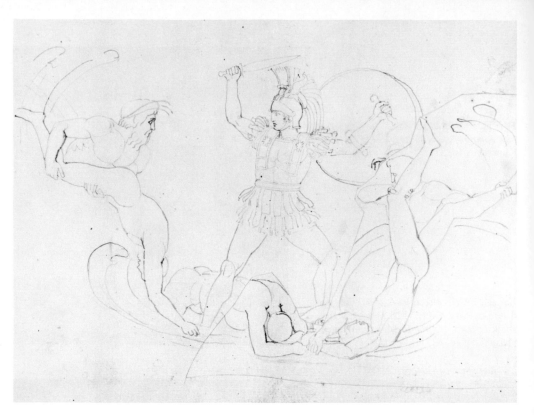

73. J. Flaxman, *Achilles Contending with the Rivers,* pencil study for plate 33 of the *Iliad,* 1793, Stanford University Museum (p. *84*)

74. J. Flaxman, *Battle for the Body of Patroclus,* etching by T. Piroli after Flaxman, plate 26 of the *Iliad,* 1793, private collection (pp. *84;* 25)

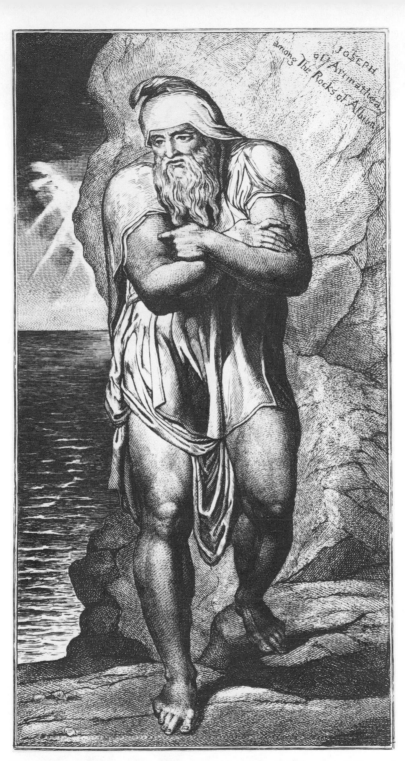

75. W. Blake, *Joseph of Arimathea Among the Rocks of Albion,* line etching and engraving, ca. 1773, Altadena, Calif., Robert N. Essick Collection (p. *86*)

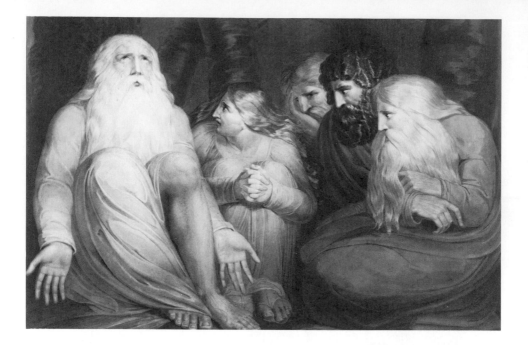

76. W. Blake, *The Complaint of Job,* pen-and-ink drawing, ca. 1785, Fine Arts Museums of San Francisco, Gift of Edward and Tullah Hanley (p. *87*)

77. W. Blake, *The Tyger,* color-printed relief etching, finished with watercolor, page 42 of *Songs of Experience,* 1794, New Haven, Yale Center for British Art, Paul Mellon Collection (p. *89*)

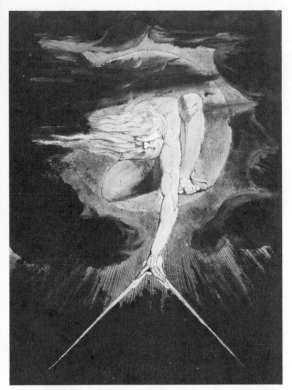

78. W. Blake, *God Creating the Universe (The Ancient Days),* relief etching, finished with watercolor, the frontispiece to *Europe, a Prophecy,* 1794, Upperville, Va., Collection of Mr. and Mrs. Paul Mellon (p. *90*)

79. W. Blake, *Newton,* monotype, finished in pen and watercolor, 1795, London, Tate Gallery (p. *92*)

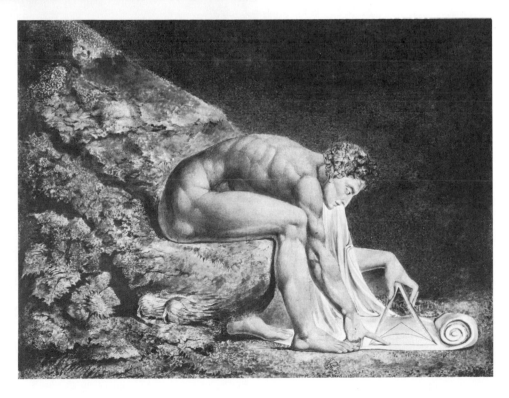

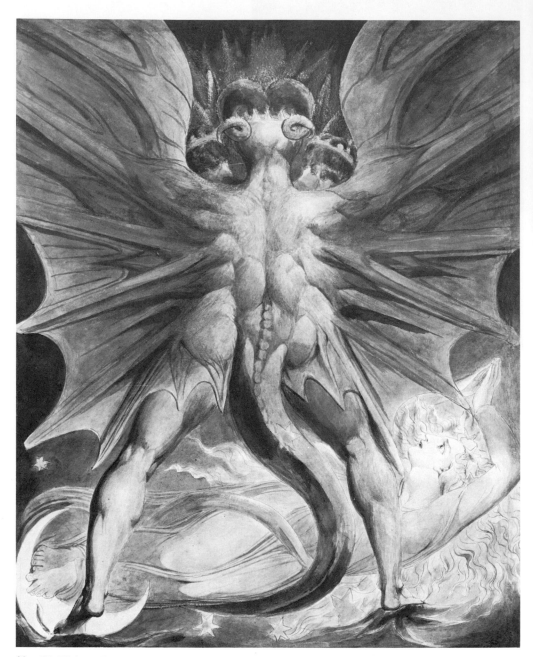

80. W. Blake, *The Great Red Dragon and the Woman Clothed in the Sun,* pen, black chalk, and water-color, ca. 1805, New York, Brooklyn Museum, Gift of William Augustus White (p. *94*)

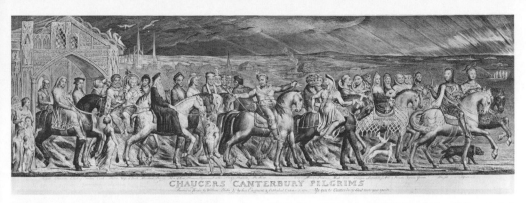

81. W. Blake, *The Canterbury Pilgrims,* engraving, 1810, Pasadena, Henry E. Huntington Library and Art Gallery (p. *94*)

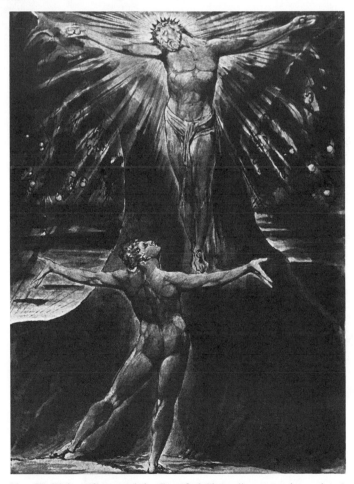

82. W. Blake, *Albion and the Crucified Christ,* line engraving, printed in relief and finished in watercolor and gold, page 76 of *Jerusalem* (Copy E), ca. 1820, Upperville, Va., Collection of Mr. and Mrs. Paul Mellon (p. *95*)

47

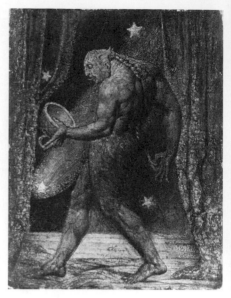

83. W. Blake, *Ghost of a Flea,* tempera, heightened with gold, on panel, ca. 1819–20, London, Tate Gallery (p. *96*)

84. W. Blake, *"With Dreams upon my bed thou scarest me & affrightest me with Visions,"* engraving, plate 11 of *The Book of Job,* 1825, private collection (p. *96*)

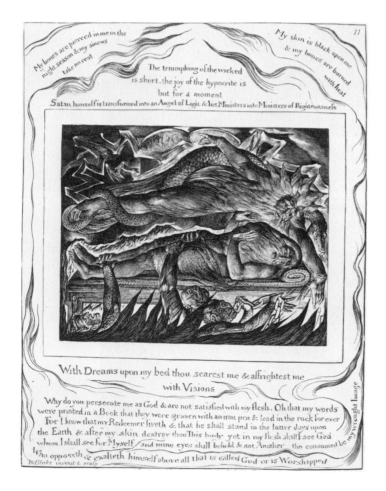

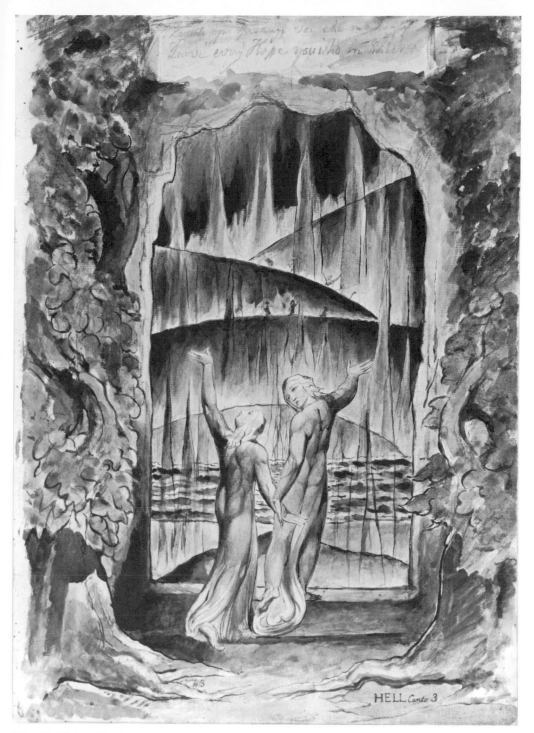

85. W. Blake, *The Inscription over Hell Gate,* chalk, pencil, pen, and watercolor, from the series of illustrations to Dante's *Divine Comedy,* 1824–27, London, Tate Gallery (p. *97*)

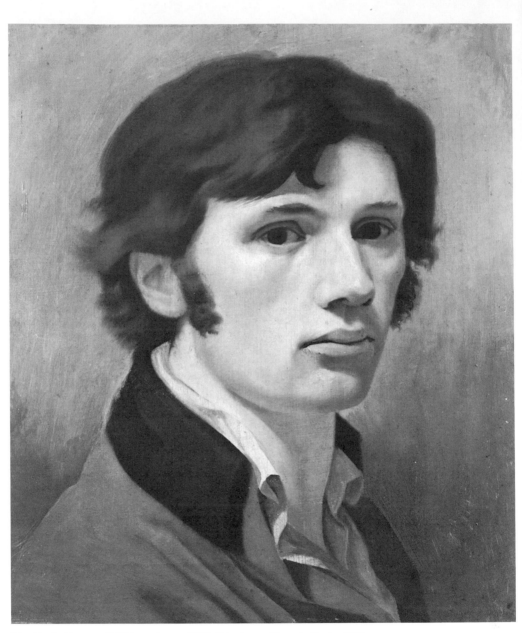

86. P. O. Runge, *Self-Portrait,* ca. 1802, Hamburg, Kunsthalle (p. 103)

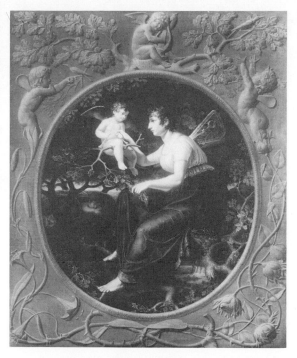

87. P. O. Runge, *The Nightingale's Lesson,*
1805, Hamburg, Kunsthalle (p. *105*)

88. P. O. Runge, *We Three,* 1805 (destroyed
by fire in 1931), formerly Hamburg, Kunst-
halle (p. *106*)

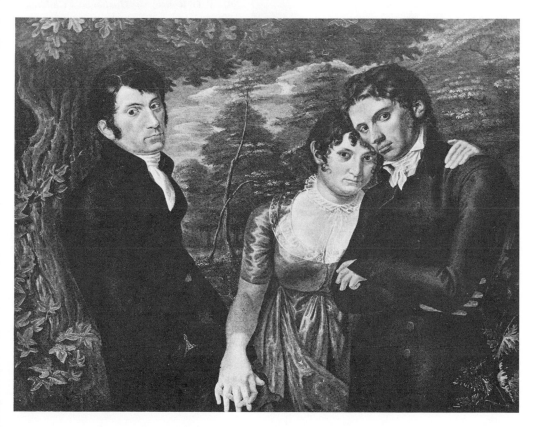

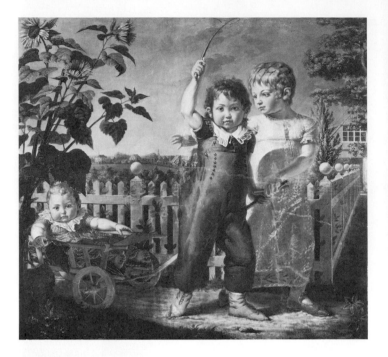

89. P. O. Runge, *The Huelsenbeck Children,* 1805–6, Hamburg, Kunsthalle (p. *106*)

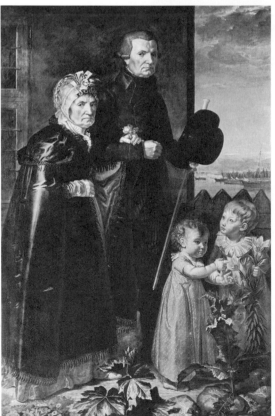

90. P. O. Runge, *The Artist's Parents,* 1806, Hamburg, Kunsthalle (p. *106*)

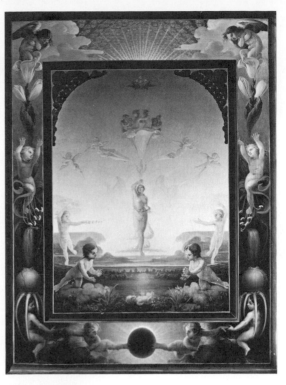

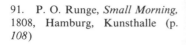

91. P. O. Runge, *Small Morning*, 1808, Hamburg, Kunsthalle (p. *108*)

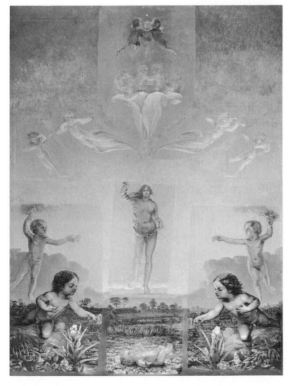

92. P. O. Runge, *Large Morning* (reconstituted), 1808–10, Hamburg, Kunsthalle (p. *108*)

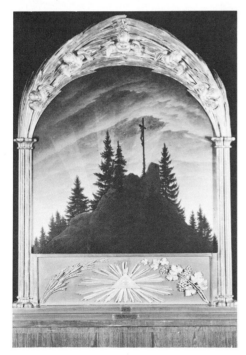

93. C. D. Friedrich, *Dolmen in the Snow,* 1807, Dresden, Staatliche Kunstsammlungen (pp. *111–12*)

94. C. D. Friedrich, *The Cross in the Mountains (Tetschen Altar),* 1808, Dresden, Staatliche Kunstsammlungen (pp. *112;* 114)

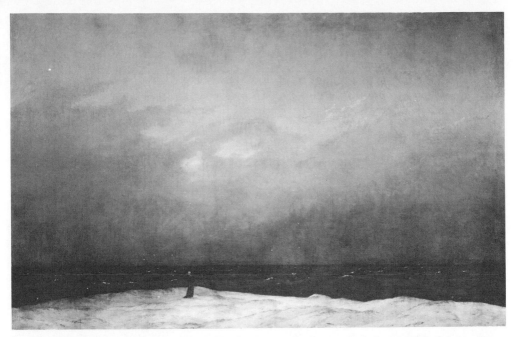

95. C. D. Friedrich, *Monk by the Sea,* 1809–10, West Berlin, Nationalgalerie, Staatliche Museen Preussischer Kulturbesitz, (pp. *113;* 149)

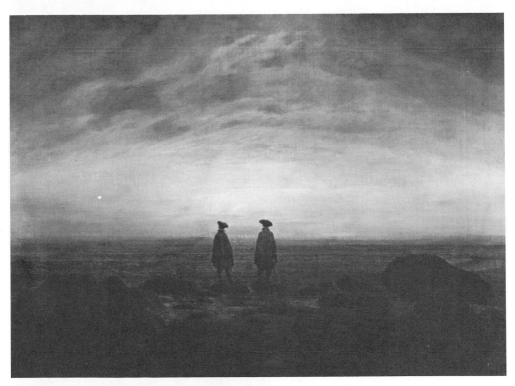

96. C. D. Friedrich, *Two Men by the Sea at Moonrise,* ca. 1817, West Berlin, Nationalgalerie, Staatliche Museen Preussischer Kulturbesitz (p. *115*)

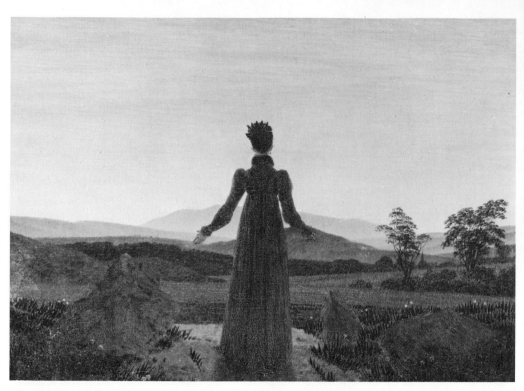

97. C. D. Friedrich, *Woman in the Sunrise,* ca. 1818, Essen, Folkwang Museum (p. *115*)

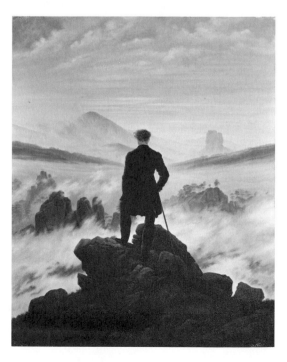

98. C. D. Friedrich, *Wanderer Above a Sea of Mist,* ca. 1818, Hamburg, Kunsthalle (p. *115*)

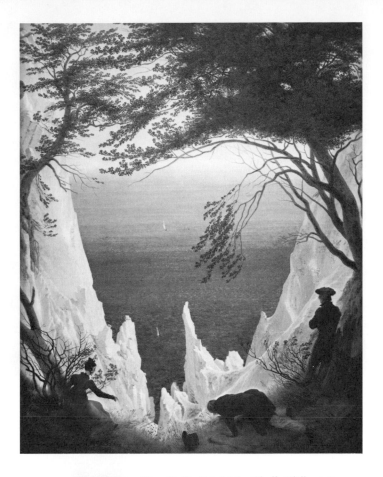

99. C. D. Friedrich, *Chalk Cliffs at Ruegen,* 1818–19, Winterthur, Switzerland, Stiftung Oskar Reinhart (p. *116*)

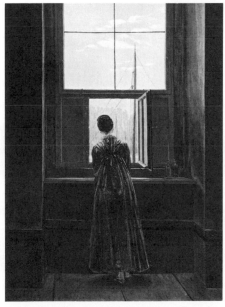

100. C. D. Friedrich, *Woman at the Window,* 1822, West Berlin, Nationalgalerie, Staatliche Museen Preussischer Kulturbesitz (p. *116*)

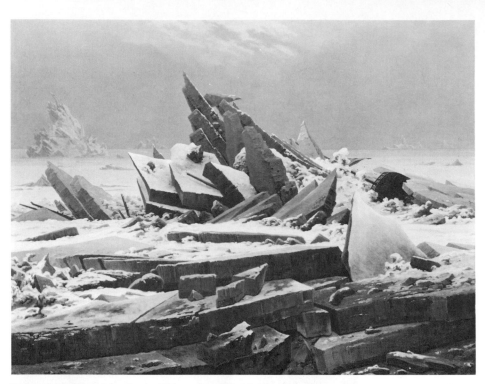

101. C. D. Friedrich, *Arctic Shipwreck,* 1823–24, Hamburg, Kunsthalle (pp. *116–17;* 149)

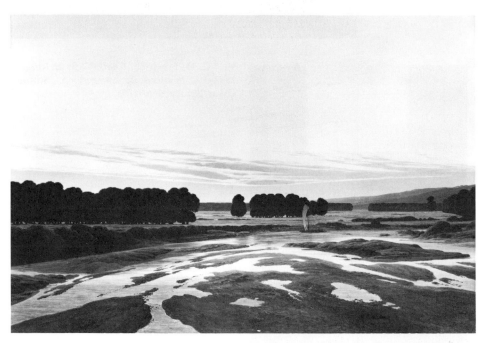

102. C. D. Friedrich, *Das grosse Gehege (The Large Enclosure Near Dresden),* 1832, Dresden, Staatliche Kunstsammlungen (p. *117*)

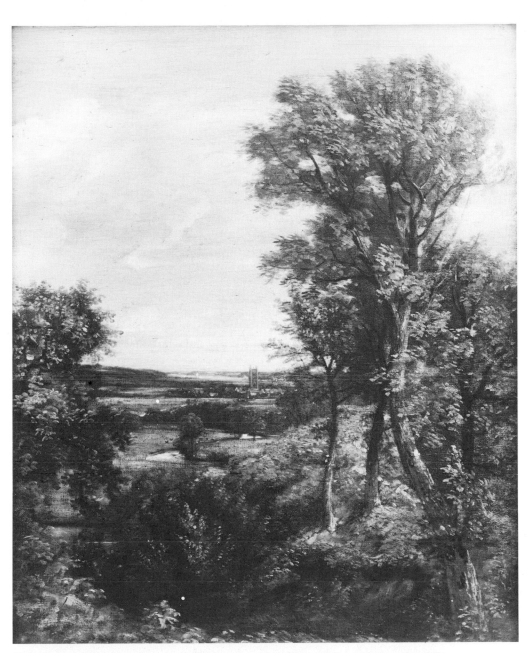

103. J. Constable, *Dedham Vale,* 1802, London, Victoria and Albert Museum (p. *125*)

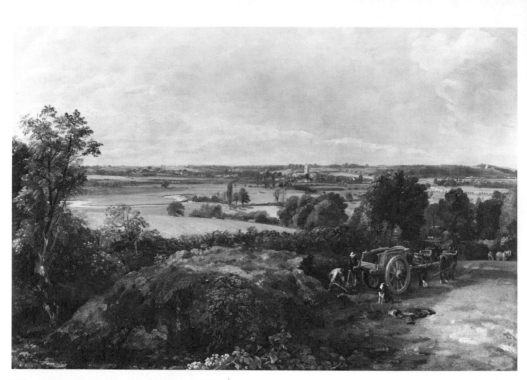

104. J. Constable, *The Stour Valley, with Dedham in the Distance,* 1814–15, Boston, Museum of Fine Arts, Warren Collection (p. *127*)

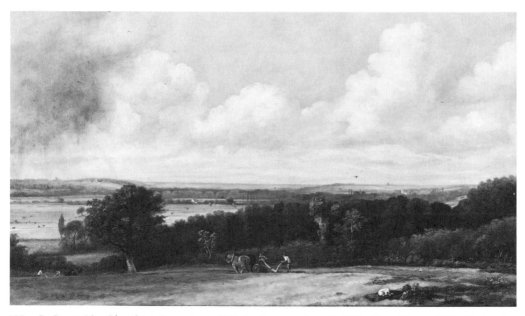

105. J. Constable, *Ploughing Scene in Suffolk (A Summer Land),* 1814, New Haven, Yale Center for British Art, Paul Mellon Collection (p. *127*)

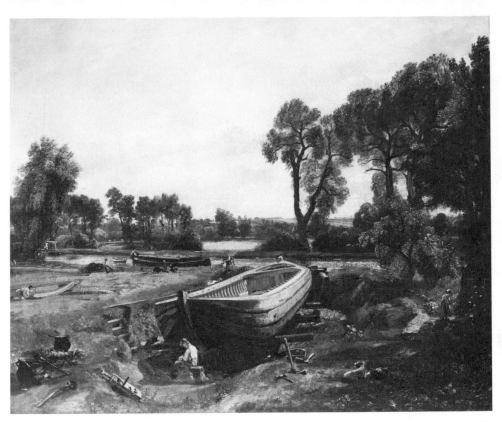

106. J. Constable, *Boat Building at Flatford,* 1815, London, Victoria and Albert Museum (p. *128*)

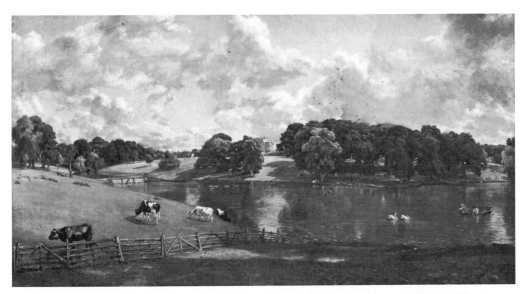

107. J. Constable, *Wivenhoe Park,* 1816, Washington, National Gallery of Art, Widener Collection (p. *128*)

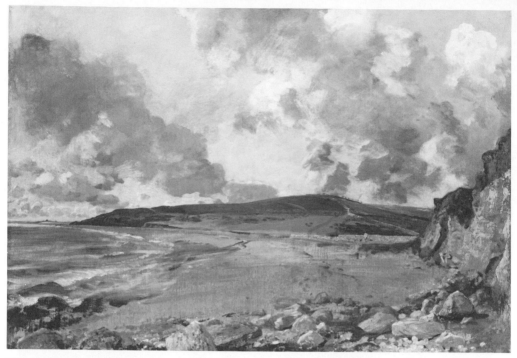

108. J. Constable, *Weymouth Bay,* 1816, London, National Gallery (p. *128*)

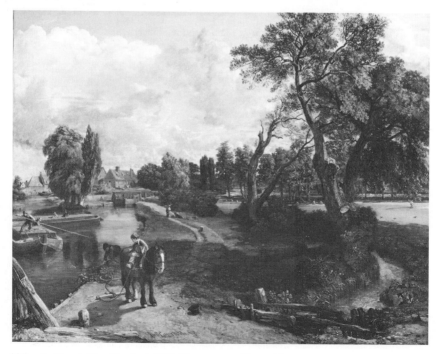

109. J. Constable, *Flatford Mill (Scene on a Navigable River),* 1817, London, Tate Gallery (p. *129*)

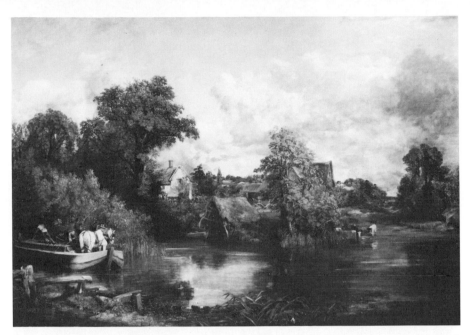

110. J. Constable, *The White Horse,* 1819, New York, Frick Collection (Copyright the Frick Collection, New York) (pp. *130;* 131)

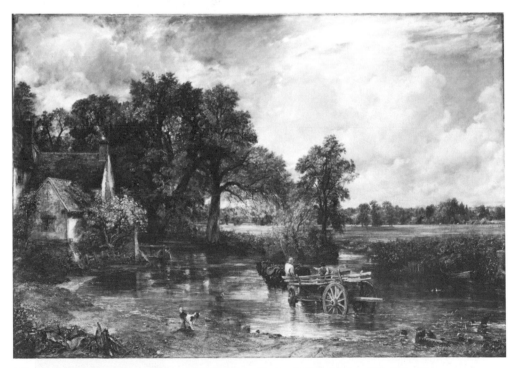

111. J. Constable, *The Haywain,* 1821, London, National Gallery (pp. *131;* 203, 206)

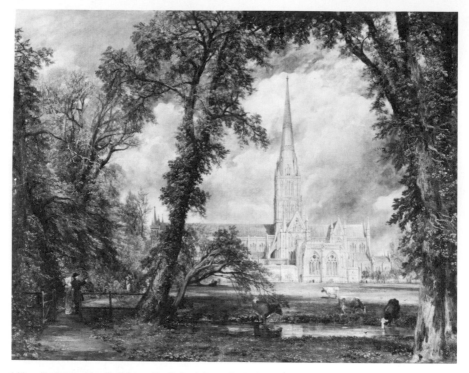

112. J. Constable, *Salisbury Cathedral from the Bishop's Grounds,* 1823, London, Victoria and Albert Museum (p. *132*)

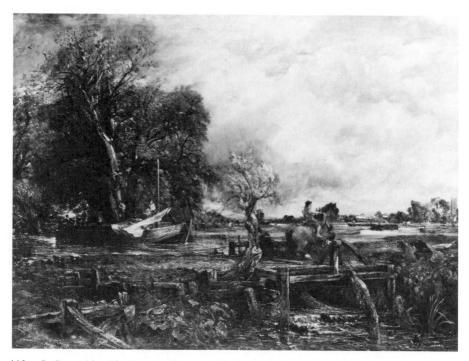

113. J. Constable, *The Leaping Horse,* 1825, London, Royal Academy of Arts (p. *133*)

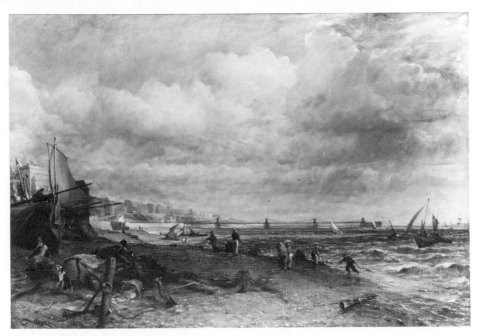

114. J. Constable, *Marine Parade and Chain Pier, Brighton,* 1827, London, Tate Gallery (p. *134*)

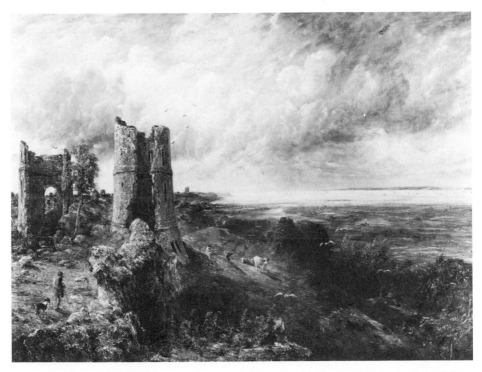

115. J. Constable, *Hadleigh Castle,* 1829, New Haven, Yale Center for British Art, Paul Mellon Collection (pp. *134–35*)

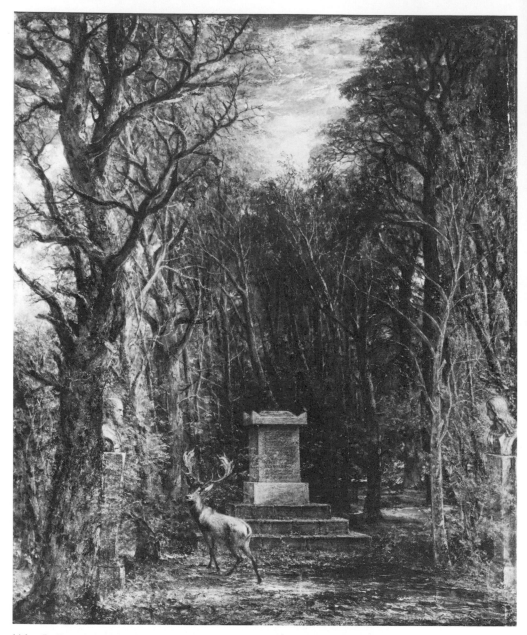

116. J. Constable, *The Cenotaph,* 1836, London, National Gallery (p. *136*)

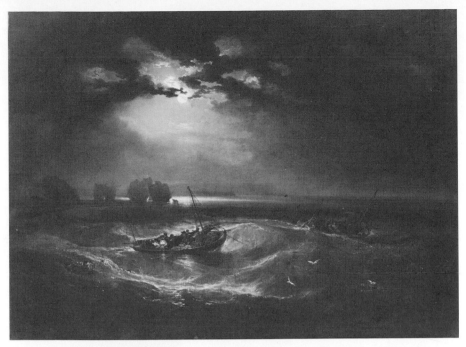

117. J. M. W. Turner, *Fishermen at Sea,* 1796, London, Tate Gallery (p. *139*)

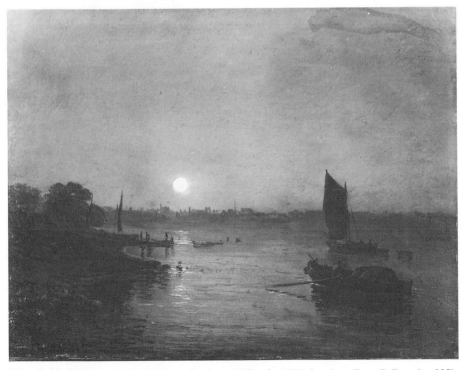

118. J. M. W. Turner, *Moonlight, a Study at Milbank,* 1797, London, Tate Gallery (p. *139*)

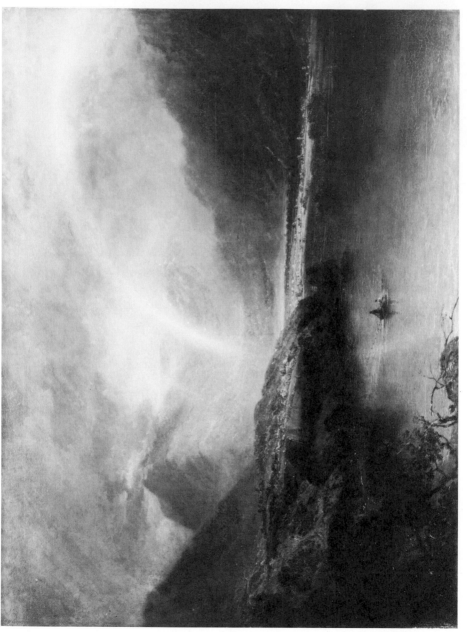

119. J. M. W. Turner, *Buttermere Lake, Cumberland: A Shower*, 1798, London, Tate Gallery (p. 139)

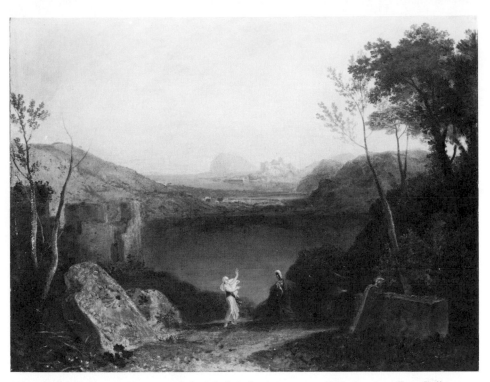

120. J. M. W. Turner, *Aeneas and the Sibyl, Lake Avernus,* ca. 1798, London, Tate Gallery
(p. *140*)

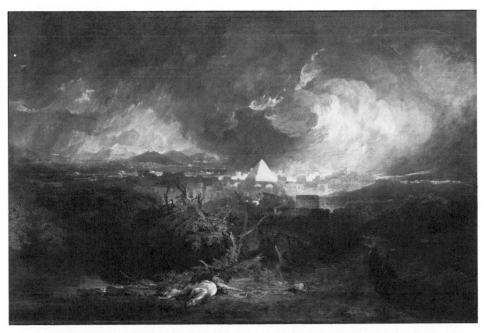

121. J. M. W. Turner, *The Fifth Plague of Egypt,* ca. 1800, Indianapolis Museum of Art, Given
in Memory of Evan F. Lilly (© Indianapolis Museum of Art) (pp. *140–41*)

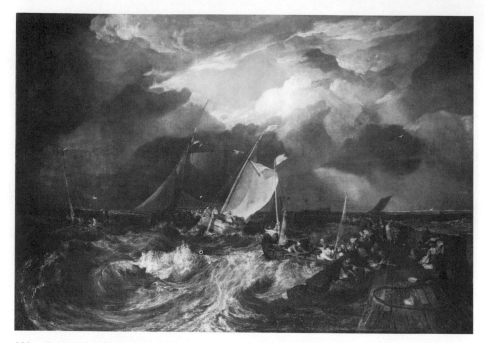

122. J. M. W. Turner, *Calais Pier,* 1803, London, National Gallery (p. *142*)

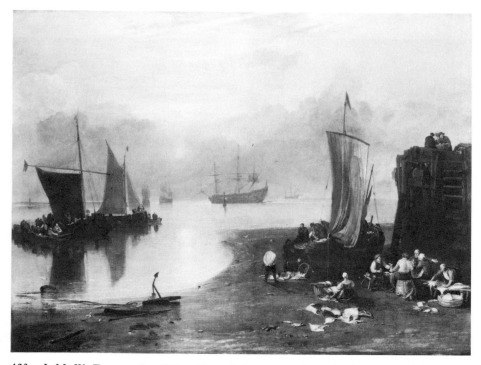

123. J. M. W. Turner, *Sun Rising Through Vapour: Fishermen Cleaning and Selling Fish,* 1807, London, National Gallery (p. *143*)

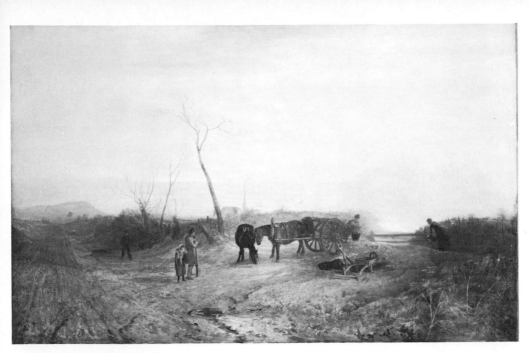

124. J. M. W. Turner, *Frosty Morning,* 1813, London, Tate Gallery (p. *144*)

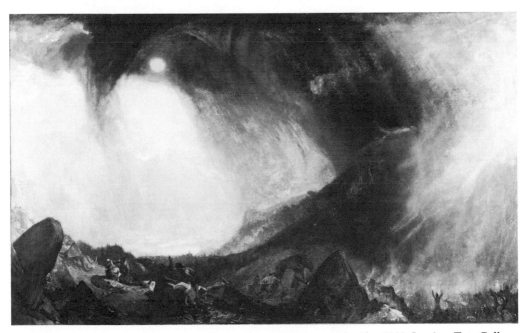

125. J. M. W. Turner, *Snowstorm: Hannibal and His Army Crossing the Alps,* 1812, London, Tate Gallery (p. *145*)

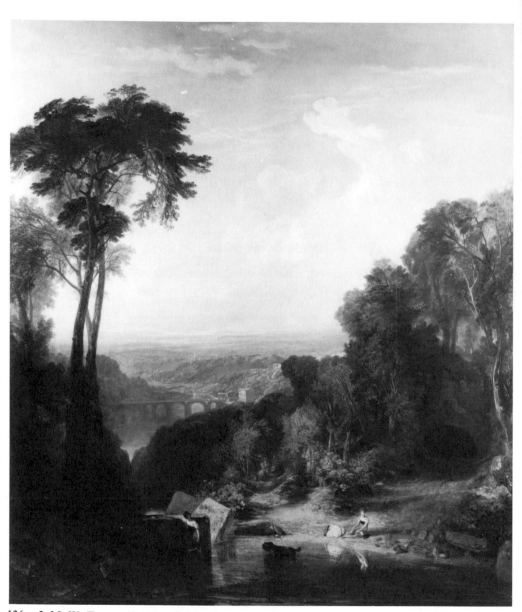

126. J. M. W. Turner, *Crossing the Brook*, 1815, London, Tate Gallery (p. *145*)

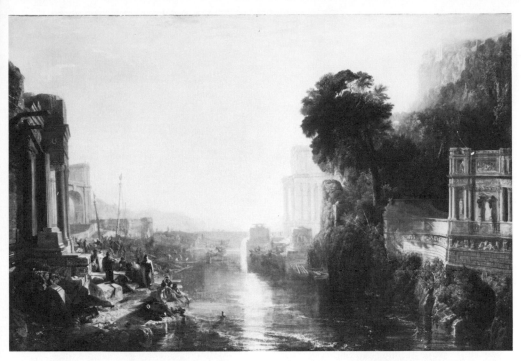

127. J. M. W. Turner, *Dido Building Carthage, or the Rise of the Carthaginian Empire,* 1815, London, National Gallery (p. *145*)

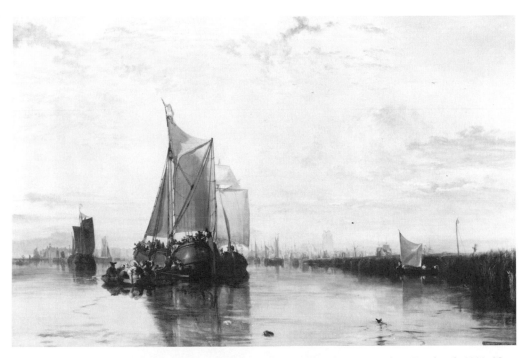

128. J. M. W. Turner, *Dort, or Dordrecht: The Dort Packet-Boat from Rotterdam Becalmed,* 1818, New Haven, Yale Center for British Art, Paul Mellon Collection (p. *146*)

73

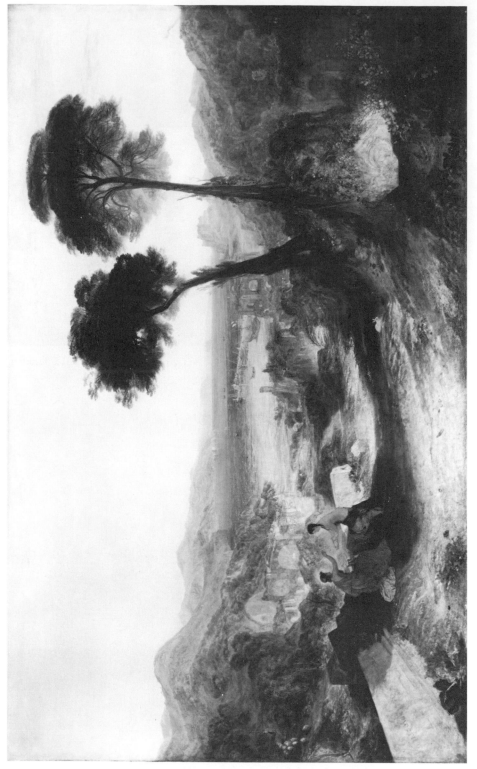

129. J. M. W. Turner, *The Bay of Baiae, Apollo and the Sybil*, 1823, London, Tate Gallery (p. 147)

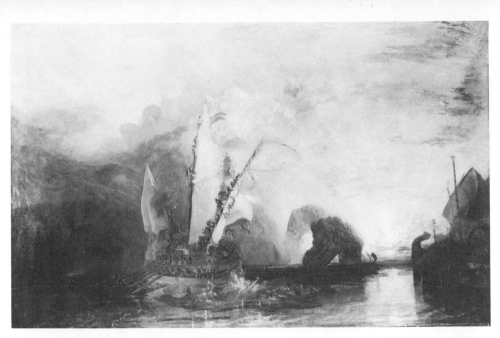

130. J. M. W. Turner, *Ulysses Deriding Polyphemus,* 1829, London, National Gallery (p. *148*)

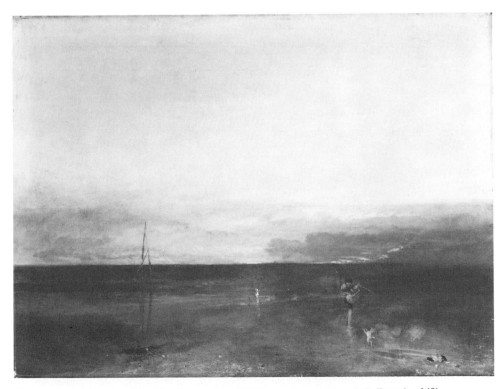

131. J. M. W. Turner, *The Evening Star,* ca. 1830, London, National Gallery (p. *149*)

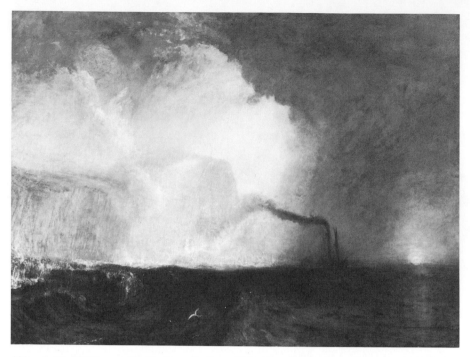

132. J. M. W. Turner, *Staffa: Fingal's Cave,* 1832, New Haven, Yale Center for British Art, Paul Mellon Collection (p. *149*)

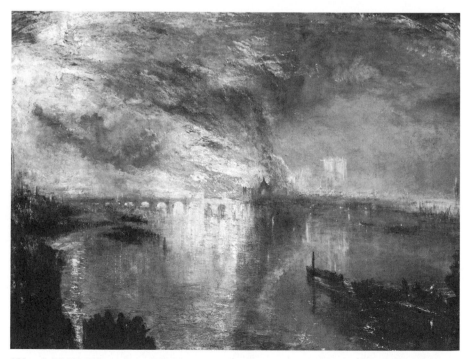

133. J. M. W. Turner, *Burning of the Houses of Parliament,* 1835, Cleveland Museum of Art, Bequest of John L. Severance (p. *149*)

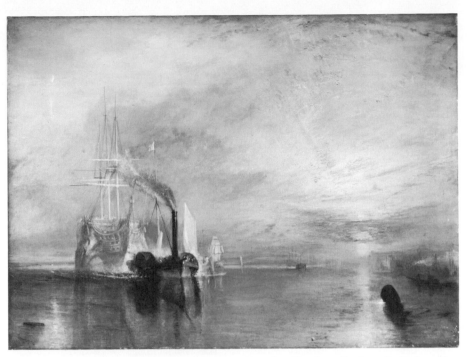

134. J. M. W. Turner, *The Fighting Temeraire Towed to Her Last Berth to Be Broken Up,*
1838, London, National Gallery (pp. *150–51*)

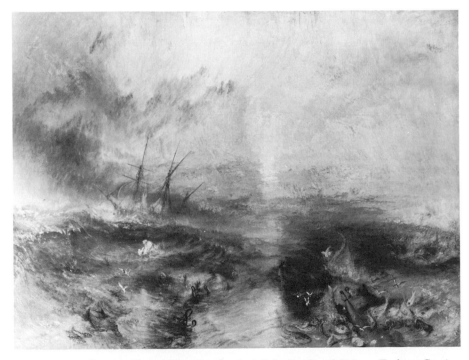

135. J. M. W. Turner, *Slavers Throwing Overboard the Dead and Dying—Typhoon Coming
On (The Slave Ship),* 1840, Boston, Museum of Fine Arts, Henry Lillie Pierce Fund (p. *151*)

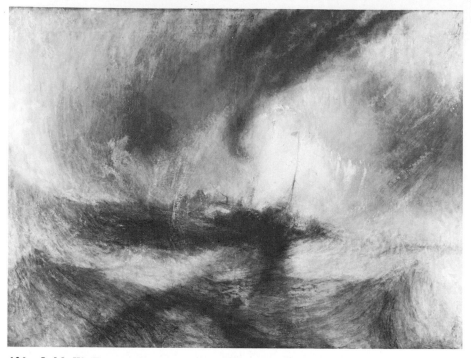

136. J. M. W. Turner, *Snowstorm—Steamboat Off a Harbor's Mouth Making Signals in Shallow Water and Going by the Lead,* 1842, London, Tate Gallery (p. *152*)

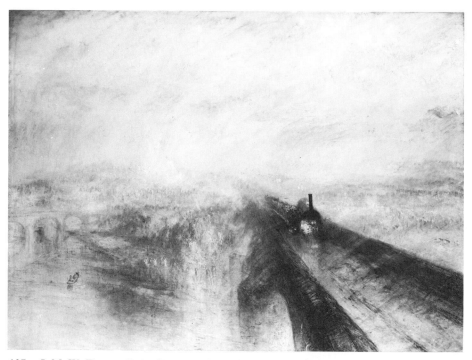

137. J. M. W. Turner, *Rain, Steam, and Speed—The Great Western Railway,* 1844, London, National Gallery (p. *152*)

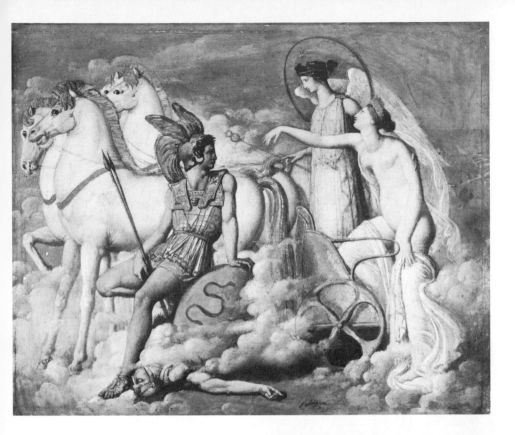

138. J.-D. Ingres, *Venus Wounded by Diomedes,* ca. 1803–5, Basel, Kunstmuseum, Gift of Martha and Robert von Hirsch (p. *159*)

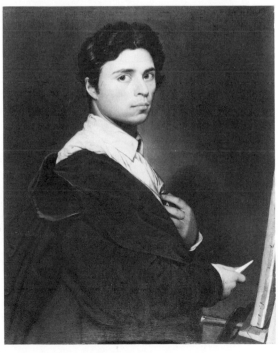

139. J.-D. Ingres, *Self-Portrait,* 1804, Chantilly, Musée Condé (p. *159*)

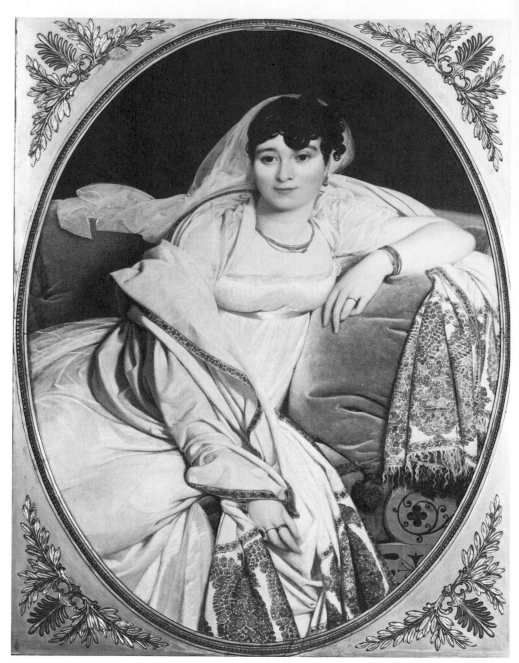

140. J.-D. Ingres, *Portrait of Mme Rivière,* 1805, Paris, Louvre (p. *159*)

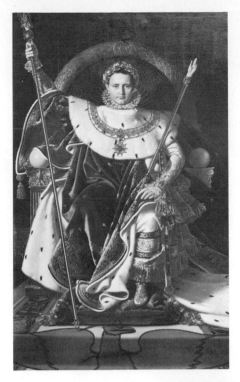

141. J.-D. Ingres, *Napoleon on the Imperial Throne,* 1806, Paris, Musée de l'Armée (p. *160*)

142. J.-D. Ingres, *Portrait of Mme Duvauçay,* 1807, Chantilly, Musée Condé (p. *161*)

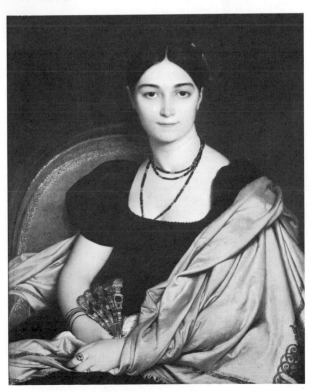

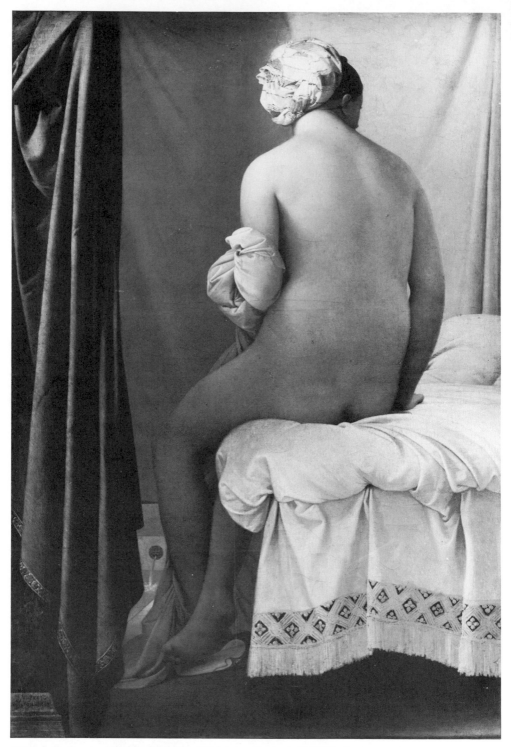

143. J.-D. Ingres, *The Grand Bather (Valpinçon Bather)*, 1808, Paris, Louvre (pp. *161;* 328, 383)

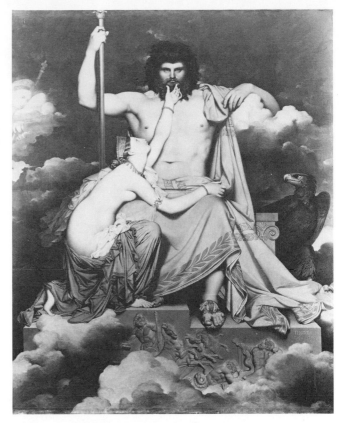

144. J.-D. Ingres, *Jupiter and Thetis*, 1811, Aix-en-Provence, Musée Granet (p. *162*)

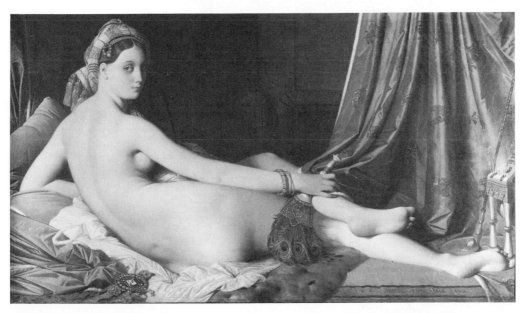

145. J.-D. Ingres, *Grand Odalisque*, 1814, Paris, Louvre (pp. *163;* 298)

146. J.-D. Ingres, *The Vow of Louis XIII,* 1821–24, Montauban, Cathedral (p. *164*)

147. J.-D. Ingres, *The Apotheosis of Homer,* 1827, Paris, Louvre (p. *165*)

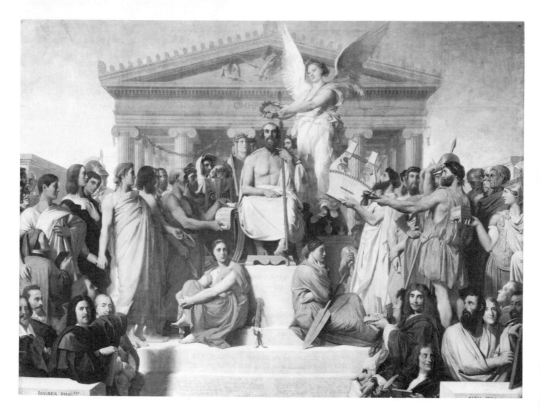

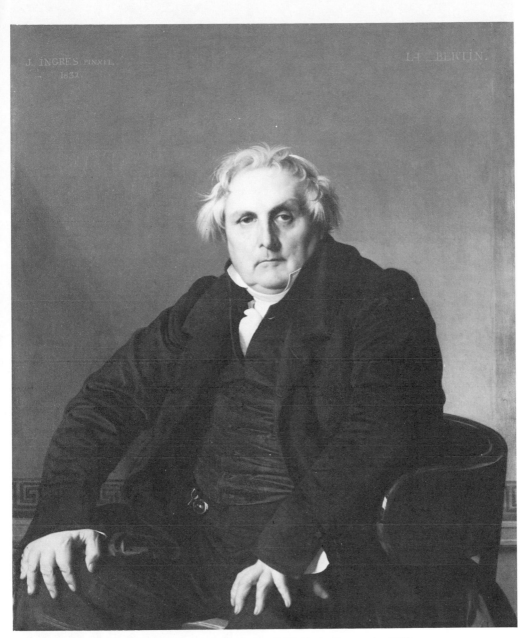

148. J.-D. Ingres, *Portrait of Louis-François Bertin,* 1832, Paris, Louvre (p. *165*)

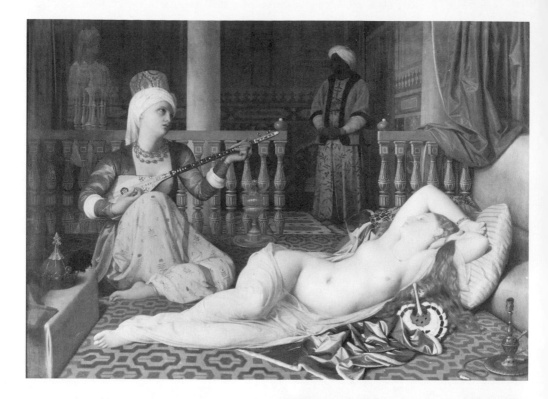

149. J.-D. Ingres, *Odalisque with Slave,* 1839, Cambridge, Mass., Fogg Art Museum, Harvard University, Bequest of Grenville L. Winthrop (p. *166*)

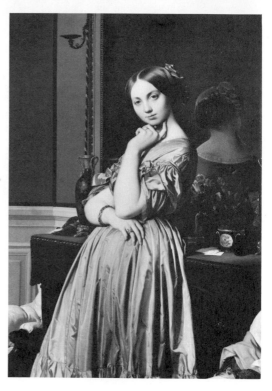

150. J.-D. Ingres, *Viscountess d'Haussonville,* 1845, New York, Frick Collection (Copyright the Frick Collection, New York) (p. *168*)

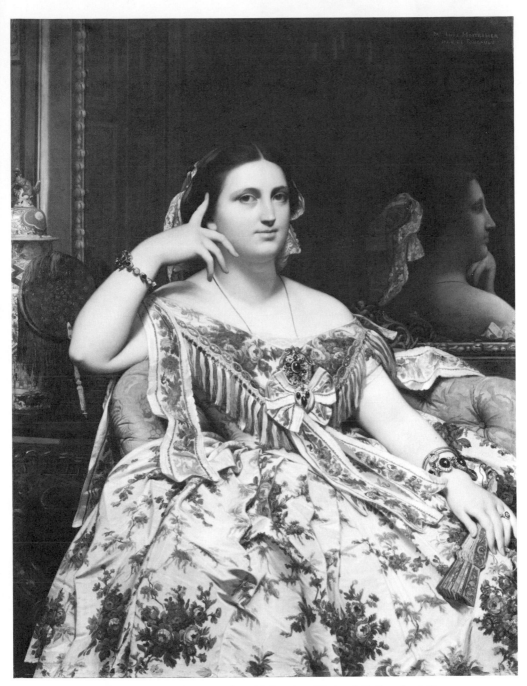

151. J.-D. Ingres, *Mme de Moitessier Seated,* 1856, London, National Gallery (p. *168*)

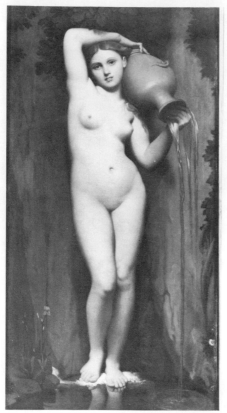

152. J.-D. Ingres, *La Source (The Fountain),* 1856, Paris, Louvre (p. *169*)

153. J.-D. Ingres, *The Turkish Bath,* 1862, Paris, Louvre (p. *169*)

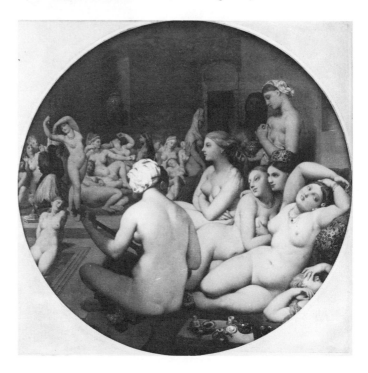

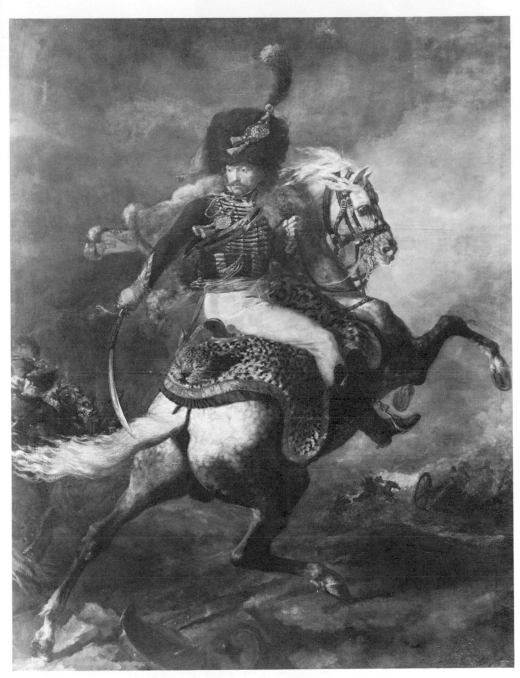

154. T. Géricault, *The Charging Chasseur,* 1812, Paris, Louvre (pp. *172;* 174)

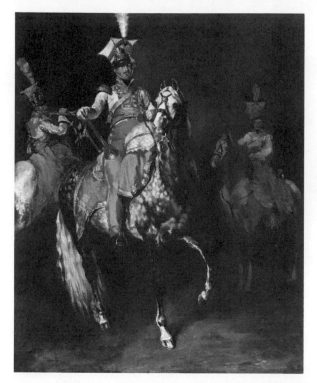

155. T. Géricault, *Three Mounted Trumpeters,* ca. 1814, Washington, National Gallery of Art, Chester Dale Fund (p. *172*)

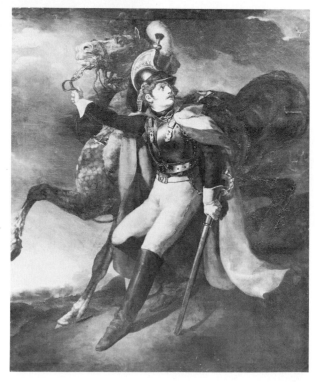

156. T. Géricault, *Wounded Cuirassier Leaving the Field of Battle,* 1814, Paris, Louvre (p. *174*)

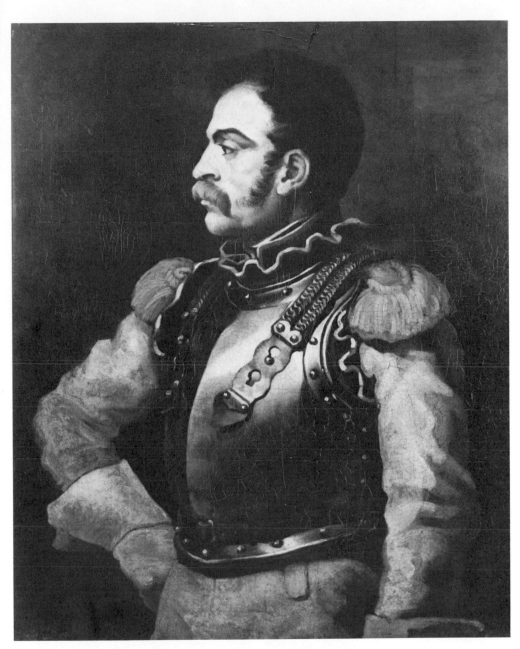

157. T. Géricault, *Portrait of a Carabinier,* 1814–15, Paris, Louvre (p. *174*)

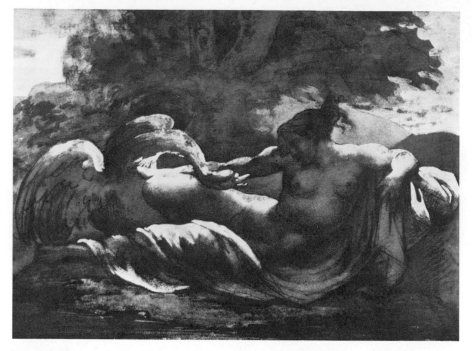

158. T. Géricault, *Leda and the Swan,* black chalk, pen, wash, watercolor, and white gouache, 1816–17, Paris, Louvre (p. *176*)

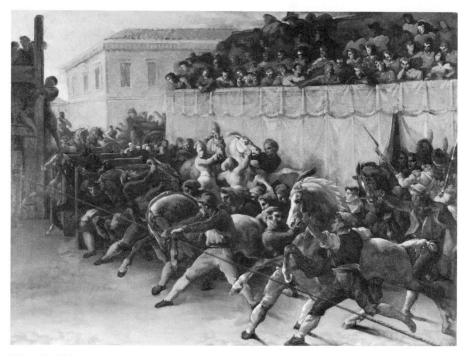

159. T. Géricault, *Race of the Barberi Horses,* 1817, Baltimore, Walters Art Gallery (p. *177*)

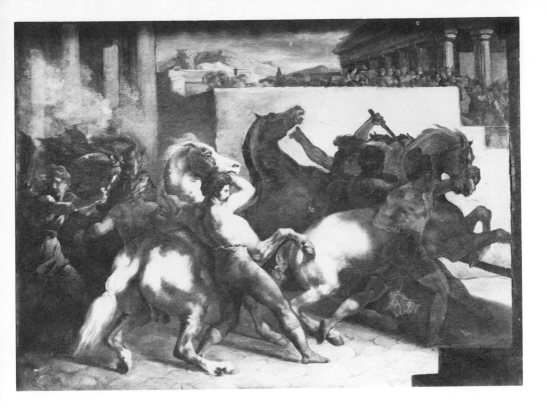

160. T. Géricault, *Race of the Barberi Horses,* 1817, Paris, Louvre (p. *177*)

161. T. Géricault, *The Cattle Market,* 1817, Cambridge, Mass., Fogg Art Museum, Harvard University, Bequest of Grenville L. Winthrop (p. *177–78*)

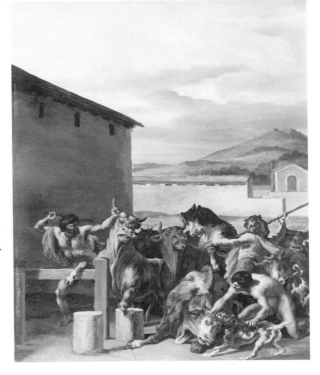

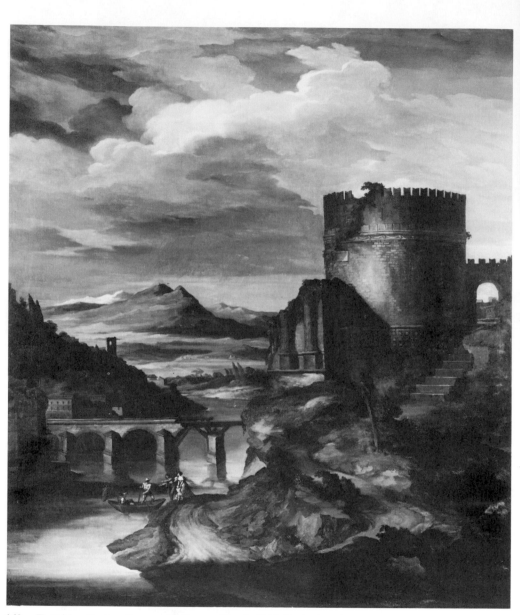

162. T. Géricault, *Landscape with Roman Tomb,* 1818, Paris, Musée du Petit Palais (p. *178*)

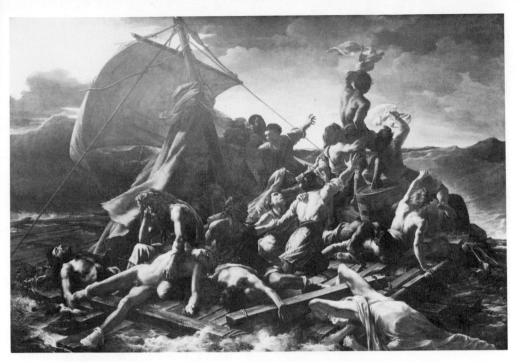

163. T. Géricault, *Raft of the Medusa,* 1818–19, Paris, Louvre (pp. *179;* 149, 188, 301)

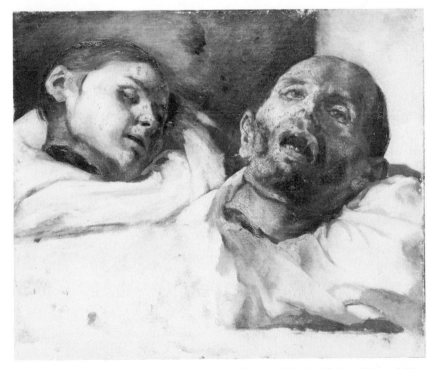

164. T. Géricault, *Study of Two Severed Heads,* ca. 1819, Stockholm, National Museum (p. *180*)

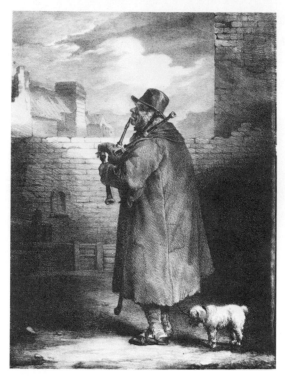

165. T. Géricault, *Piper,* lithograph, 1821, Stanford University Museum (p. *180*)

166. T. Géricault, *The Epsom Downs Derby,* 1821, Paris, Louvre (pp. *180;* 318)

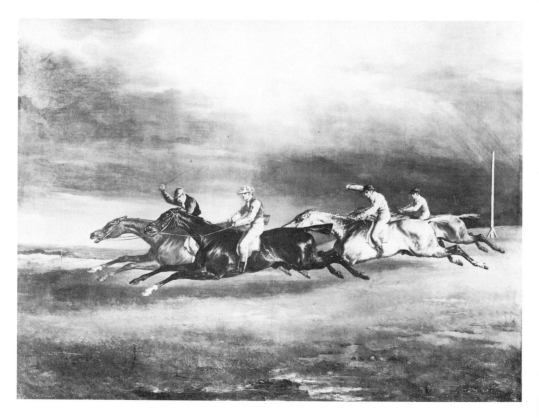

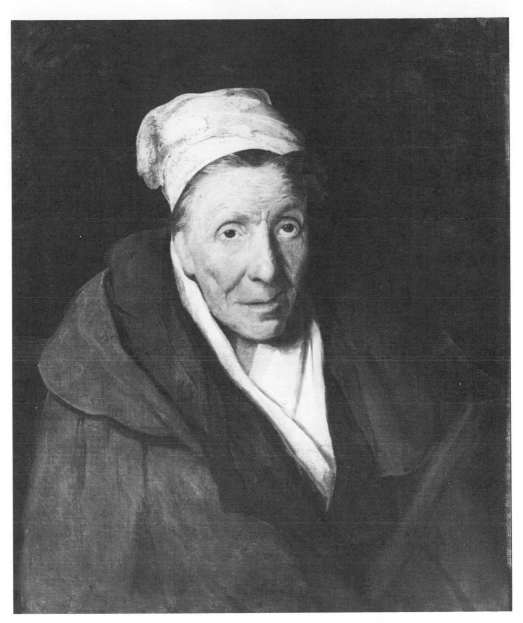

167. T. Géricault, *Portrait of a Woman Addicted to Gambling,* ca. 1822, Paris, Louvre (p. *182*)

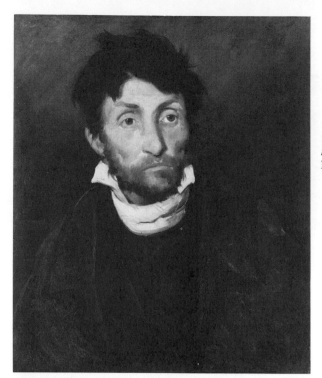

168. T. Géricault, *Portrait of a Klepto-maniac,* ca. 1822, Ghent, Musée des Beaux-Arts (p. *182*)

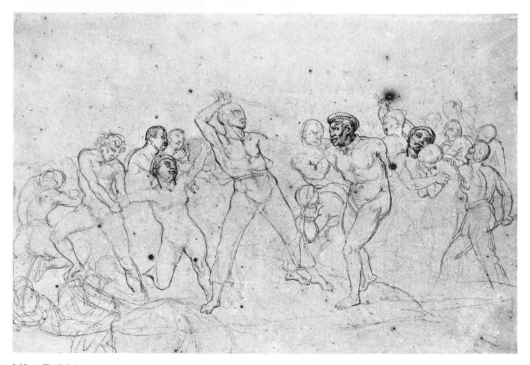

169. T. Géricault, *The African Slave Trade,* black and red chalk, 1823, Paris, Ecole Nationale Supérieure des Beaux-Arts (p. *182*)

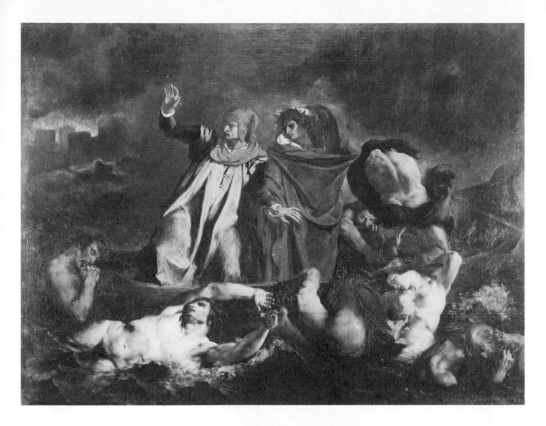

170. E. Delacroix, *Bark of Dante (Dante and Virgil Ferried by Phlegias to the City of Hell),* 1822, Paris, Louvre (p. *185*)

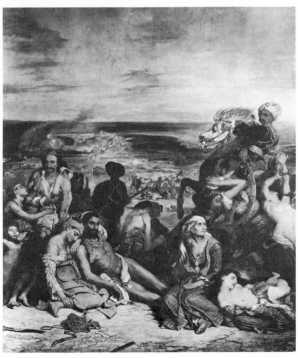

171. E. Delacroix, *Massacre of Chios,* 1824, Paris, Louvre (pp. *185;* 190)

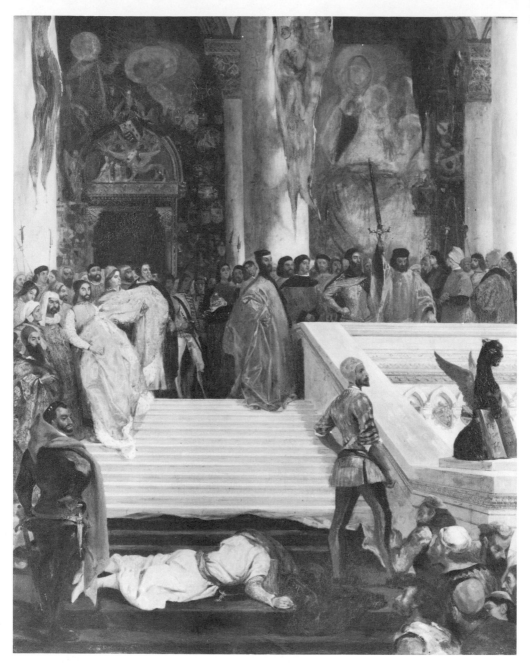

172. E. Delacroix, *The Execution of the Doge Marino Faliero,* 1826, London, Wallace Collection (p. *186*)

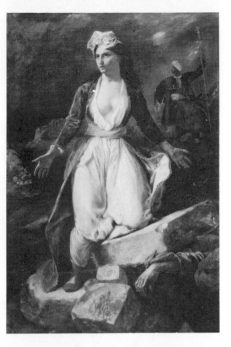

173. E. Delacroix, *Greece on the Ruins of Missolunghi,*
1826, Bordeaux, Musée des Beaux-Arts (pp. *186; 188*)

174. E. Delacroix, *Death of Sardanapalus,* 1827, Paris,
Louvre (p. *187*)

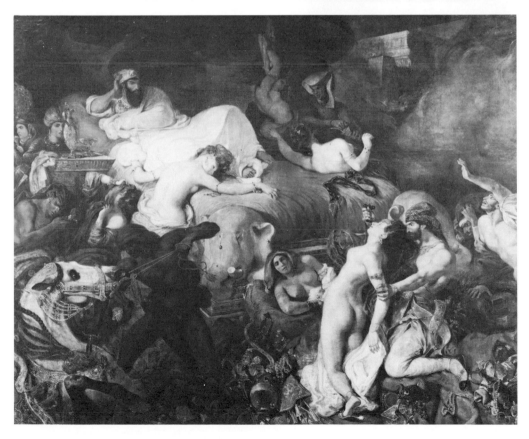

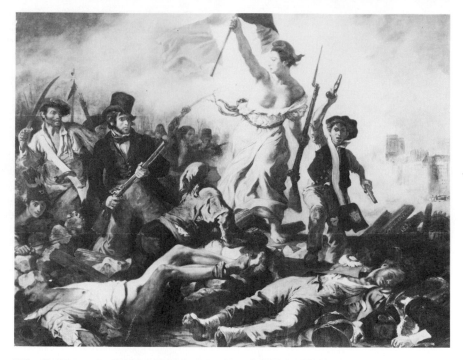

175. E. Delacroix, *Liberty Leading the People,* 1830, Paris, Louvre (pp. *188;* 190, 234)

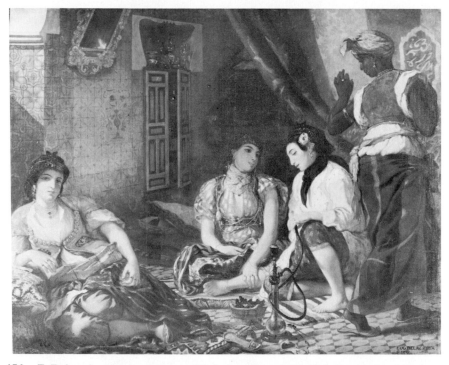

176. E. Delacroix, *Algerian Women in Their Apartment,* 1834, Paris, Louvre (pp. *189;* 166)

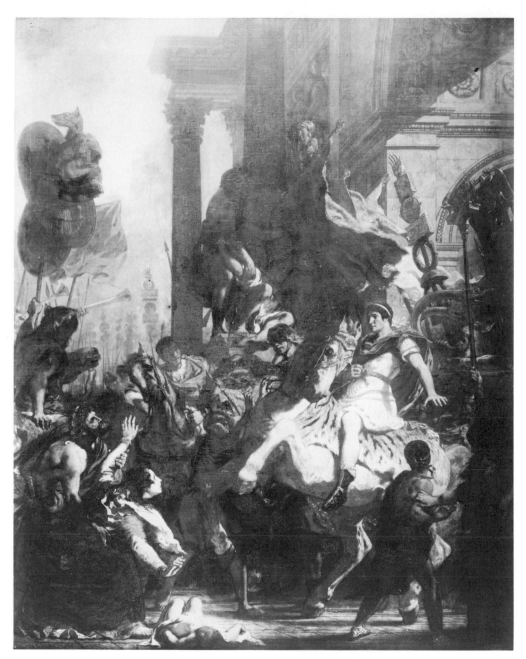

177. E. Delacroix, *The Justice of Trajan,* 1840, Rouen, Musée des Beaux-Arts (p. *190*)

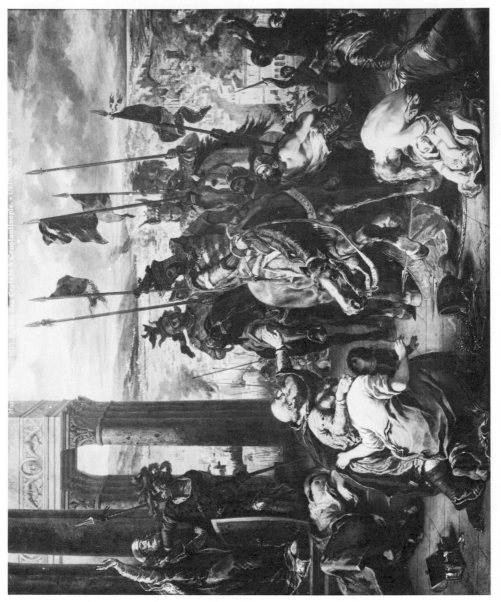

178. E. Delacroix, *The Entry of the Crusaders into Constantinople*, 1840, Paris, Louvre (p. 190)

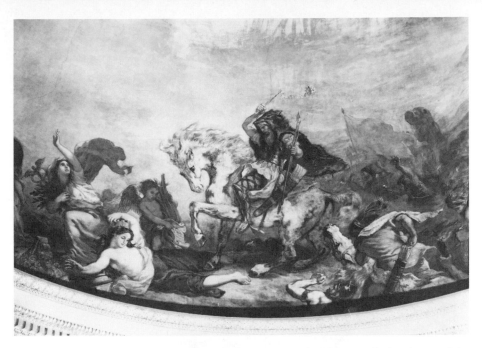

179. E. Delacroix, *Attila Despoiling Italy,* detail of one of the half-domes in the Library of the Chamber of Deputies, 1838–44, Paris, Palais Bourbon (p. *191*)

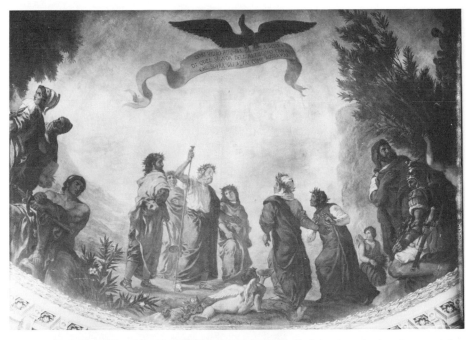

180. E. Delacroix, *Virgil Presenting Dante to Homer,* detail of the dome in the Library of the Senate, 1840–46, Paris, Palais du Luxembourg (p. *191*)

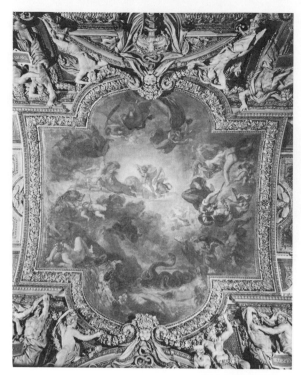

181. E. Delacroix, *Apollo Victorious Over Python,* ceiling of the Galerie d'Apollon, 1850–51, Paris, Louvre (p. *191*)

182. E. Delacroix, *Jacob Wrestling with the Angel,* 1854–61, Paris, Saint-Sulpice, Chapel of the Holy Angels (p. *193*)

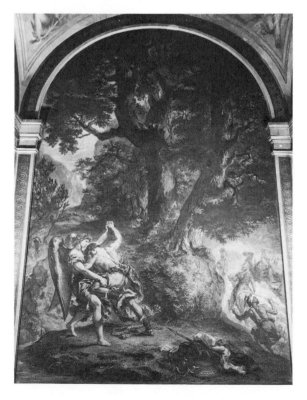

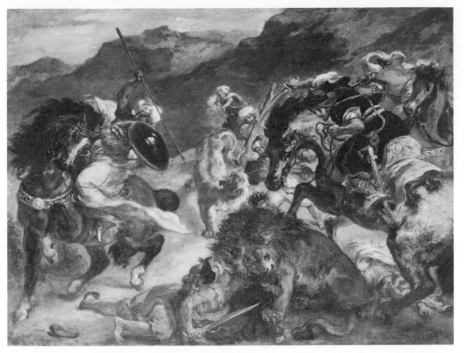

183. E. Delacroix, *Lion Hunt,* 1858, Boston, Museum of Fine Arts, S. A. Denio Collection (p. *193*)

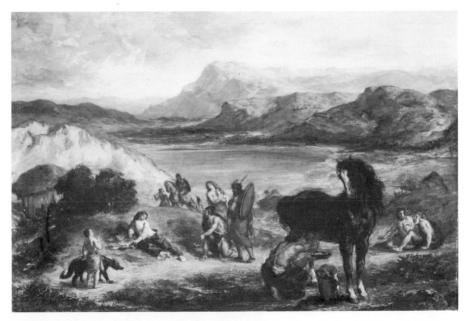

184. E. Delacroix, *Ovid Among the Scythians,* 1859, London, National Gallery (p. *194*)

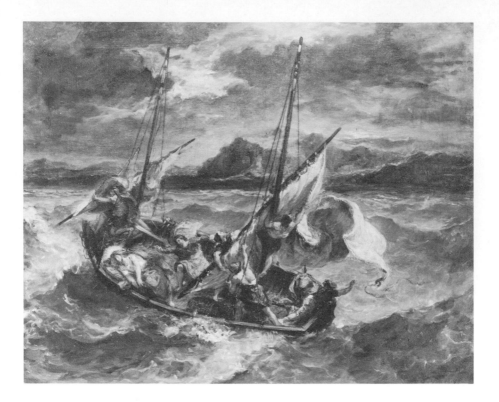

185. E. Delacroix, *Christ on the Sea of Galilee,* 1854, Baltimore, Walters Art Gallery (p. *194*)

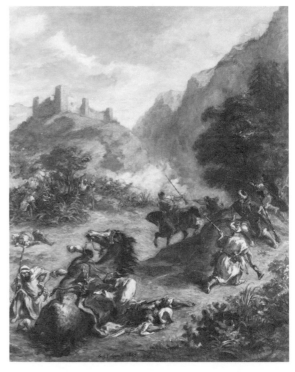

186. E. Delacroix, *Arabs Skirmishing in the Mountains,* 1863, Washington, National Gallery of Art, Chester Dale Fund (p. *195*)

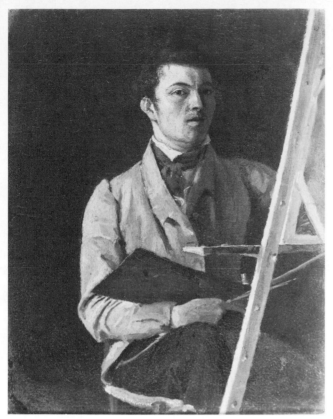

187. C. Corot, *Self-Portrait*, 1825, Paris, Louvre (p. *201*)

188. C. Corot, *View of the Colosseum from the Farnese Gardens*, 1826, Paris, Louvre (p. *201*)

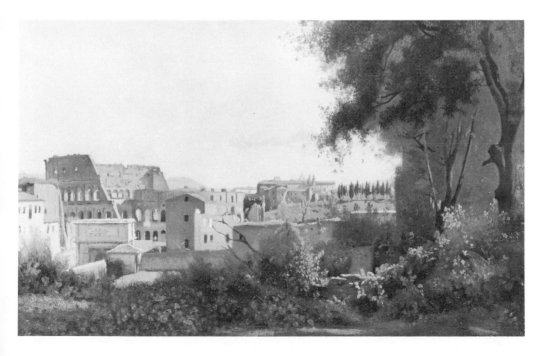

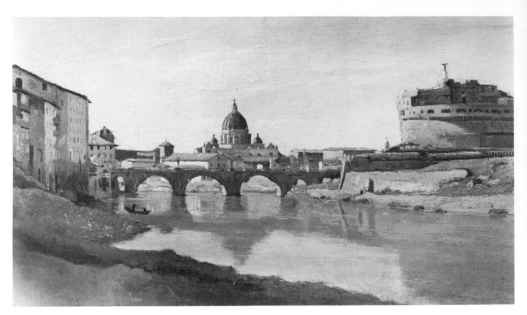

189. C. Corot, *Ponte and Castel Sant'Angelo, Rome,* 1826–28, Fine Arts Museums of San Francisco, Gift of A. M. Huntington (p. *201*)

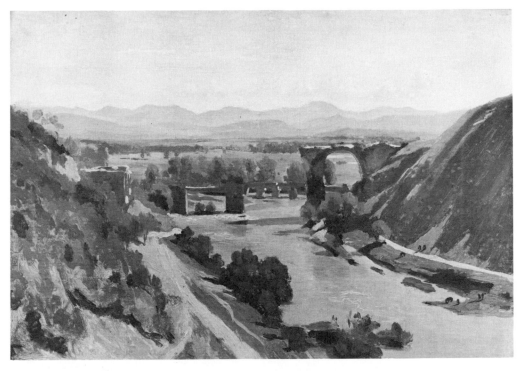

190. C. Corot, *Narni Bridge* (study), 1826, Paris, Louvre (p. *201*)

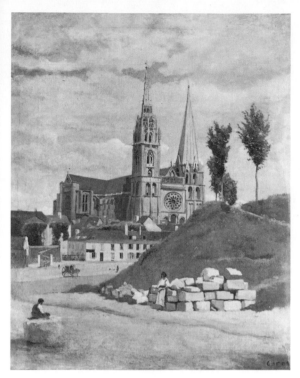

191. C. Corot, *Chartres Cathedral,* 1830, Paris, Louvre (pp. *202;* 206)

192. C. Corot, *View of Genoa from Acqua Sola,* 1834, Art Institute of Chicago, Mr. and Mrs. Martin A. Ryerson Collection (p. *203*)

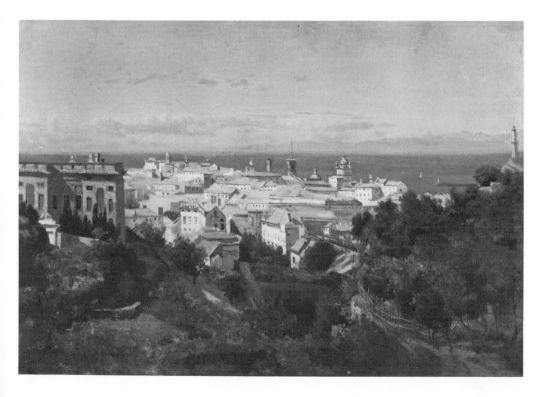

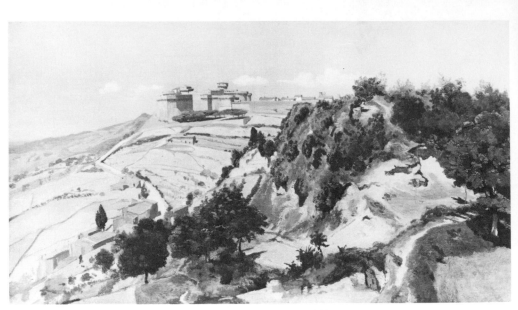

193. C. Corot, *Volterra, the Citadel,* 1834, Paris, Louvre (p. *203*)

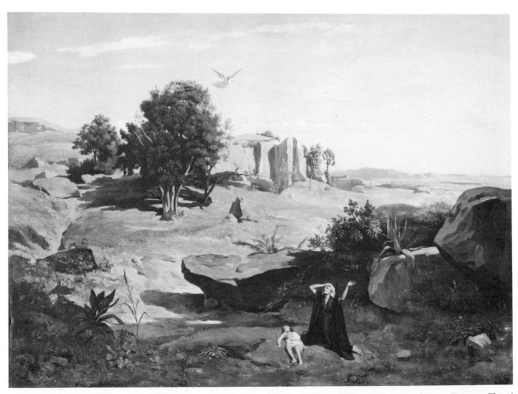

194. C. Corot, *Hagar in the Wilderness,* 1835, New York, Metropolitan Museum of Art, Rogers Fund (pp. *203–4*)

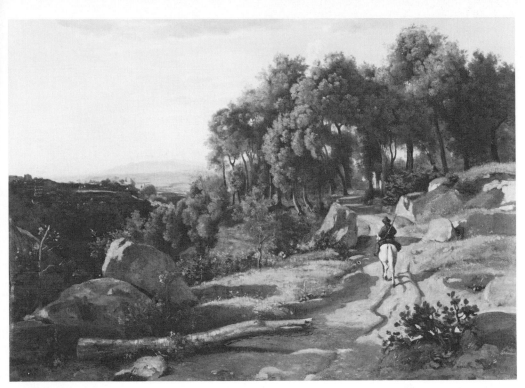

195. C. Corot, *Souvenir of Volterra*, 1838, Washington, National Gallery of Art, Chester Dale Collection (p. *204*)

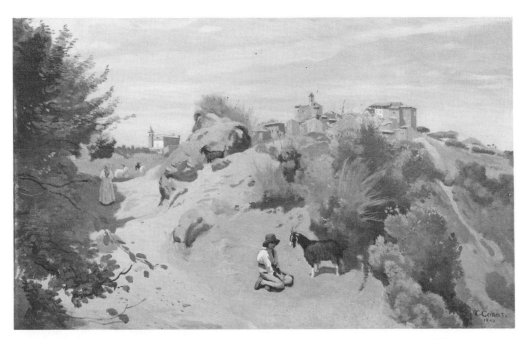

196. C. Corot, *The Goatherd of Genzano*, 1843, Washington, Phillips Collection (p. *205*)

113

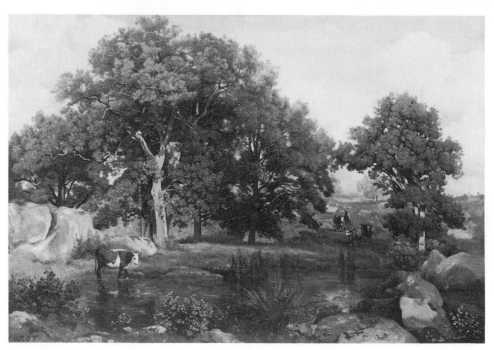

197. C. Corot, *The Forest of Fontainebleau,* 1846, Boston, Museum of Fine Arts, Gift of Mrs. Samuel Dennis Warren (p. *206*)

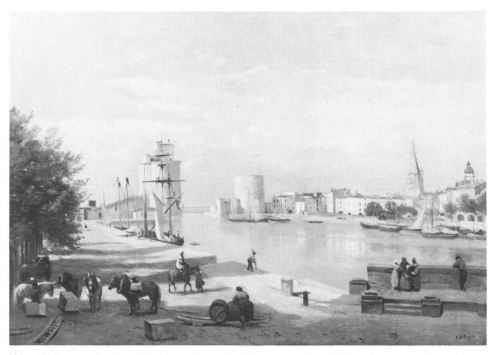

198. C. Corot, *The Port of La Rochelle,* 1851, New Haven, Yale University Art Gallery, Bequest of Stephen Carlton Clark, B.A. 1903 (p. *206*)

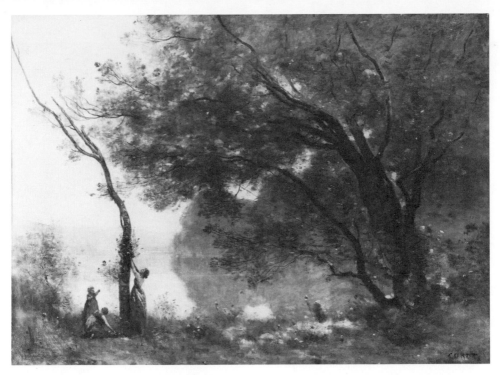

199. C. Corot, *Recollection of Mortefontaine,* 1864, Paris, Louvre (Musée d'Orsay) (p. *208*)

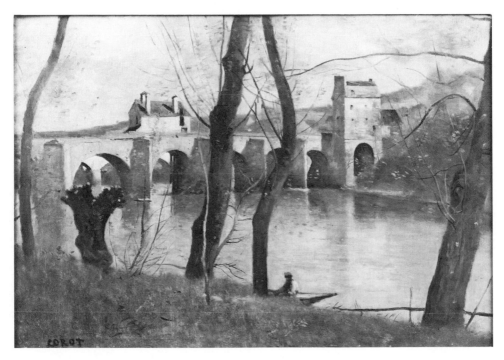

200. C. Corot, *The Bridge of Mantes,* 1868–70, Paris, Louvre (Musée d'Orsay) (p. *208*)

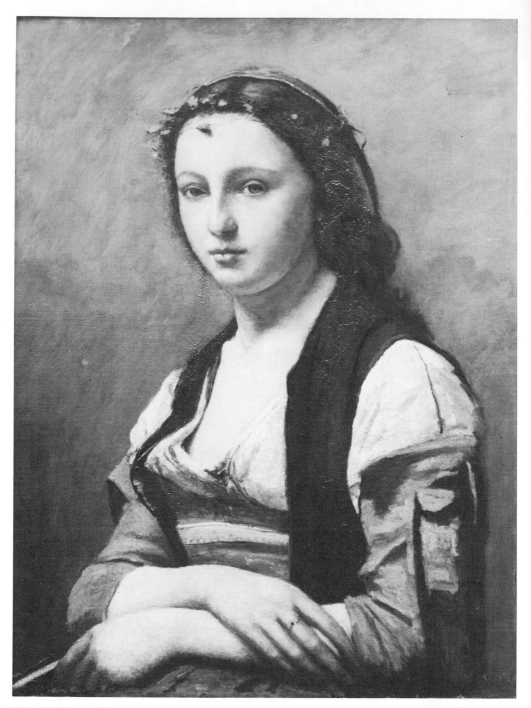

201. C. Corot, *Woman with a Pearl,* 1868–70, Paris, Louvre (Musée d'Orsay) (p. *209*)

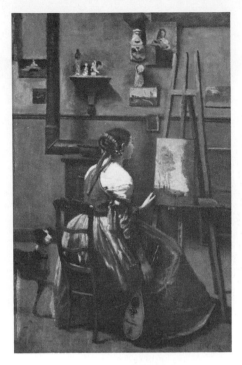

202. C. Corot, *The Artist's Studio,* ca. 1870, Washington, National Gallery of Art, Widener Collection (p. *210*)

203. C. Corot, *Belfry of Douai,* 1871, Paris, Louvre (Musée d'Orsay) (p. *210*)

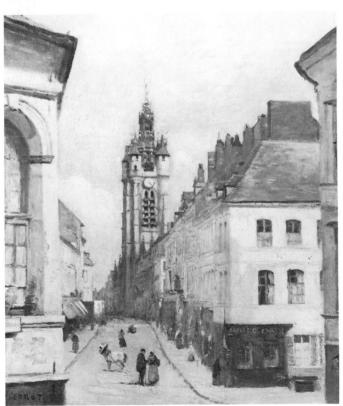

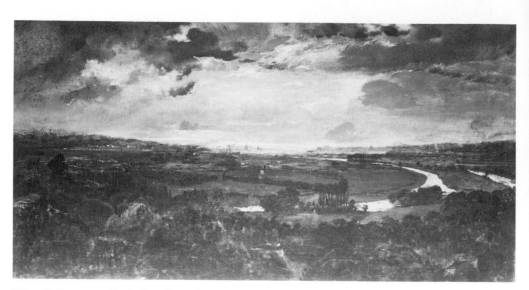

204. T. Rousseau, *Paris Seen from the Terrace of Bellevue,* 1833, Brussels, Musées Royaux (p. *218*)

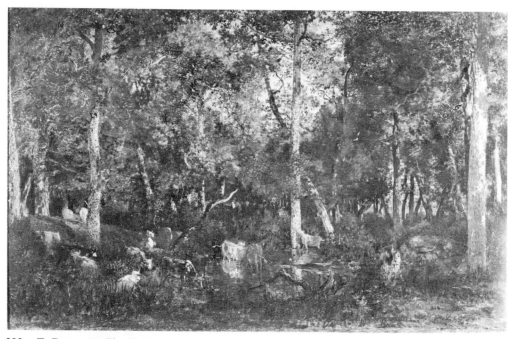

205. T. Rousseau, *The Forest of Fontainebleau at Bas Bréau (Le Vieux Dormoir),* 1836 (completed in 1867), Paris, Louvre (Musée d'Orsay) (p. *219*)

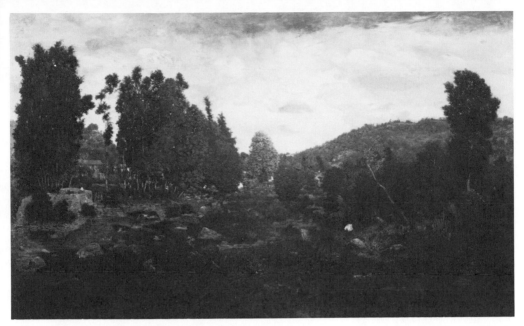

206. T. Rousseau, *The Valley of Tiffauge,* 1837–44, Cincinnati Art Museum, Gift of Emilie L. Heine in memory of Mr. and Mrs. John Hauck (p. *219*)

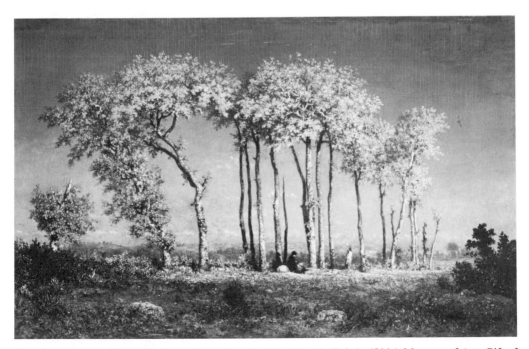

207. T. Rousseau, *Under the Beech Trees ("Le Curé"),* 1842–43, Toledo (Ohio) Museum of Art, Gift of Arthur J. Secor (p. *219*)

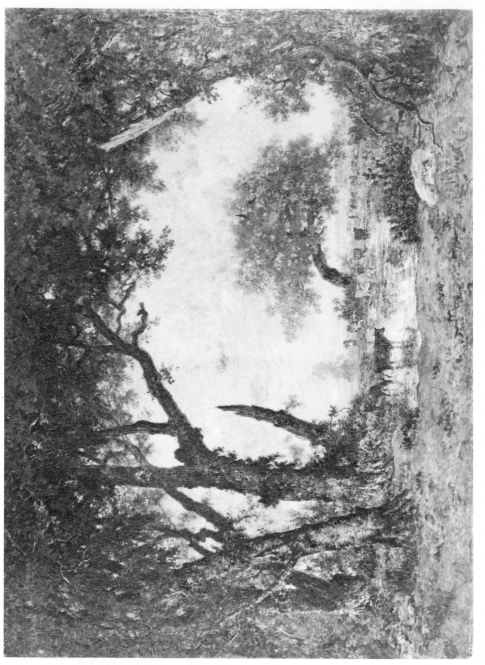

208. T. Rousseau, *View from the Forest of Fontainebleau: Sunset*, 1848–49, Paris, Louvre (Musée d'Orsay) (p. 220)

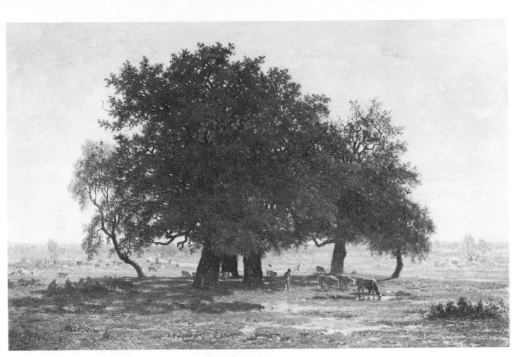

209. T. Rousseau, *Oaks at Apremont,* 1852, Paris, Louvre (Musée d'Orsay) (p. *221*)

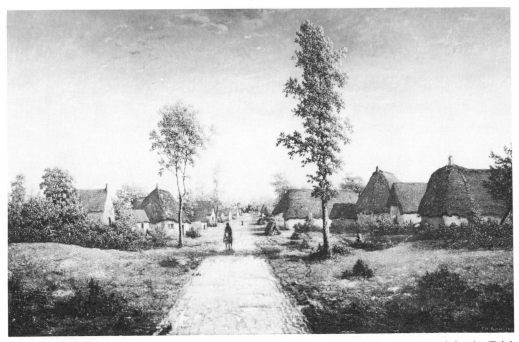

210. T. Rousseau, *The Village of Bécquigny,* 1864, New York, Frick Collection (Copyright the Frick Collection, New York) (p. *222*)

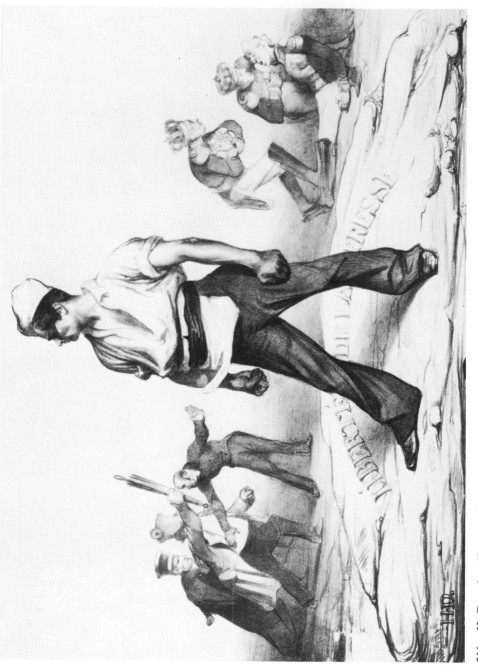

211. H. Daumier, *Ne vous y frottez pas (Freedom of the Press)*, lithograph published by the Association Mensuelle, 1834, Stanford University Museum (p. 233)

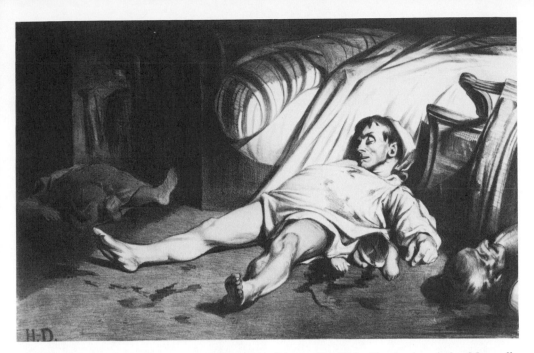

212. H. Daumier, *Rue Transnonain, 15 April 1834,* lithograph published by the Association Mensuelle, 1834, Stanford University Museum (p. *233*)

213. H. Daumier, *"Good-bye, Ophelia!"* lithograph from the series *Les Basbleus,* 1844, Stanford University Museum (p. *234*)

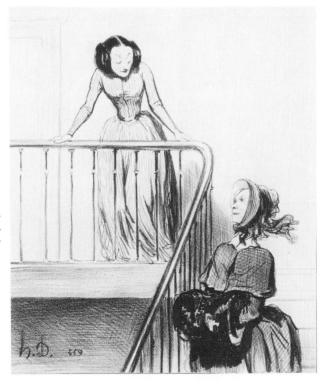

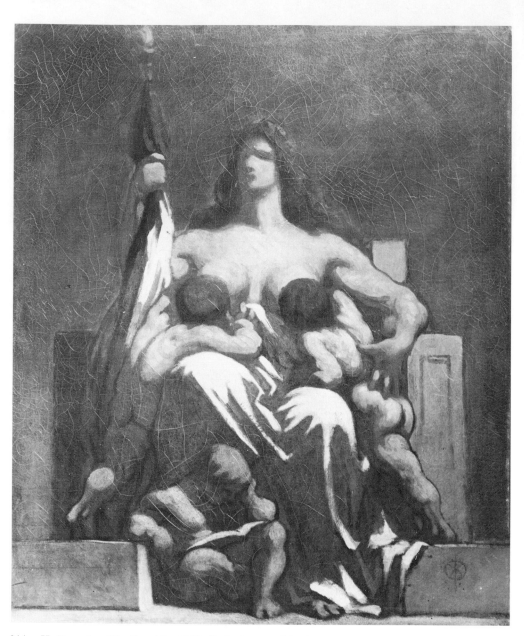

214. H. Daumier, *The Republic,* 1848, Paris, Louvre (Musée d'Orsay) (p. *234*)

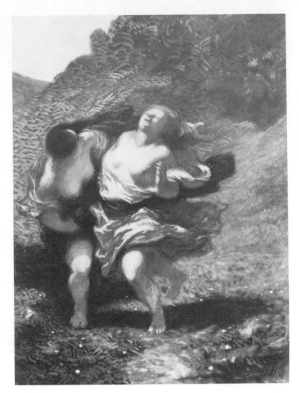

215. H. Daumier, *Nymphs Pursued by a Satyr,* 1850, Montreal, Museum of Fine Arts, Adaline Van Horne Bequest (p. *234*)

216. H. Daumier, *Saltimbanques,* ca. 1847–50, Washington, National Gallery of Art, Chester Dale Collection (p. *235*)

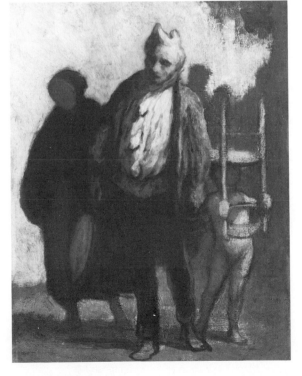

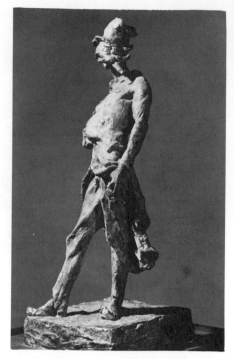

217. H. Daumier, *Ratapoil,* original plaster, 1851, Buffalo, Albright-Knox Art Gallery, Elizabeth H. Gates Fund (p. *234*)

218. H. Daumier, *The Uprising,* ca. 1860, Washington, Phillips Collection (p. *234*)

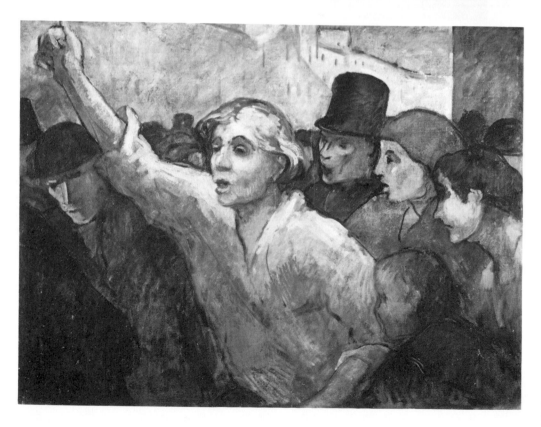

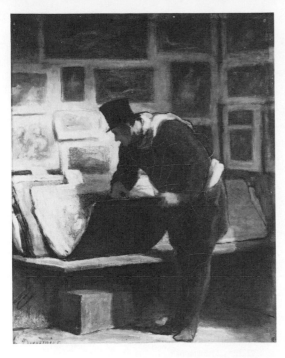

219. H. Daumier, *The Print Collector,* ca. 1865, Paris, Musée du Petit Palais (p. *235*)

220. H. Daumier, *Don Quixote,* ca. 1865–70, Munich, Neue Pinakothek (p. *235*)

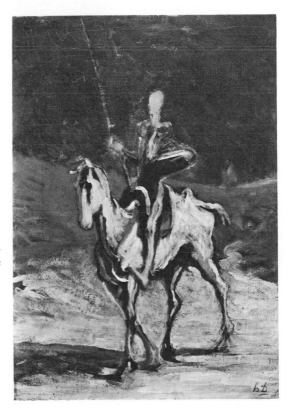

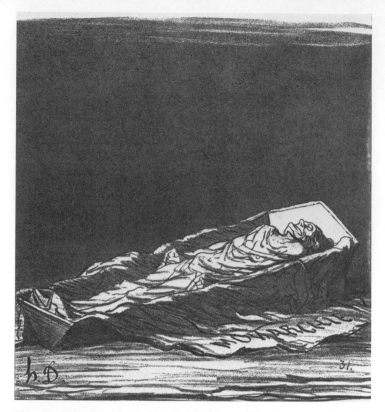

221. H. Daumier, *Monarchy Is Dead ("... and they keep saying that she's never been better!"),* lithograph, published in *Charivari,* 1872, private collection (p. *235*)

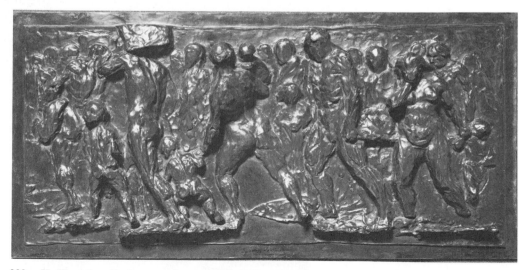

222. H. Daumier, *Emigrants,* plaster relief, 1871, Washington, National Gallery of Art, Rosenwald Collection (p. *235*)

223. F. Millet, *Self-Portrait,* ca. 1840–41, Boston, Museum of Fine Arts, Gift by Contribution (p. *238*)

224. F. Millet, *Portrait of Mlle Ono,* 1841–42, Cherbourg, Musée des Beaux-Arts (p. *238*)

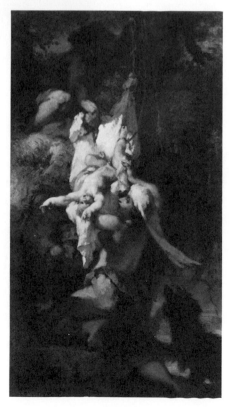

225. F. Millet, *The Infant Oedipus Taken from a Tree,* 1847, Ottawa, National Gallery of Canada (p. *238*)

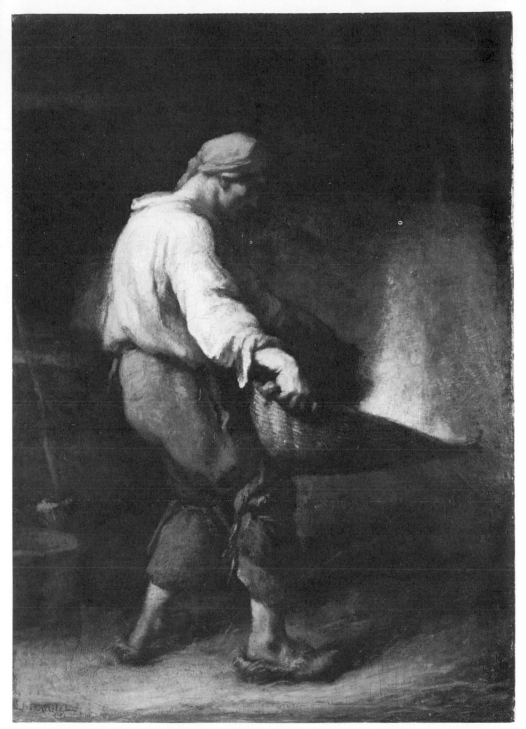

226. F. Millet, *The Grain-Sifter*, 1847–48, London, National Gallery (p. *238*)

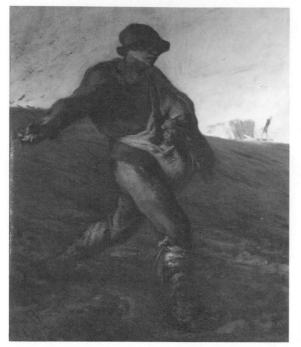

227. F. Millet, *The Sower*, 1850, Boston, Museum of Fine Arts, Gift of Quincy Adam Shaw through Quincy A. Shaw, Jr., and Mrs. Marion Shaw Haughton (p. *239*)

228. F. Millet, *Man Grafting a Tree*, 1855, Munich, Neue Pinakothek (p. *240*)

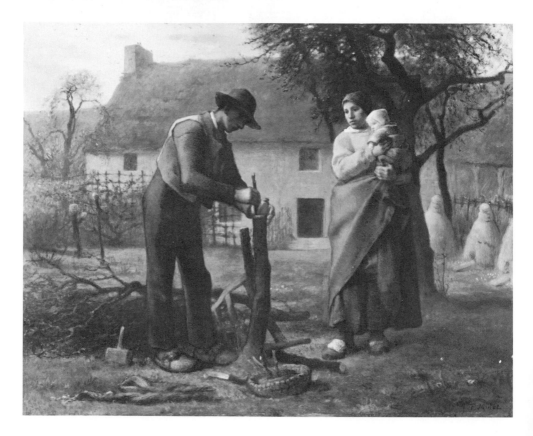

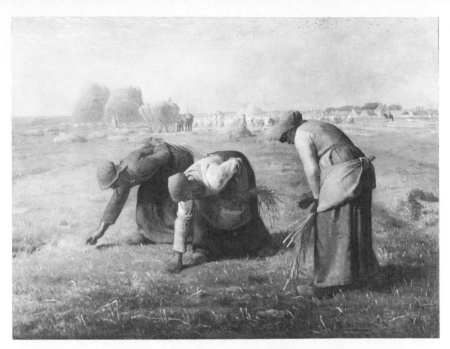

229. F. Millet, *The Gleaners,* 1857, Paris, Louvre (Musée d'Orsay) (p. *241*)

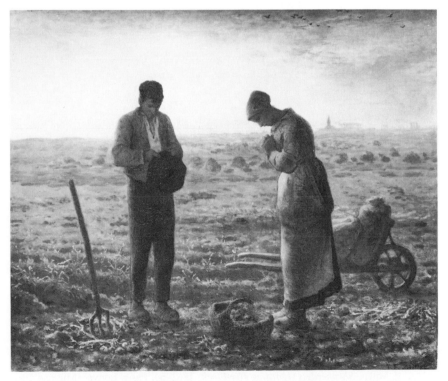

230. F. Millet, *The Angelus,* 1859, Paris, Louvre (Musée d'Orsay) (pp. *241–42*)

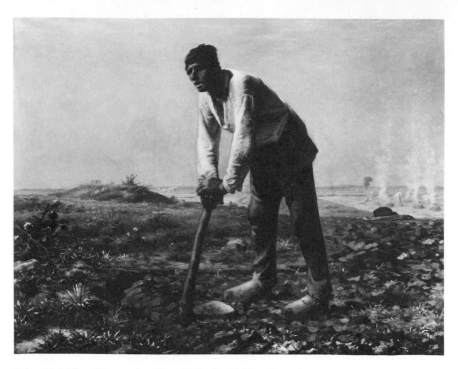

231. F. Millet, *Man with a Hoe,* 1860–62, Malibu, J. Paul Getty Museum (pp. *242–43*)

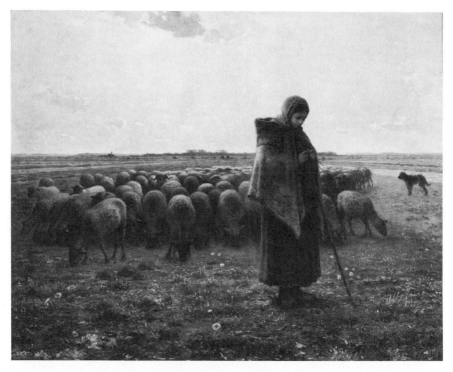

232. F. Millet, *Shepherdess Guarding Her Flock,* 1862–64, Paris, Louvre (Musée d'Orsay) (p. *243*)

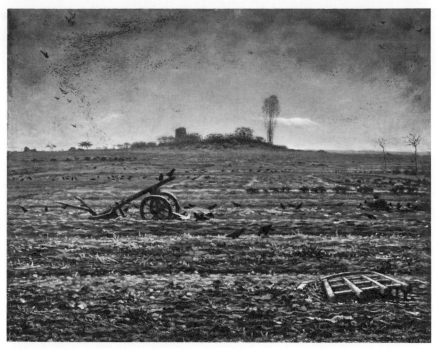

233. F. Millet, *Winter, the Plain of Chailly,* 1862–63, Vienna, Oesterreichische Galerie
(p. *244*)

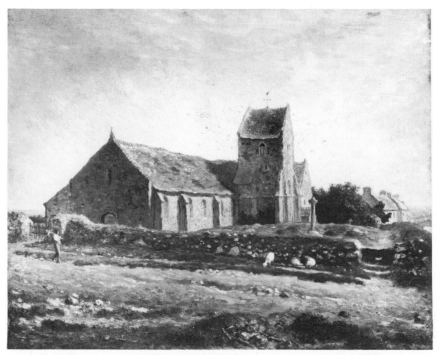

234. F. Millet, *The Church of Gréville,* 1871–74, Paris, Louvre (Musée d'Orsay)(p. *245*)

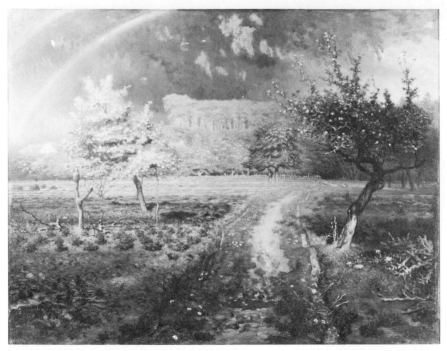

235. F. Millet, *Spring,* 1868–73, Paris, Louvre (Musée d'Orsay) (p. *246*)

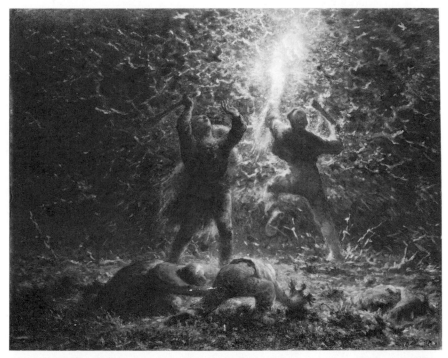

236. F. Millet, *The Bird Nesters,* 1874, Philadelphia Museum of Art, William L. Elkins Collection (p. *246*)

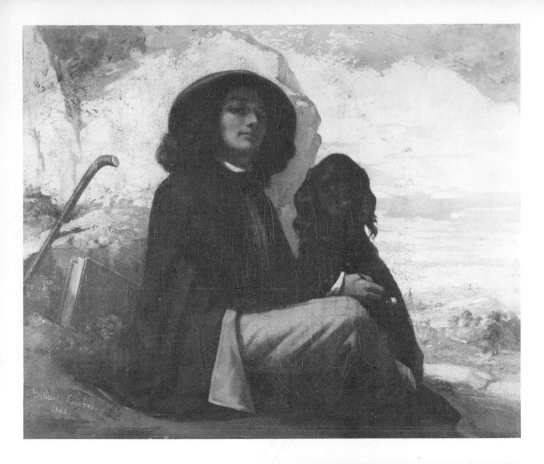

237. G. Courbet, *Self-Portrait with Black Span-iel,* 1842–44, Paris, Musée du Petit Palais (p. *250*)

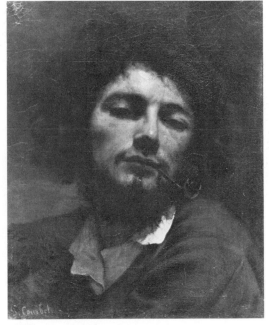

238. G. Courbet, *Self-Portrait with Pipe,* ca. 1849, Montpellier, Musée Fabre (p. *251*)

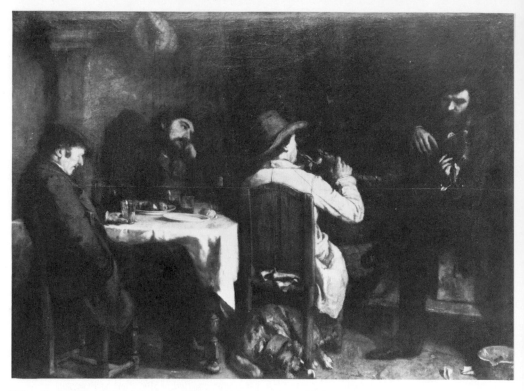

239. G. Courbet, *After Dinner at Ornans,* 1848–49, Lille, Musée des Beaux-Arts (pp. *253;* 302)

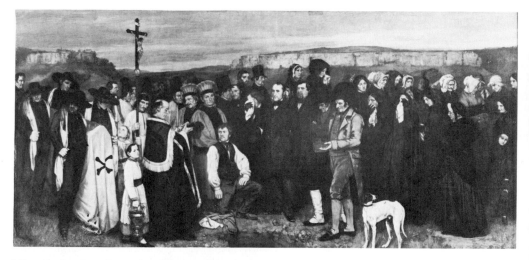

240. G. Courbet, *Funeral at Ornans,* 1849–50, Paris, Louvre (Musée d'Orsay) (pp. *254;* 239)

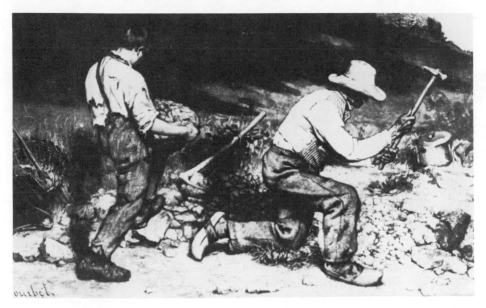

241. G. Courbet, *Stone Breakers,* 1849–50, formerly in Dresden, Staatliche Kunstsammlung (destroyed in 1945) (pp. *254;* 239, 259)

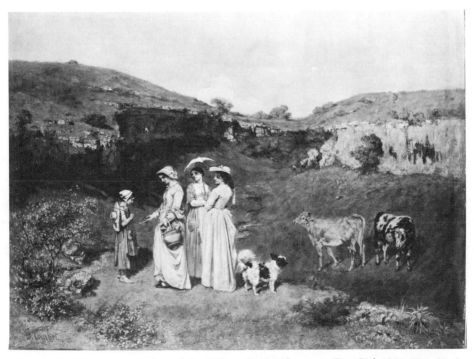

242. G. Courbet, *Young Ladies of the Village Giving Alms to a Cow Girl,* 1851, New York, Metropolitan Museum of Art, Gift of H. P. Bingham (pp. *255;* 257, 259, 260)

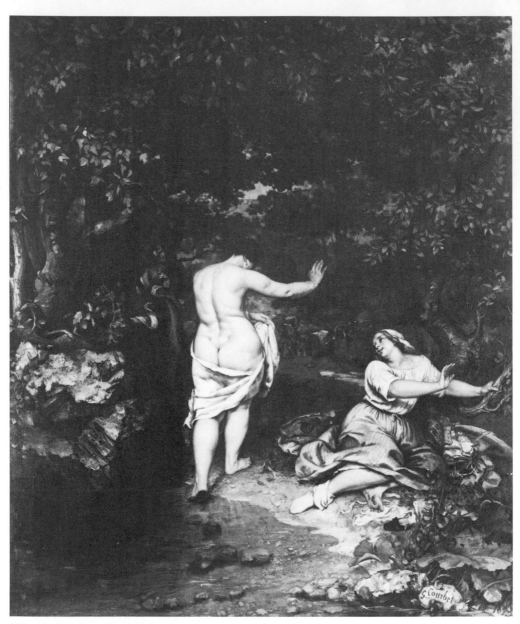

243. G. Courbet, *The Bathers,* 1853, Montpellier, Musée Fabre (pp. *256;* 260, 297)

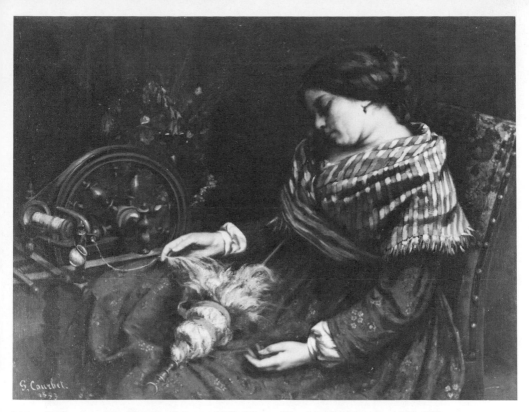

244. G. Courbet, *The Sleeping Spinner,* 1853, Montpellier, Musée Fabre (pp. *256;* 259)

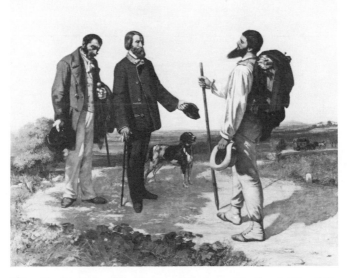

245. G. Courbet, *The Meeting ("Bonjour, M. Courbet"),* 1854, Montpellier, Musée Fabre (pp. *257;* 259)

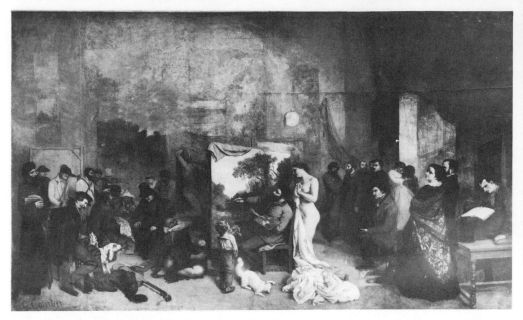

246. G. Courbet, *The Studio (A Real Allegory Summing Up Seven Years of My Artistic Life)*, 1854–55, Paris, Louvre (Musée d'Orsay) (pp. *258–59;* 260, 323)

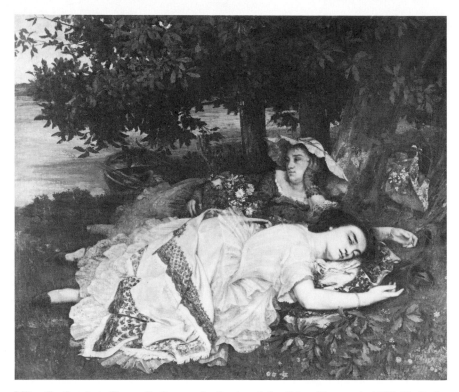

247. G. Courbet, *Young Ladies on the Banks of the Seine (Summer)*, 1856–57, Paris, Musée du Petit Palais (pp. *260;* 297)

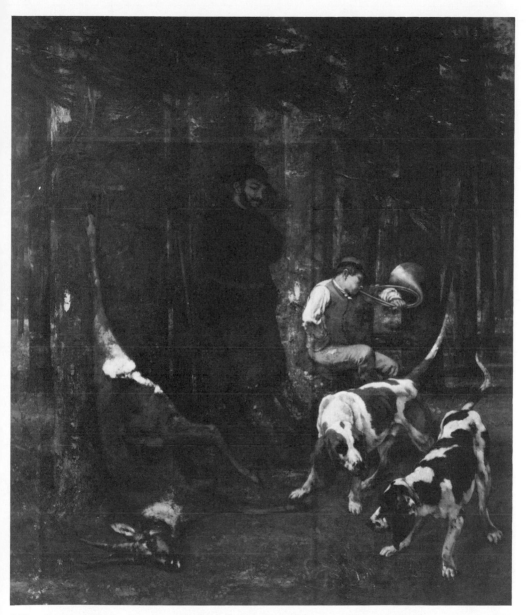

248. G. Courbet, *The Quarry,* 1857, Boston, Museum of Fine Arts, Henry Lillie Pierce Fund (p. *260*)

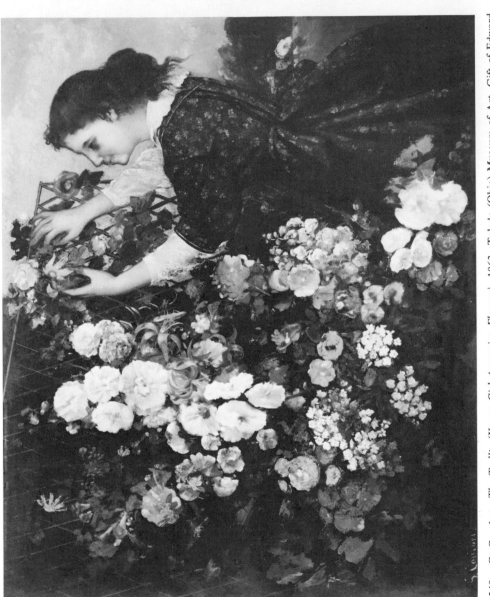

249. G. Courbet, *The Trellis (Young Girl Arranging Flowers)*, 1863, Toledo (Ohio) Museum of Art, Gift of Edward Drummond Libbey (p. 262)

250. G. Courbet, *Source of the Loue,* 1863–65, Washington, National Gallery of Art, Gift of Charles L. Lindeman (p. *263*)

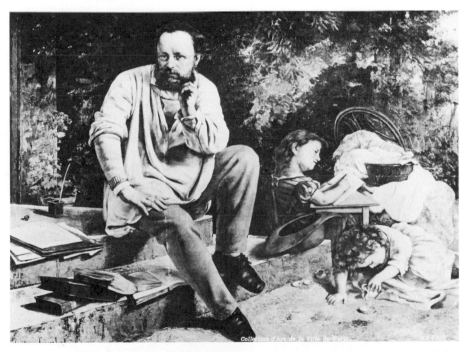

251. G. Courbet, *Proudhon and His Family in 1853,* 1865, Paris, Musée du Petit Palais (pp. *263–64*)

145

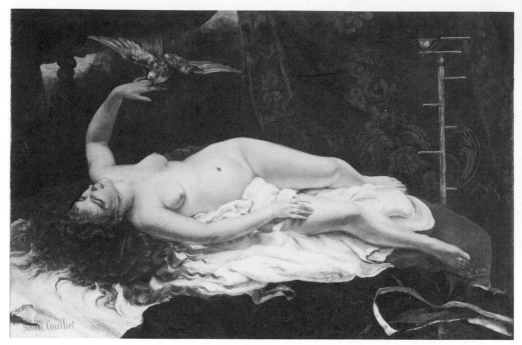

252. G. Courbet, *Woman with Parrot,* 1866, New York, Metropolitan Museum of Art, Bequest of H. O. Havemeyer (pp. *262;* 370)

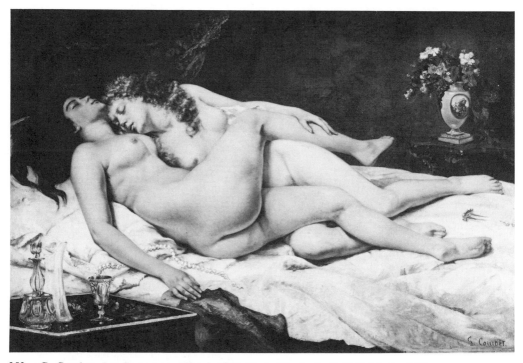

253. G. Courbet, *Les Dormeuses (Sleep),* 1866, Paris, Musée du Petit Palais (p. *262*)

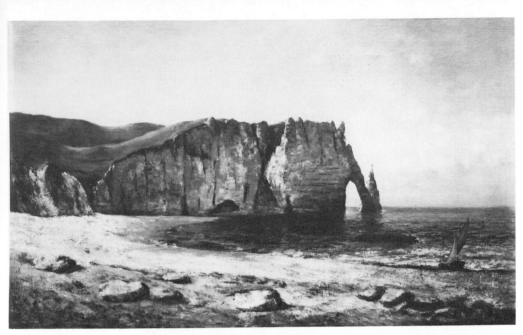

254. G. Courbet, *Cliffs at Etretat,* 1869, Birmingham, Barber Institute of Fine Arts (p. *264*)

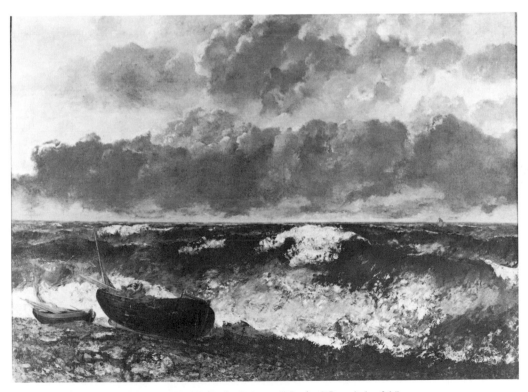

255. G. Courbet, *The Wave,* 1869–70, Paris, Louvre (Musée d'Orsay) (p. *264*)

147

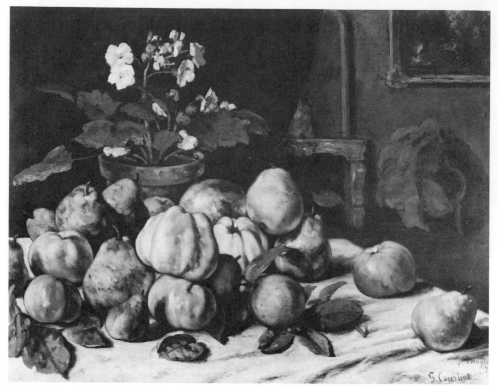

256. G. Courbet, *Still Life of Apples, Pears, and Primroses,* 1871, Pasadena, Norton Simon Foundation (p. *265*)

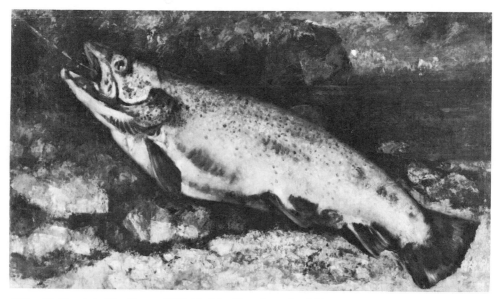

257. G. Courbet, *The Trout,* 1872, Zurich, Kunsthaus (p. *265*)

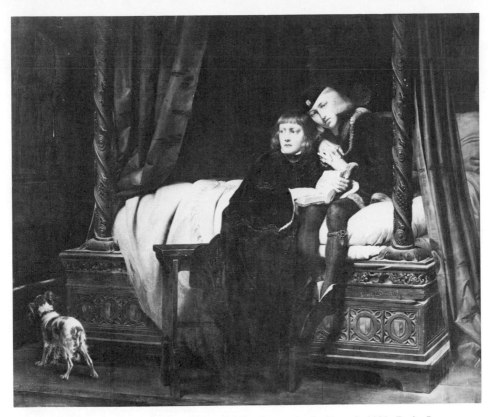

258. P. Delaroche, *Les Enfants d'Edouard (The Princes in the Tower),* 1830, Paris, Louvre
(p. *282*)

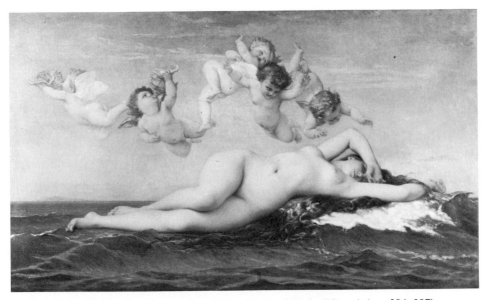

259. A. Cabanel, *Birth of Venus,* 1863, Paris, Louvre (Musée d'Orsay) (pp. *284;* 297)

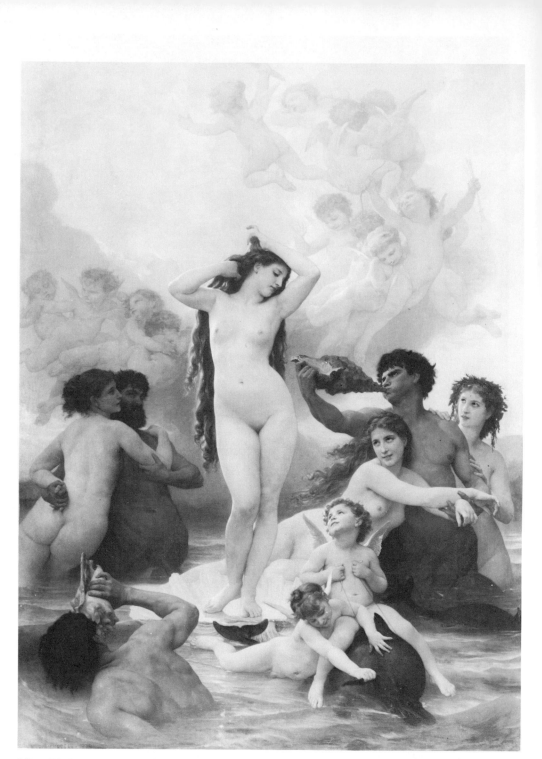

260. W. Bouguereau, *Birth of Venus,* 1879, Paris, Louvre (Musée d'Orsay) (p. *284*)

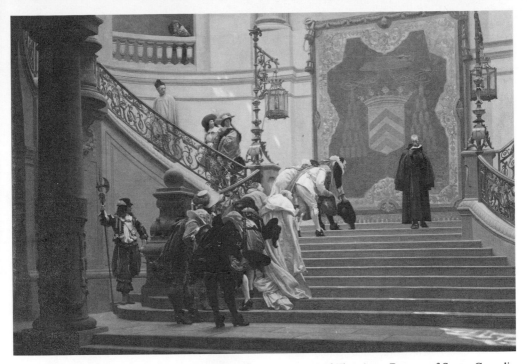

261. J.-L. Gérôme, *L'Eminence grise,* 1874, Boston, Museum of Fine Arts, Bequest of Susan Cornelia
Warren (p. *282*)

262. J.-E.-L. Meissonier, *The Sergeant,*
1874, Hamburg, Kunsthalle (p. *282*)

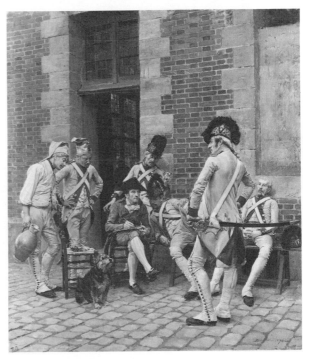

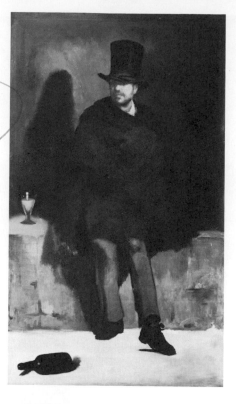

263. E. Manet, *The Absinthe Drinker,* 1858–59, Copenhagen, Ny Carlsberg Glyptotek (pp. *292, 295*)

264. E. Manet, *The Spanish Singer,* 1860, New York, Metropolitan Museum of Art, Gift of William C. Osborn (p. *294*)

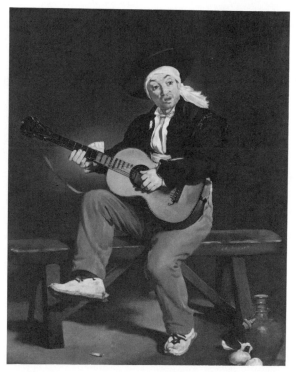

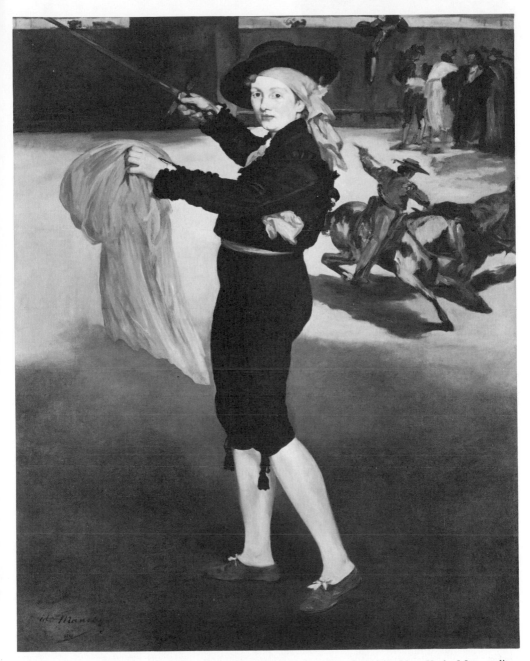

265. E. Manet, *Mlle Victorine Meurent in the Costume of an Espada,* 1862, New York, Metropolitan Museum of Art, Bequest of H. O. Havemeyer (pp. *295; 297*)

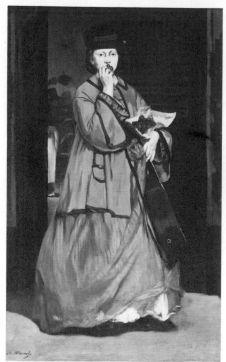

266. E. Manet, *The Street Singer,* 1862, Boston, Museum of Fine Arts, Bequest of Sarah Choate Sears in Memory of Her Husband, John Montgomery Sears (p. *295*)

267. E. Manet, *The Old Musician,* 1862, Washington, National Gallery of Art, Chester Dale Collection (p. *295*)

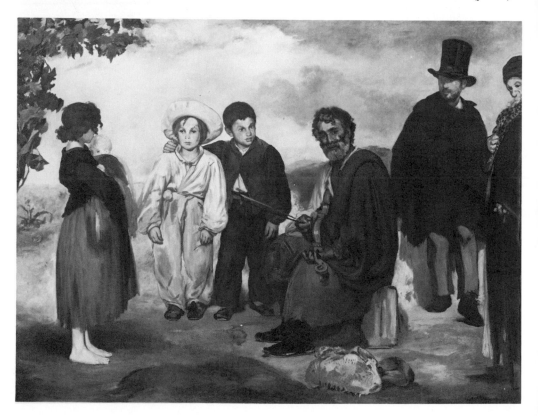

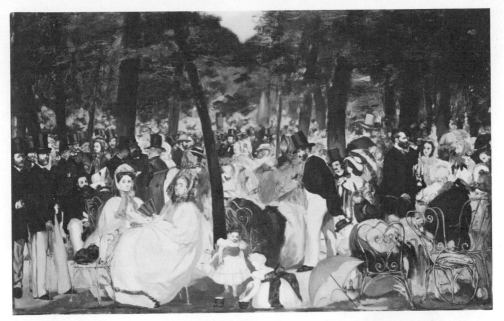

268. E. Manet, *Concert in the Tuileries,* 1862, London, National Gallery (pp. *296–97;* 299, 303, 304, 378)

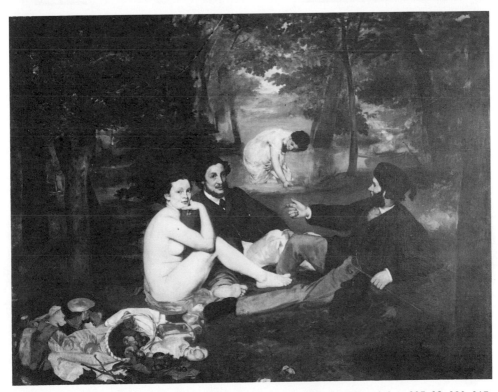

269. E. Manet, *Le Déjeuner sur l'herbe,* 1863, Paris, Louvre (Musée d'Orsay) (pp. *297–98;* 303, 317, 348–49, 370, 423, 439)

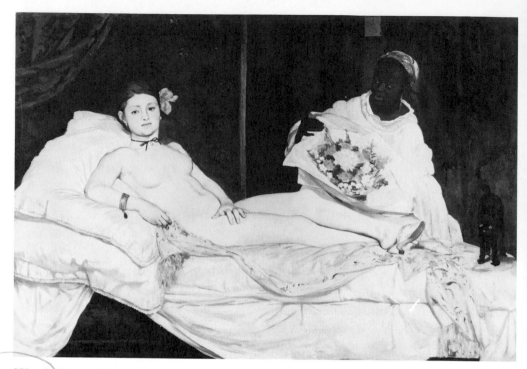

270. E. Manet, *Olympia,* 1863, Paris, Louvre (Musée d'Orsay) (pp. *298;* 306, 423)

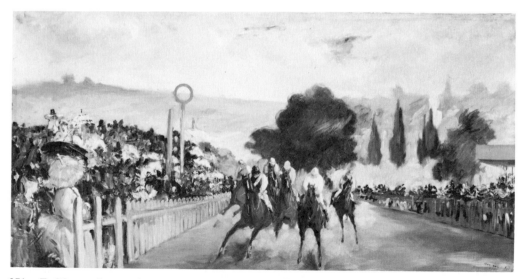

271. E. Manet, *Racetrack Near Paris (Course à Longchamp),* 1867, Art Institute of Chicago, Potter Palmer Collection (p. 299)

156

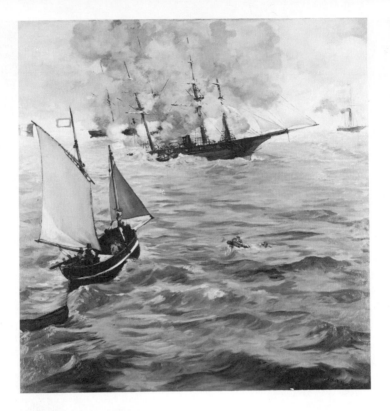

272. E. Manet, *Battle of the Kearsarge and the Alabama Off Cherbourg*, 1864, Philadelphia Museum of Art, John G. Johnson Collection (pp. *299; 309*)

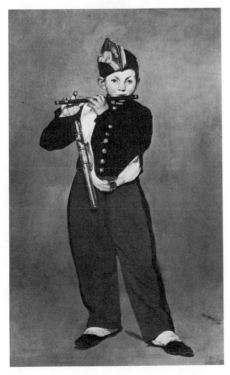

273. E. Manet, *The Fifer*, 1866, Paris, Louvre (Musée d'Orsay) (p. *300*)

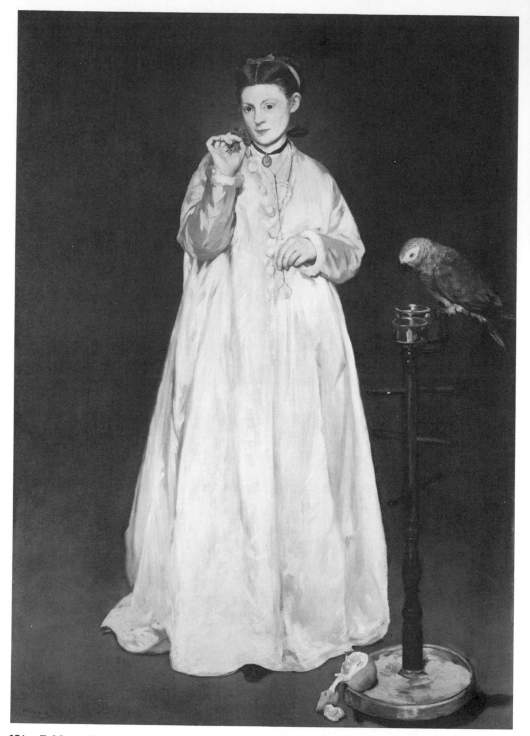

274. E. Manet, *Woman with a Parrot,* 1866, New York, Metropolitan Museum of Art, Gift of Erwin Davis (pp. *300;* 301)

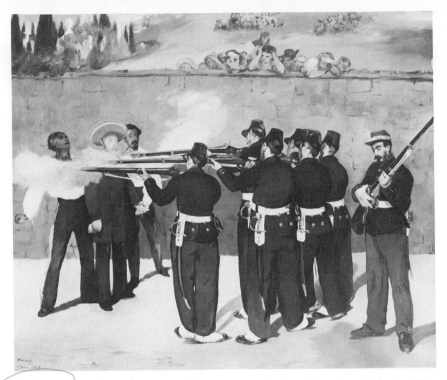

275. E. Manet, *The Execution of Maximilian,* 1867, Mannheim, Kunsthalle (p. *301*)

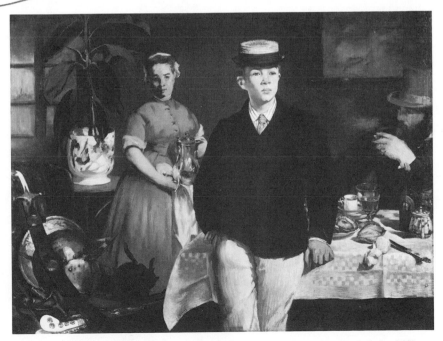

276. E. Manet, *Luncheon in the Studio,* 1868, Munich, Neue Pinakothek (p. *302*)

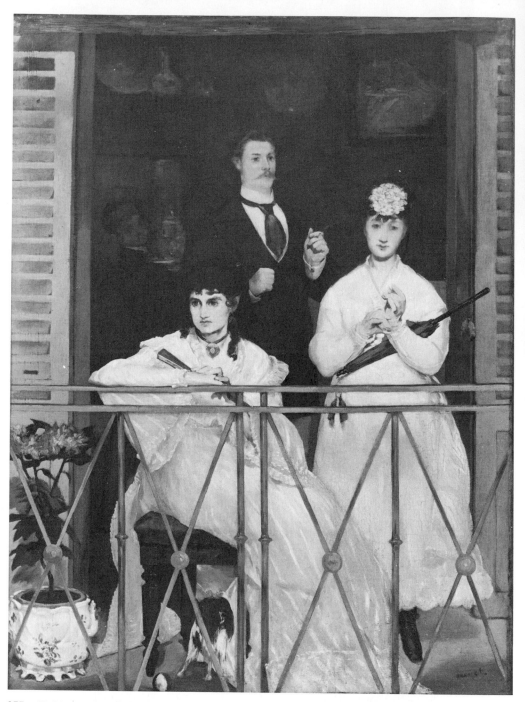

277. E. Manet, *The Balcony,* 1868–69, Paris, Louvre (Musée d'Orsay) (pp. *302; 308*)

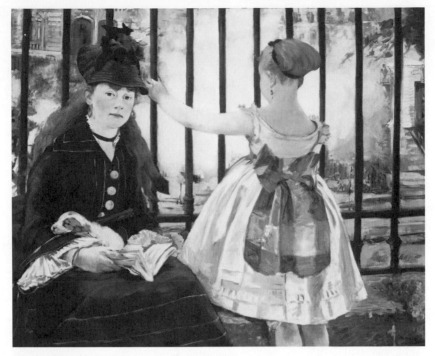

278. E. Manet, *The Railroad,* 1873, Washington, National Gallery of Art, Gift of Horace Havemeyer in Memory of His Mother, Louisine W. Havemeyer (pp. *304;* 310)

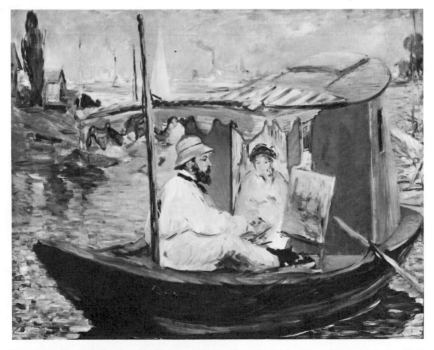

279. E. Manet, *Monet in His Painting Boat,* 1874, Munich, Neue Pinakothek (p. *304*)

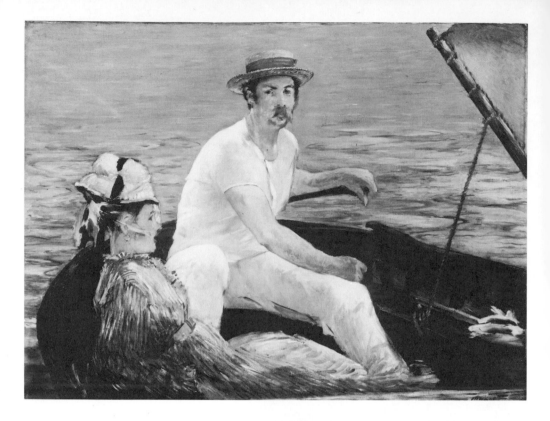

280. E. Manet, *Boating,* 1874, New York, Metropolitan Museum of Art, Bequest of H. O. Havemeyer (p. *305*)

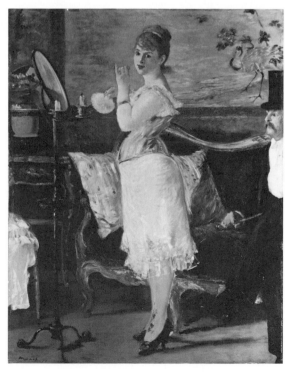

281. E. Manet, *Nana,* 1877, Hamburg, Kunsthalle (p. *306*)

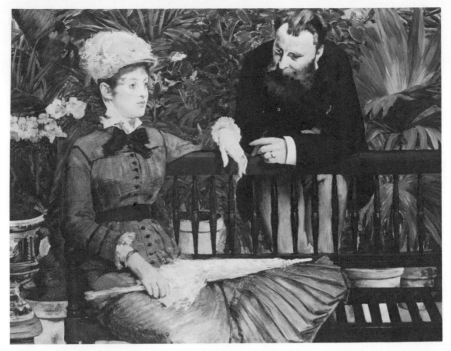

282. E. Manet, *In the Conservatory,* 1879, West Berlin, Nationalgalerie, Staatliche Museen Preussischer Kulturbesitz (pp. *307–8;* 324)

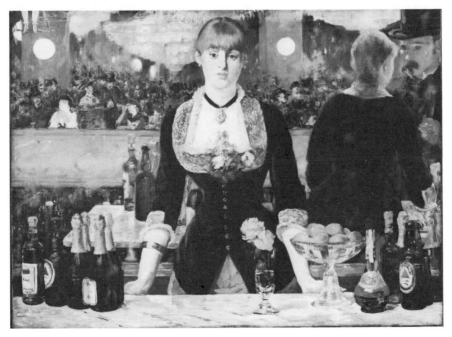

283. E. Manet, *Bar at the Folies-Bergère,* 1881–82, London, Courtauld Institute Galleries (p. *310*)

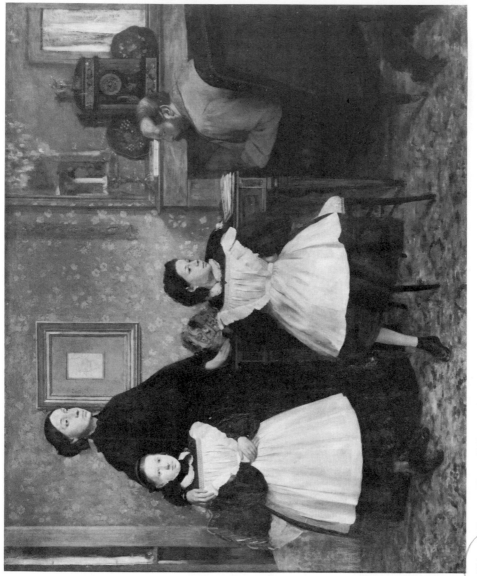

284. E. Degas, *The Bellelli Family*, 1858–62, Paris, Louvre (Musée d'Orsay) (p. 317)

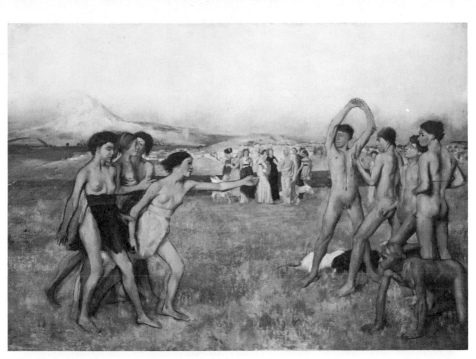

285. E. Degas, *Spartan Boys and Girls Exercising (Les Filles Spartiates),* ca. 1860, London, National Gallery (p. *317*)

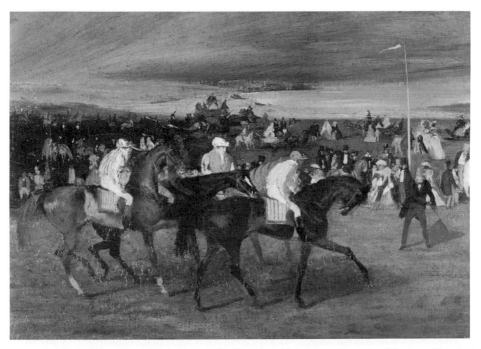

286. E. Degas, *Start of the Horse Race,* 1860–62, Cambridge, Mass., Fogg Art Museum, Harvard University, Bequest of Grenville L. Winthrop (p. *318*)

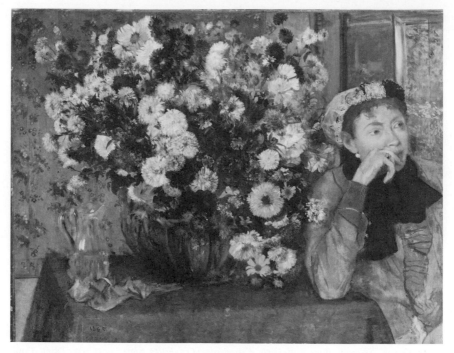

287. E. Degas, *Woman with Chrysanthemums (Mme Hertel),* 1865, New York, Metropolitan Museum of Art, Bequest of H. O. Havemeyer (pp. *319;* 321)

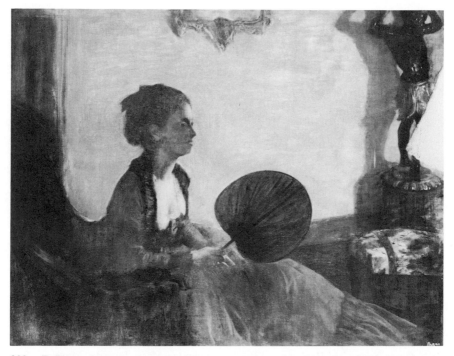

288. E. Degas, *Mme Camus (Mme Camus en rouge),* 1870, Washington, National Gallery of Art, Chester Dale Collection (p. *320*)

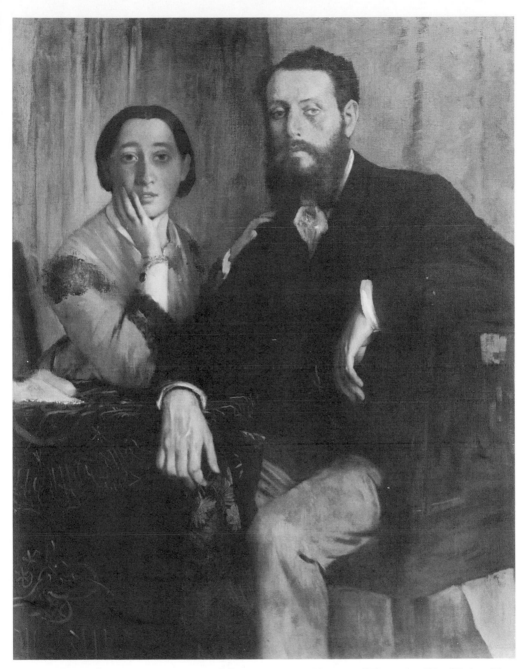

289. E. Degas, *Edmondo and Teresa Morbilli,* 1867, Boston, Museum of Fine Arts, Gift of Robert Treat Paine II (p. *320*)

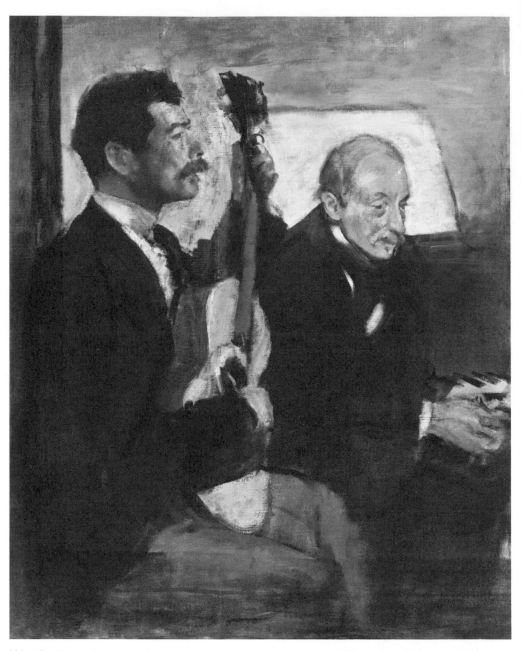

290. E. Degas, *Degas's Father Listening to the Singer Pagans,* ca. 1869, Boston, Museum of Fine Arts, Bequest of John T. Spaulding (pp. *320–21*)

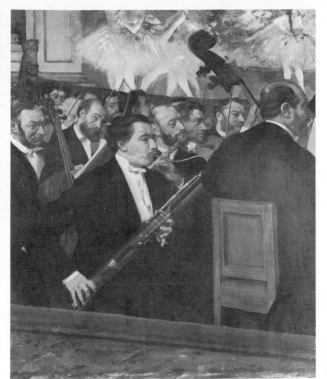

291. E. Degas, *The Orchestra of the Opera*, 1868–69, Paris, Louvre (Musée d'Orsay) (p. *321*)

292. E. Degas, *Interior*, 1868–69, Philadelphia Museum of Art, Henry P. McIlhenny Collection (pp. *321; 324*)

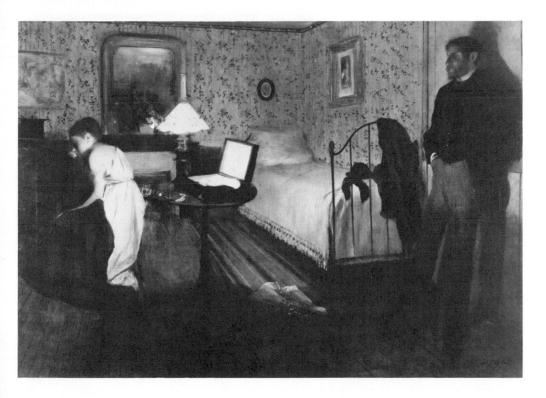

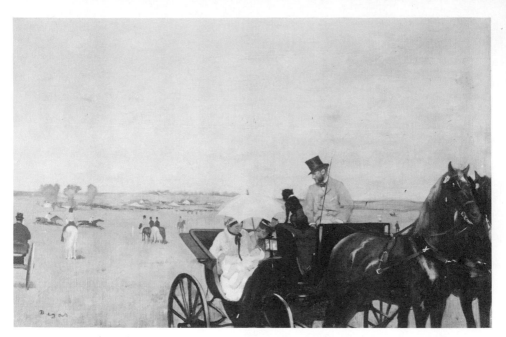

293. E. Degas, *Carriages at the Races,* 1871–72, Boston, Museum of Fine Arts, Purchase Fund (pp. *322;* 324)

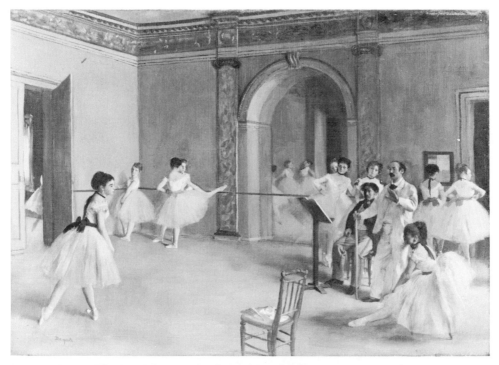

294. E. Degas, *The Dance Foyer at the Opera,* 1872, Paris, Louvre (Musée d'Orsay) (p. *322*)

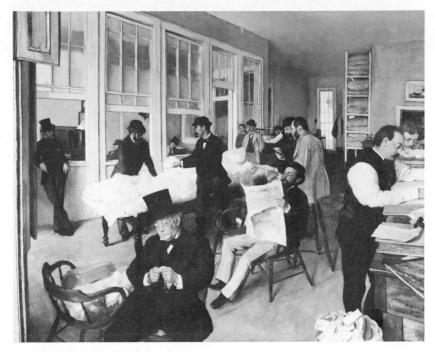

295. E. Degas, *Portraits in an Office—The Cotton Exchange, New Orleans,* 1873, Pau, Musée des Beaux-Arts (pp. *322–23*)

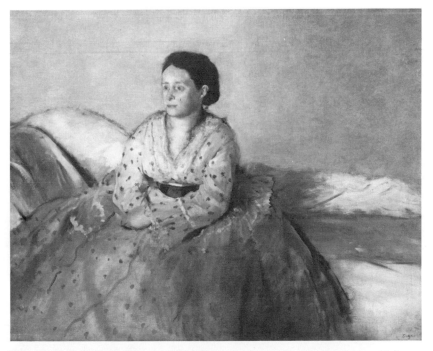

296. E. Degas, *Estelle Musson (Mme René de Gas),* 1872–73, Washington, National Gallery of Art, Chester Dale Collection (p. *323*)

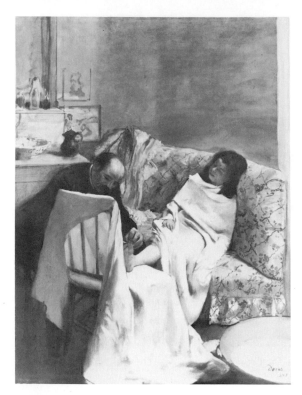

297. E. Degas, *Pedicure,* 1873, Paris, Louvre (Musée d'Orsay) (p. *323*)

298. E. Degas, *Sulking (The Banker),* 1869–71, New York, Metropolitan Museum of Art, Bequest of H. O. Havemeyer (p. *324*)

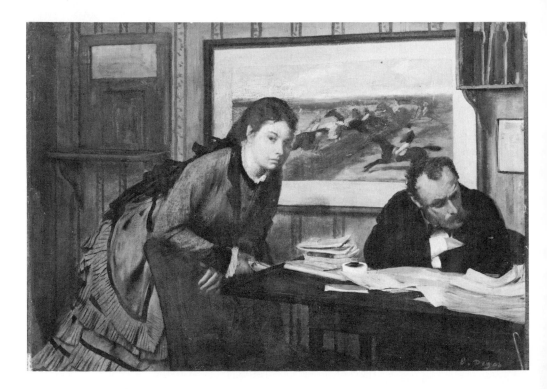

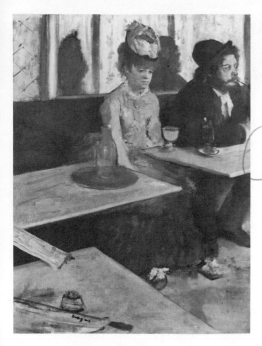

299. E. Degas, *Absinthe,* 1876, Paris, Louvre (Musée d'Orsay) (p. *324*)

300. E. Degas, *Dancers at the Practice Bar,* 1876, New York, Metropolitan Museum of Art, Bequest of H. O. Havemeyer (p. *325*)

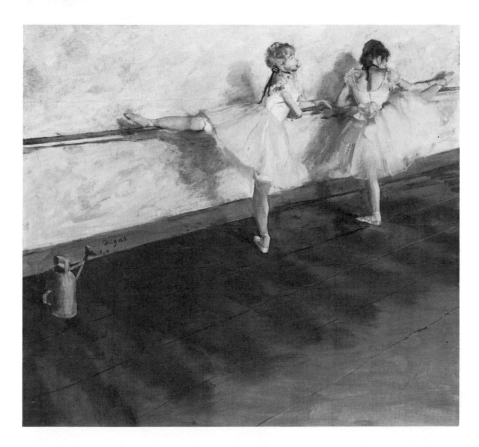

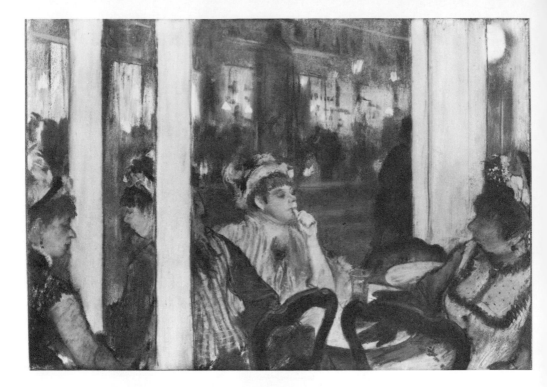

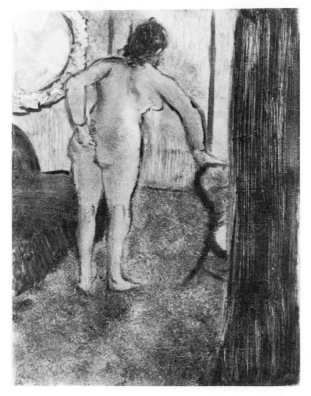

301. E. Degas, *Women in a Café, Boulevard Montmartre,* monotype with pastel, 1877, Paris, Louvre (Musée d'Orsay) (p.*326*)

302. E. Degas, *Nude in a Brothel,* monotype, ca. 1879, Stanford University Museum (p. *326*)

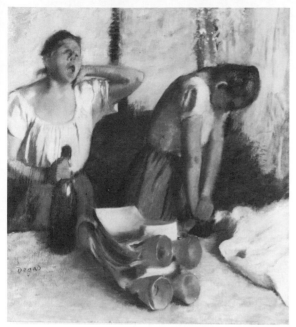

303. E. Degas, *Two Laundry Women,* ca. 1884, Pasadena, Norton Simon Foundation (p. *327*)

304. E. Degas, *At the Milliner's,* pastel, 1882, New York, Metropolitan Museum of Art, Bequest of H. O. Havemeyer (p. *328*)

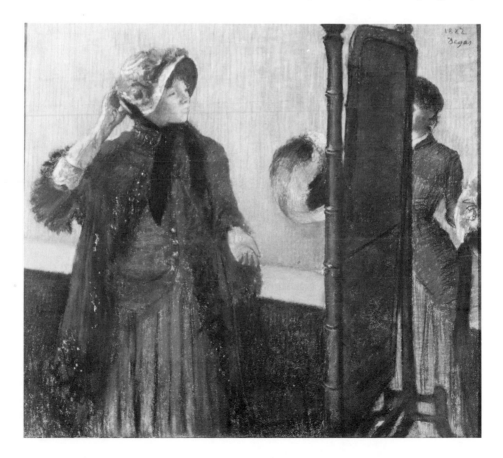

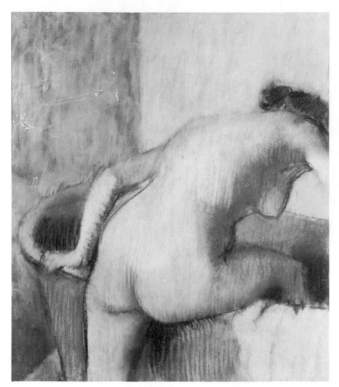

305. E. Degas, *Nude Stepping into the Bath Tub,* pastel, ca. 1890, New York, Metropolitan Museum of Art, Bequest of H. O. Havemeyer (p. *329*)

306. E. Degas, *Bather Drying Her Hair,* pastel, ca. 1905–7, Pasadena, Norton Simon Foundation (p. *329*)

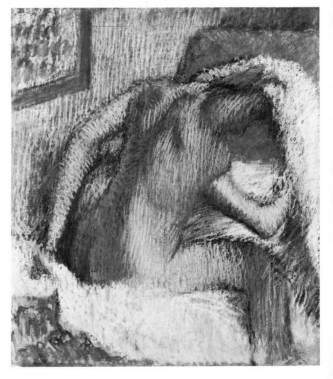

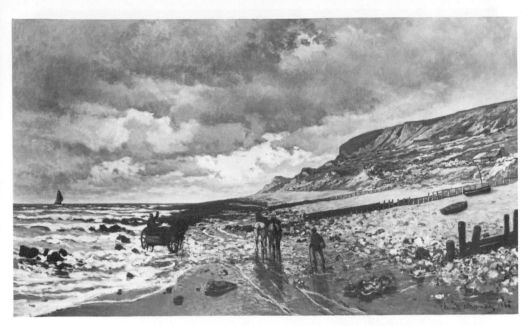

307.　C. Monet, *The Pointe de la Hève at Low Tide,* 1865, Fort Worth, Kimbell Art Museum (p. *347*)

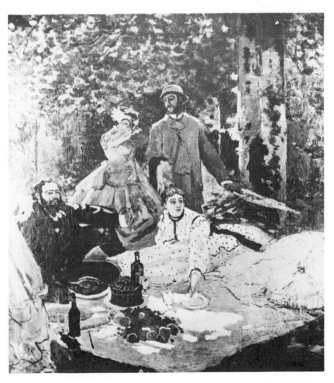

308.　C. Monet, *Déjeuner sur l'herbe,* 1865, Paris, private collection
(p. *348*)

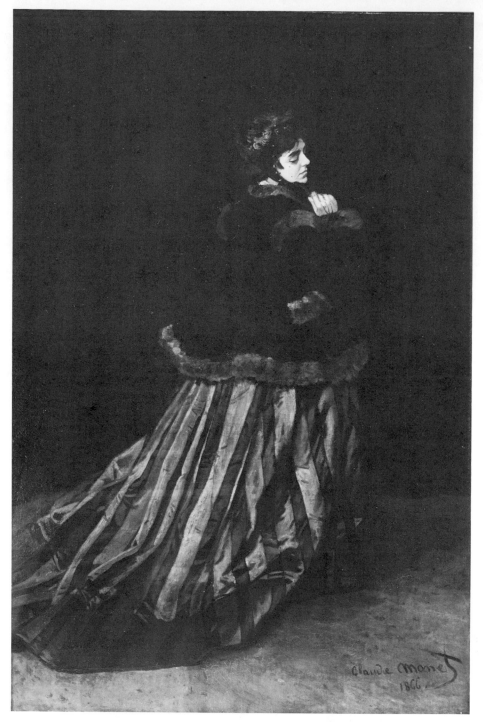

309. C. Monet, *Camille (The Green Dress)*, 1866, Bremen, Kunsthalle (p. *349*)

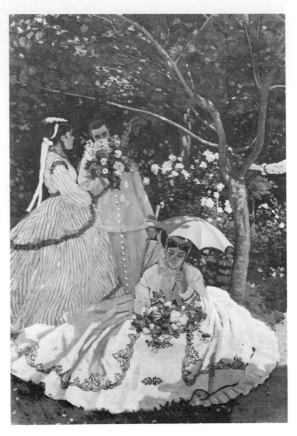

310. C. Monet, *Women in the Garden,* 1867, Paris, Louvre (Musée d'Orsay) (p. *349*)

311. C. Monet, *Terrace at Sainte-Adresse,* 1867, New York, Metropolitan Museum of Art, Funds Given or Bequeathed by Friends of the Museum (p. *350*)

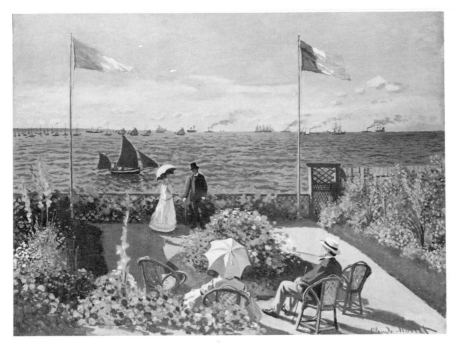

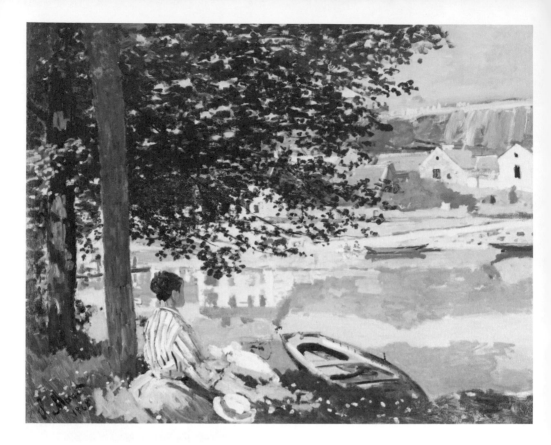

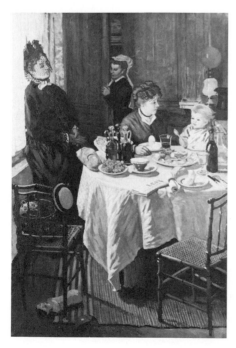

312. C. Monet, *The River (The Seine at Bennecourt),* 1868, Art Institute of Chicago, Potter Palmer Collection (p. *350*)

313. C. Monet, *The Luncheon,* 1868, Frankfurt, Staedelsches Kunstinstitut (pp. *351;* 352)

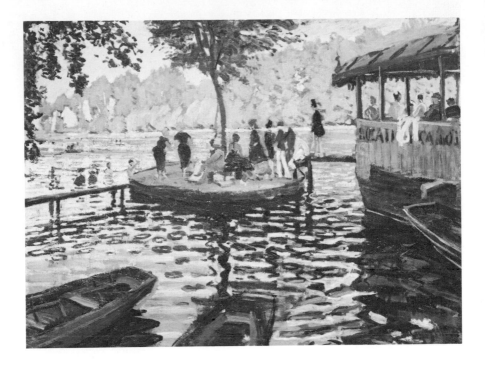

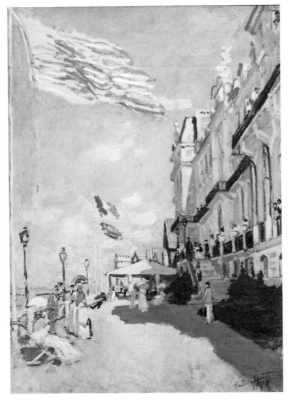

314. C. Monet, *La Grenouillère,* 1869, New York, Metropolitan Museum of Art, Bequest of H. O. Havemeyer (pp. *352;* 372)

315. C. Monet, *The Roches Noires Hotel at Trouville,* 1870, Paris, Louvre (Musée d'Orsay) (p. *353*)

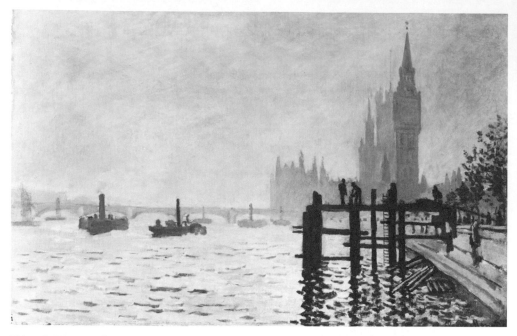

316. C. Monet, *The Thames and the Houses of Parliament,* 1871, London, National Gallery (p. *353*)

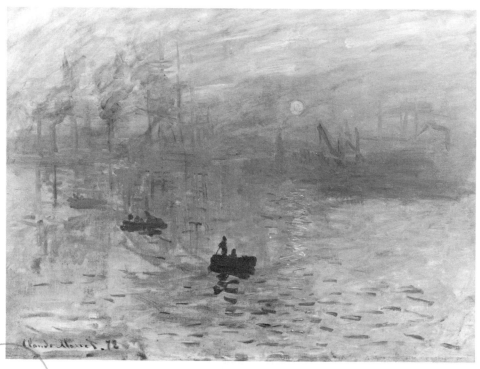

317. C. Monet, *Impression: Sunrise,* 1873 (dated "1872"), Paris, Musée Marmottan (pp. *354; 335,* *355*)

182

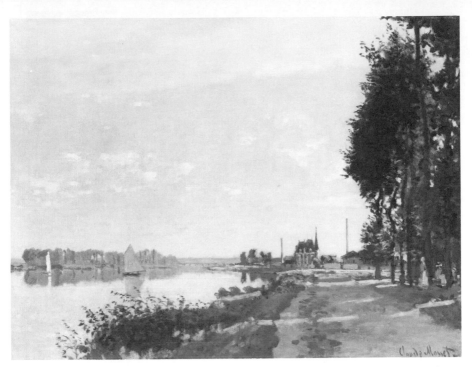

318. C. Monet, *The Promenade, Argenteuil,* ca. 1872, Washington, National Gallery of Art, Ailsa Mellon Bruce Collection (p. *354*)

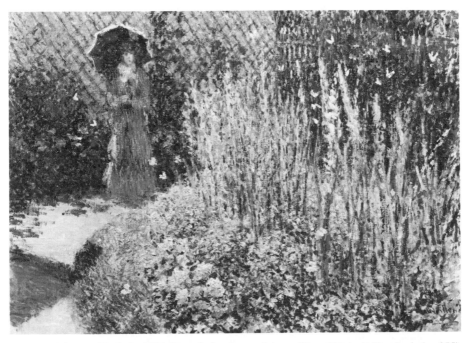

319. C. Monet, *Gladioli,* 1876, Detroit Institute of Arts, City of Detroit Purchase (p. *355*)

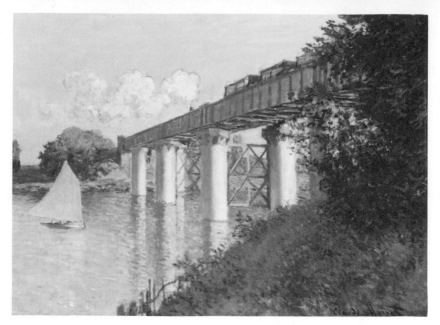

320. C. Monet, *The Railway Bridge at Argenteuil,* 1874, Philadelphia Museum of Art, John G. Johnson Collection (p. *356*)

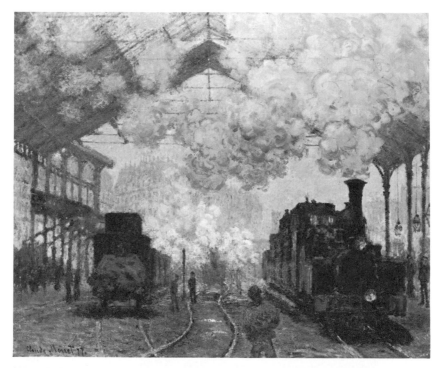

321. C. Monet, *The Saint-Lazare Railway Station,* 1877, Cambridge, Mass., Fogg Art Museum, Harvard University, Bequest of Maurice Wertheim (Class of 1906) (p. *357*)

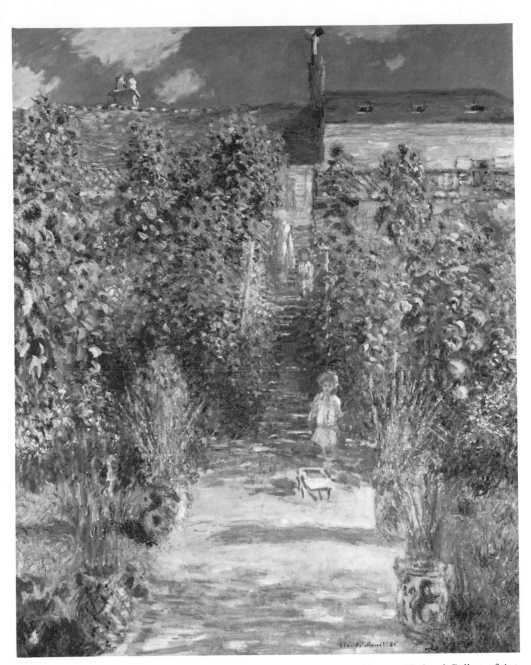

322. C. Monet, *Monet's Garden at Vetheuil,* 1881 (dated "1880"), Washington, National Gallery of Art, Ailsa Mellon Bruce Collection (p. *358*)

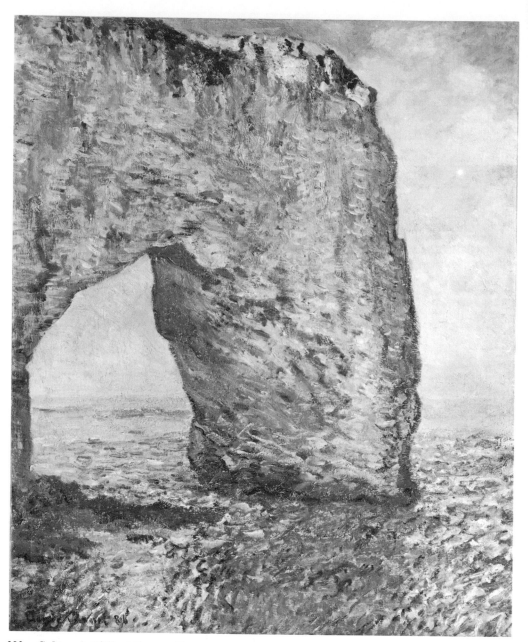

323. C. Monet, *Cliffs at Etretat: Manneporte*, 1886, New York, Metropolitan Museum of Art, Bequest of Lizzie P. Bliss (p. *360*)

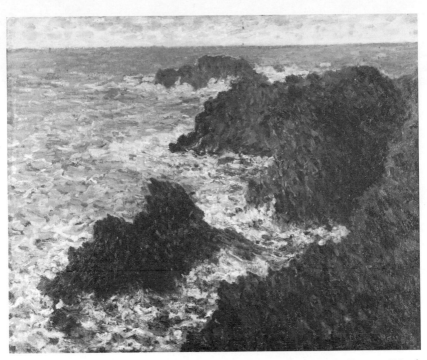

324. C. Monet, *La Côte sauvage (Rocks at Belle-Ile)*, 1886, Paris, Louvre (Musée d'Orsay) (p. *360*)

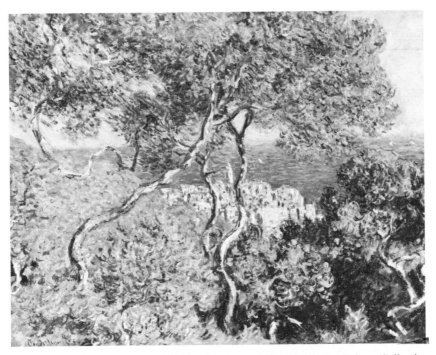

325. C. Monet, *Bordighera*, 1884, Art Institute of Chicago, Potter Palmer Collection (p. *360*)

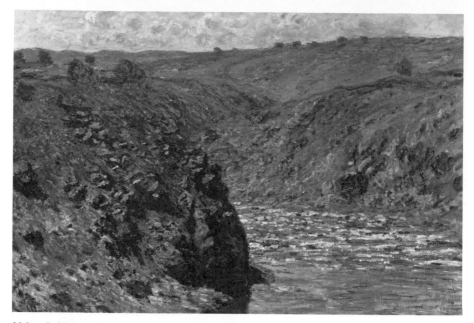

326. C. Monet, *Eaux-Semblantes at Fresselines on the Creuse,* 1889, Boston, Museum of Fine Arts, Julia Cheney Edwards Collection (p. *360*)

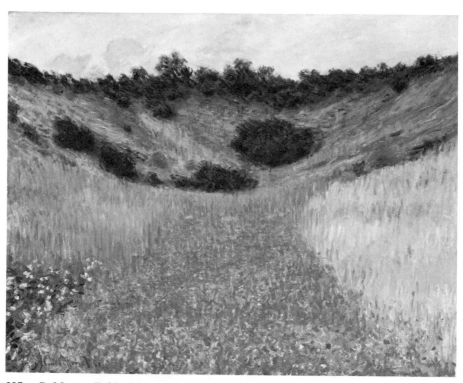

327. C. Monet, *Field of Poppies near Giverny,* 1885, Boston, Museum of Fine Arts, Julia Cheney Edwards Collection (p. *361*)

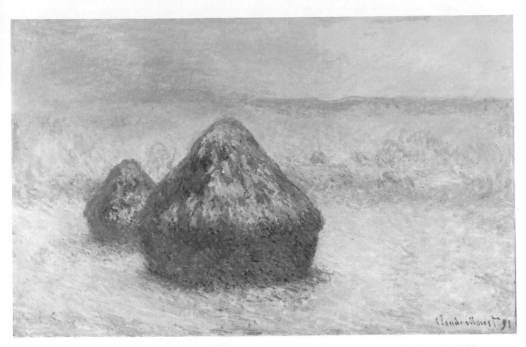

328. C. Monet, *Grainstacks,* 1891, Art Institute of Chicago, Potter Palmer Collection (p. *361*)

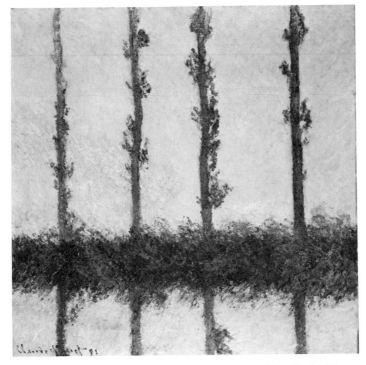

329. C. Monet, *Poplars Along the Epte River,* 1891, New York, Metropolitan Museum of Art, Bequest of H. O. Havemeyer (pp. *362;* 397)

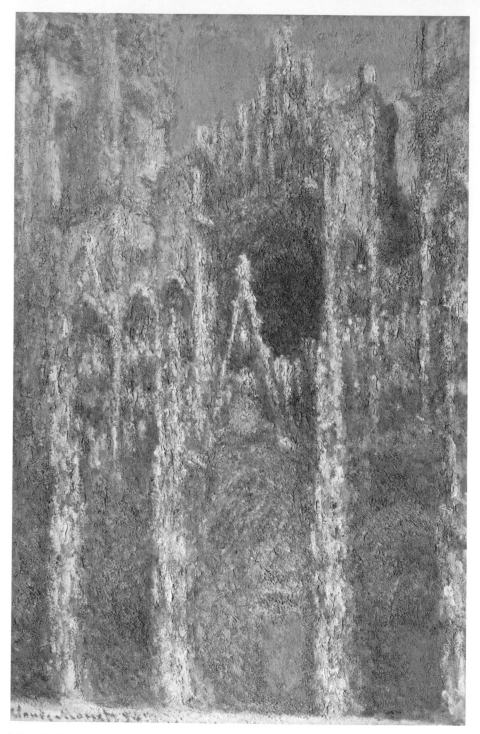

330. C. Monet, *Rouen Cathedral*, 1892–93 (dated "1894"), Boston, Museum of Fine Arts, Julia Cheney Edwards Collection (pp. *362;* 397)

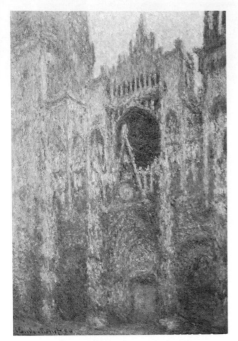

331. C. Monet, *Rouen Cathedral*, 1892–93 (dated "1894"), Washington, National Gallery of Art, Chester Dale Collection (pp. *362; 397*)

332. C. Monet, *The Houses of Parliament, London*, 1901–4, Washington, National Gallery of Art, Chester Dale Collection (p. *363*)

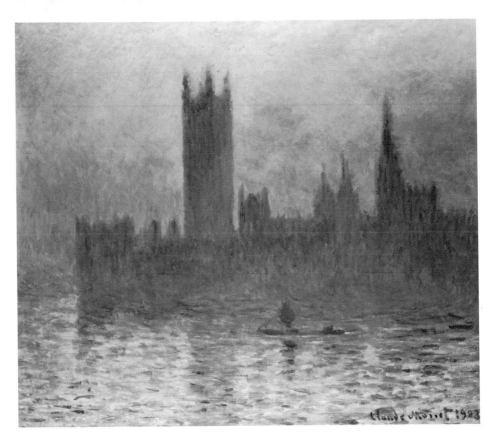

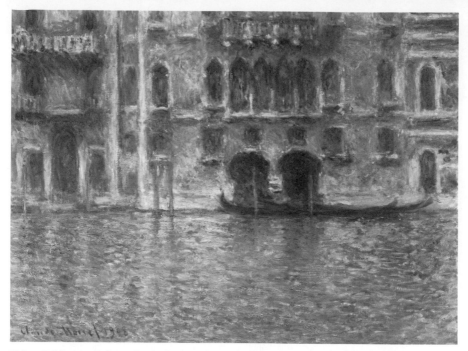

333. C. Monet, *Palazzo da Mula, Venice,* 1908–12(?) (dated "1908"), Washington, National Gallery of Art, Chester Dale Collection (p. *363*)

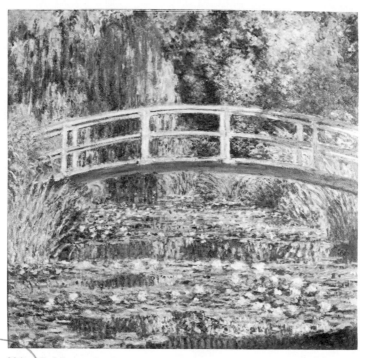

334. C. Monet, *Le Bassin aux nymphéas (The Water-Lily Pond),* 1899, Art Museum, Princeton University, Collection of William Church Osborn (p. *364*)

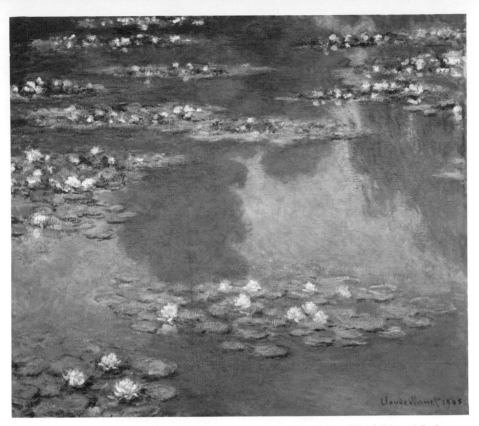

335. C. Monet, *Water Lilies*, 1905, Boston, Museum of Fine Arts, Gift of Edward Jackson Holmes (p. *364*)

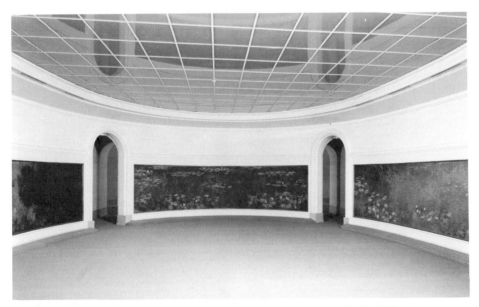

336. C. Monet, *Les Nymphéas*, 1916–25, Paris, Musée de l'Orangerie (p. *365*)

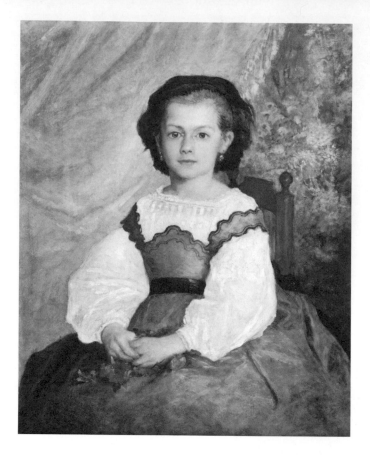

337. A. Renoir, *Portrait of Mlle Romaine Lacaux,* 1864, Cleveland Museum of Art, Gift of the Hanna Fund (p. *369*)

338. A. Renoir, *At the Inn of Mère Anthony,* 1866, Stockholm, National Museum (p. *370*)

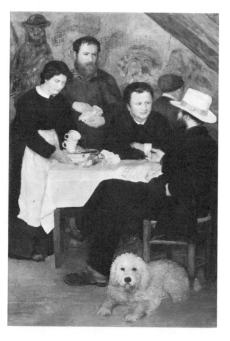

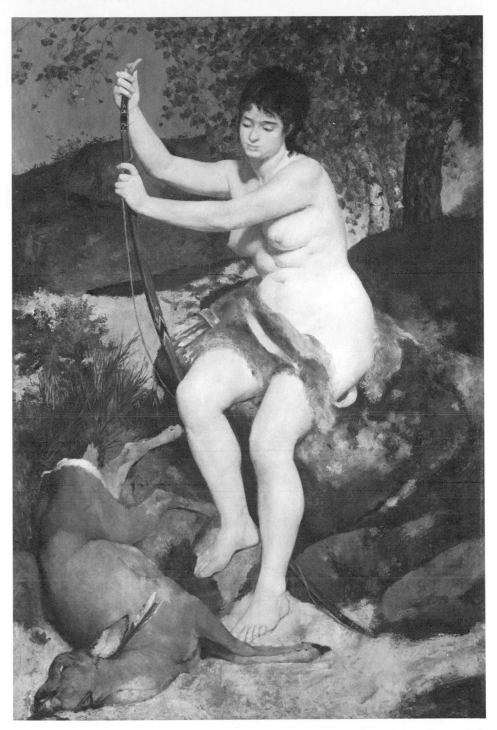

339. A. Renoir, *Diana the Huntress,* 1867, Washington, National Gallery of Art, Chester Dale
Collection (pp. *370; 377*)

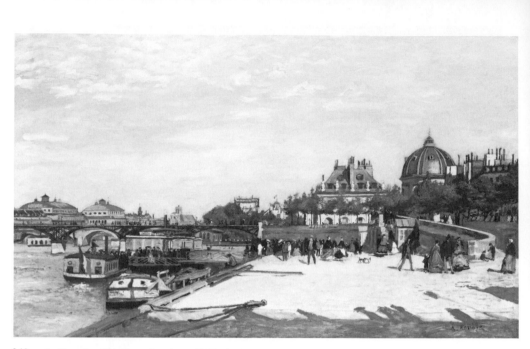

340. A. Renoir, *The Pont des Arts,* 1867, Pasadena, Norton Simon Foundation (p. *371*)

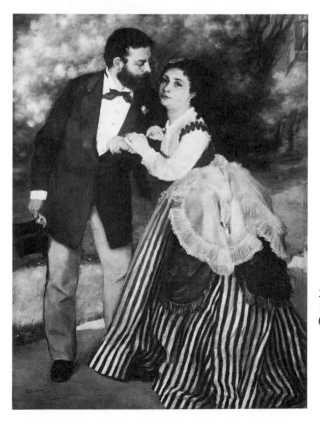

341. A. Renoir, *The Engaged Couple,* 1868, Cologne, Wallraf-Richartz Museum (p. *372*)

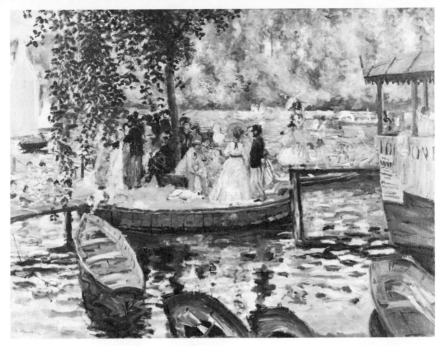

342. A. Renoir, *La Grenouillère,* 1869, Stockholm, National Museum (p. *372*)

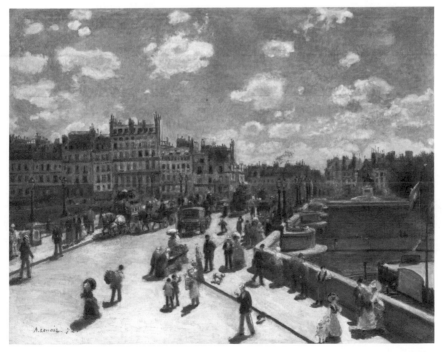

343. A. Renoir, *The Pont Neuf,* 1872, Washington, National Gallery of Art, Ailsa Mellon Bruce Collection (p. *374*)

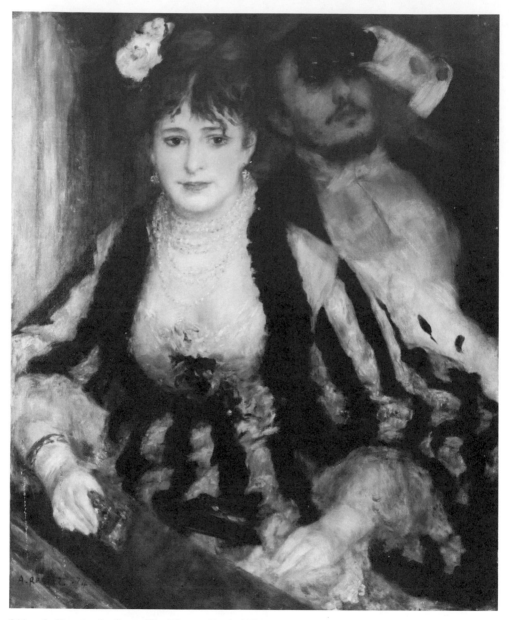

344. A. Renoir, *La Loge (The Theater Box)*, 1874, London, Courtauld Institute Galleries (p. *375*)

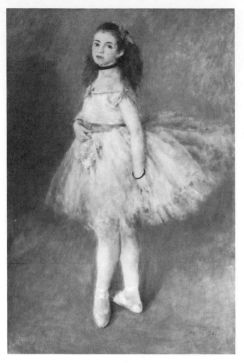

345. A. Renoir, *The Dancer,* 1874, Washington, National Gallery of Art, Widener Collection (p. *375*)

346. A. Renoir, *Portrait of Victor Chocquet,* ca. 1875, Cambridge, Mass., Fogg Art Museum, Harvard University, Bequest of Grenville L. Winthrop (p. *377*)

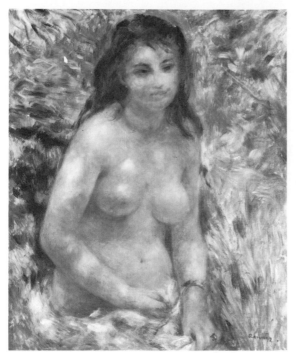

347. A. Renoir, *Study (Nude in the Sunlight),* 1875, Paris, Louvre (Musée d'Orsay) (p. *377*)

348. A. Renoir, *Ball at the Moulin de la Galette,* 1876, Paris, Louvre (Musée d'Orsay) (p. *378*)

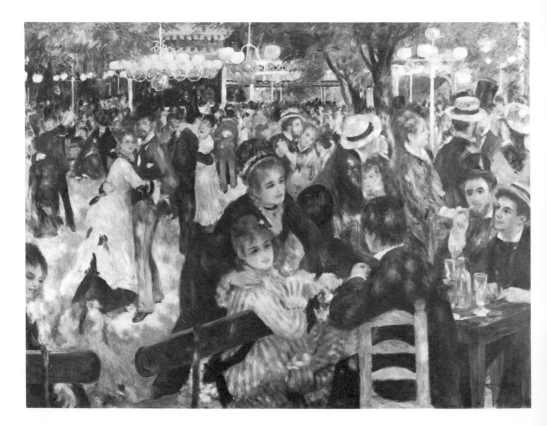

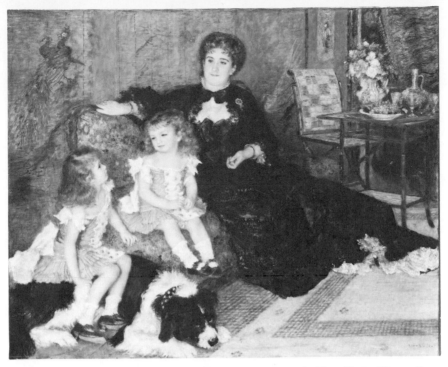

349. A. Renoir, *Mme Charpentier and Her Children,* 1878, New York, Metropolitan Museum of Art, Wolfe Fund 1907, Catharine Lorillard Wolfe Collection (p. *378*)

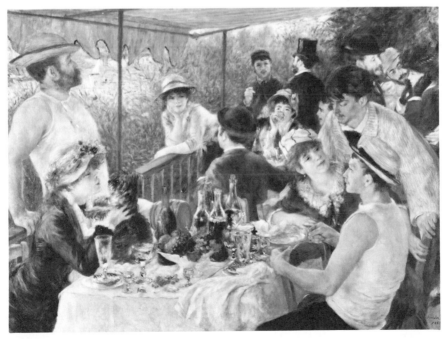

350. A. Renoir, *The Luncheon of the Boating Party,* 1880–81, Washington, Phillips Collection (p. *380*)

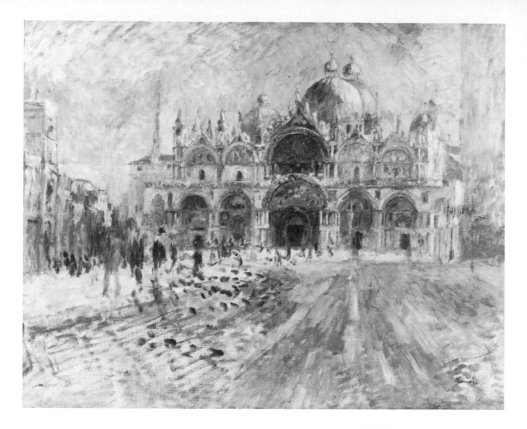

351. A. Renoir, *Piazza San Marco, Venice,*
1881, Minneapolis Institute of Arts, John R.
Van Derlip Fund (p. *381*)

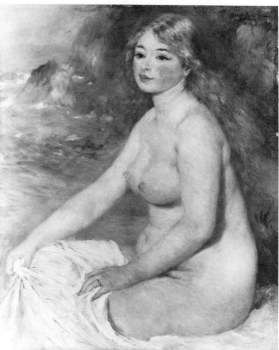

352. A. Renoir, *The Blond Bather,* 1881,
Williamstown, Sterling and Francine Clark
Art Institute (p. *381*)

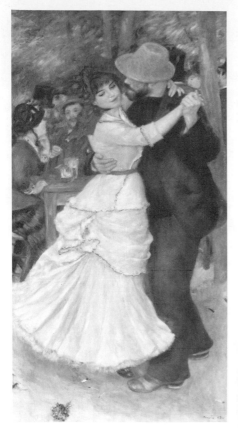

353. A. Renoir, *Dance at Bougival,* 1882–83, Boston, Museum of Fine Arts, Picture Fund (p. *382*)

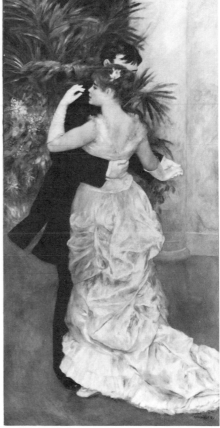

354. A. Renoir, *Dance in the City,* 1882–83, Paris, Louvre (Musée d'Orsay) (p. *382*)

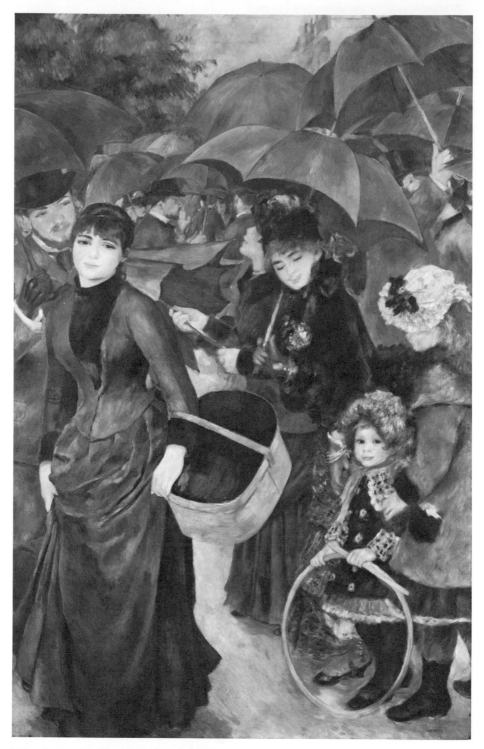

355. A. Renoir, *The Umbrellas,* ca. 1881 and ca. 1885, London, National Gallery (p. *383*)

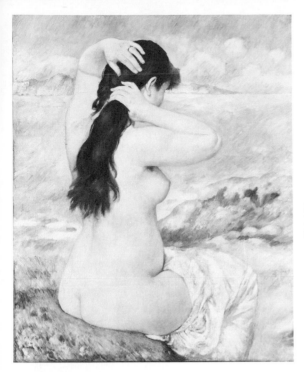

356. A. Renoir, *Bather Arranging Her Hair,*
1885, Williamstown, Sterling and Francine
Clark Art Institute (p. *383*)

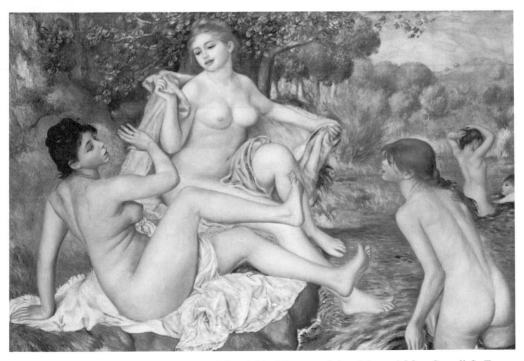

357. A. Renoir, *The Bathers,* 1885–87, Philadelphia Museum of Art, Mr. and Mrs. Carroll S. Tyson
Collection (p. *383*)

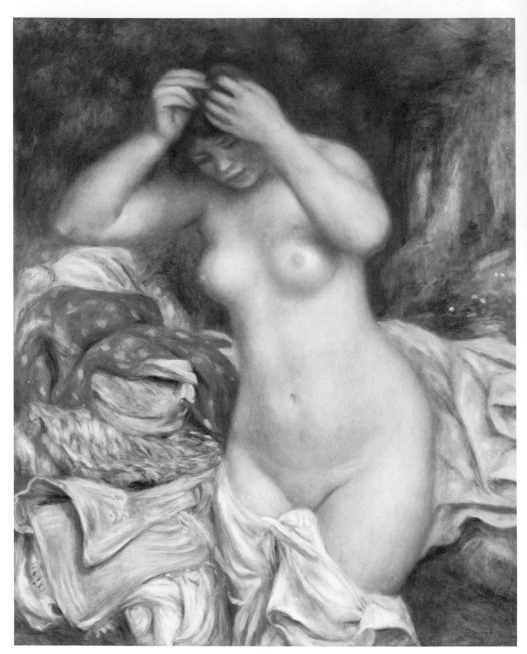

358. A. Renoir, *Bather Arranging Her Hair,* 1893, Washington, National Gallery of Art, Chester Dale Collection (p. *385*)

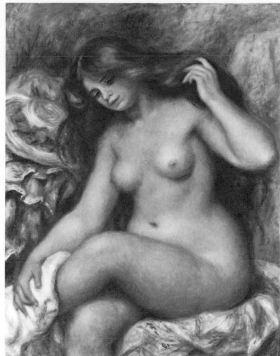

359. A. Renoir, *Bather,* ca. 1903, Vienna, Oesterreichische Galerie (p. *385*)

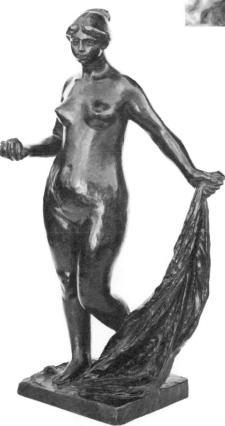

360. A. Renoir, *Venus Victorious* (small version), bronze, 1913, Stanford University Museum (p. *386*)

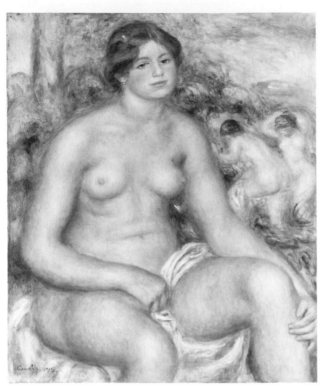

361. A. Renoir, *Seated Bather,* 1914, Art Institute of Chicago, Gift of Annie Swan Coburn to the Mr. and Mrs. Lewis L. Coburn Memorial Collection (p. *386*)

362. A. Renoir, *The Bathers,* 1918–19, Paris, Louvre (Musée d'Orsay) (p. *386*)

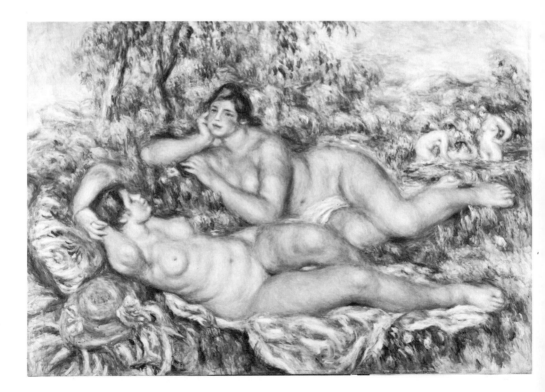

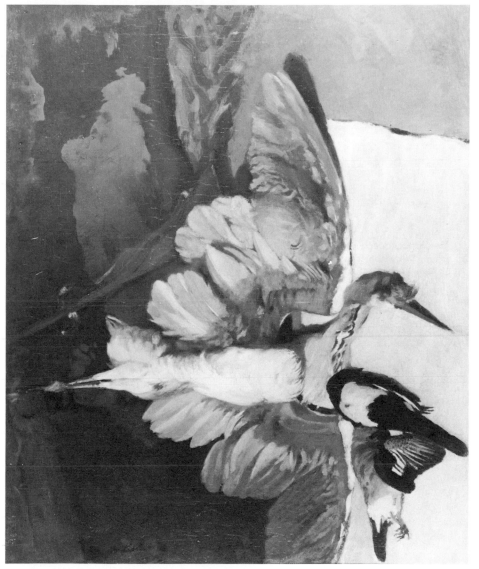

363. A. Sisley, *Still Life with Dead Heron*, 1867, Paris, Louvre (Musée d'Orsay) (p. *390*)

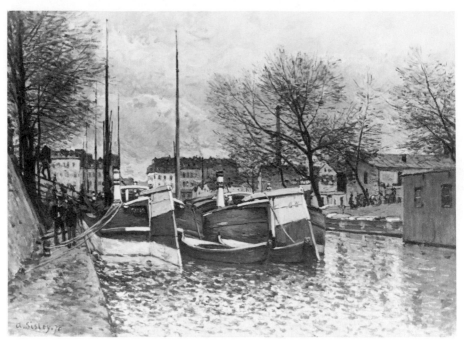

364. A. Sisley, *Barges on the Canal Saint-Martin,* 1870, Winterthur, Switzerland, Reinhart Collection, "Am Römerholz" (p. *391*)

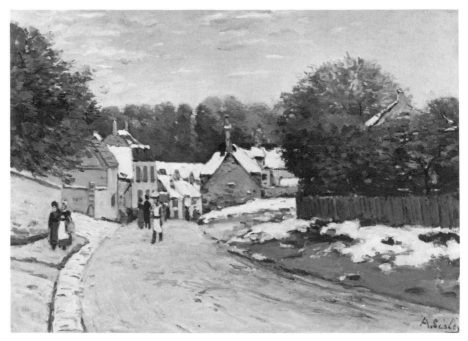

365. A. Sisley, *Early Snow in Louveciennes,* ca. 1870, Boston, Museum of Fine Arts, Bequest of John T. Spaulding (p. *391*)

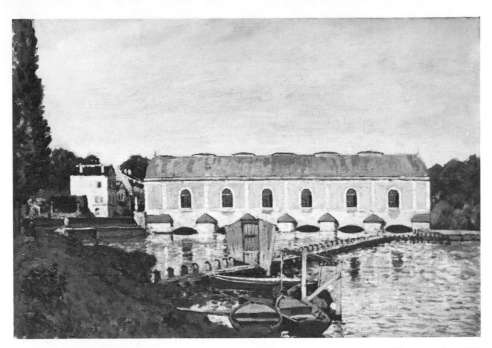

366. A. Sisley, *The Waterworks at Marly,* 1873, Copenhagen, Ny Carlsberg Glyptotek (p. *392*)

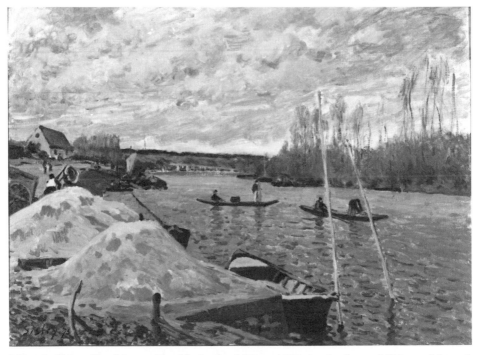

367. A. Sisley, *The Seine at Port-Marly, Sand Heaps,* 1875, Art Institute of Chicago, Mr. and Mrs. Martin A. Ryerson Collection (p. *393*)

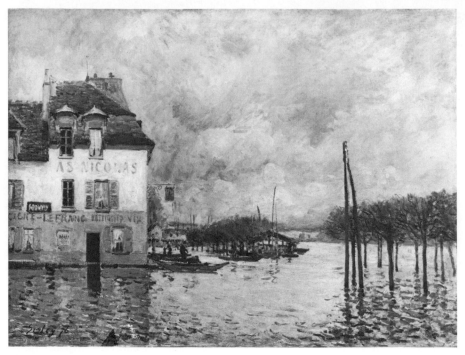

368. A. Sisley, *Flood at Port-Marly,* 1876, Paris, Louvre (Musée d'Orsay) (pp. *393–94;* 397)

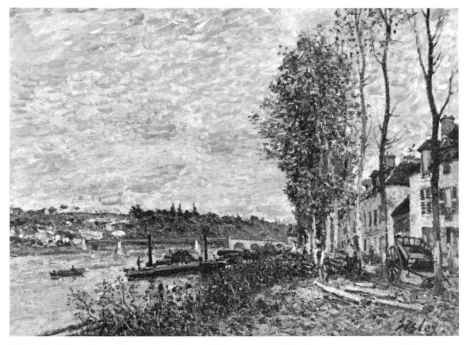

369. A. Sisley, *Saint Mammès, Cloudy Weather,* ca. 1880, Boston, Museum of Fine Arts, Juliana Cheney Edwards Collection (p. *395*)

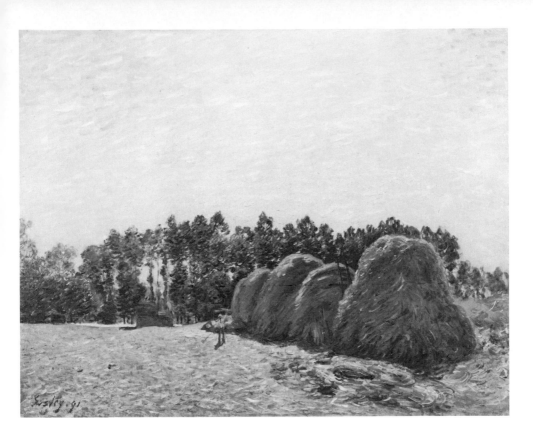

370. A. Sisley, *Haystacks at Moret,* 1891, Melbourne, National Gallery of Victoria (p. *396*)

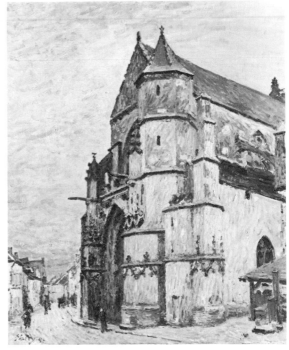

371. A. Sisley, *Church at Moret,* 1893–94, Detroit Institute of Arts (p. *396*)

213

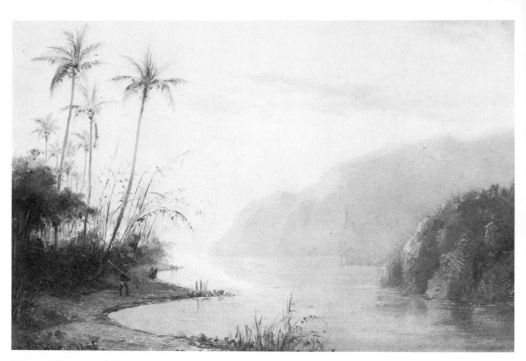

372. C. Pissarro, *A Cove at St. Thomas,* 1856, Washington, National Gallery of Art, Gift of Paul Mellon (p. *400*)

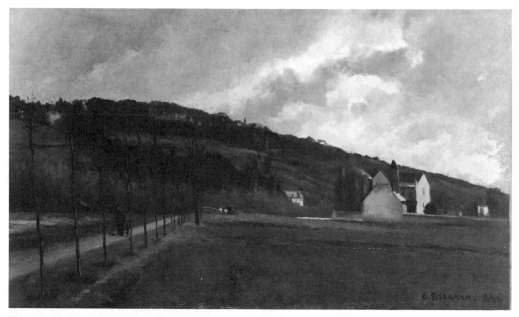

373. C. Pissarro, *Banks of the Marne, Winter,* 1866, Art Institute of Chicago, Mr. and Mrs. Lewis Larned Coburn Memorial Collection (p. *402*)

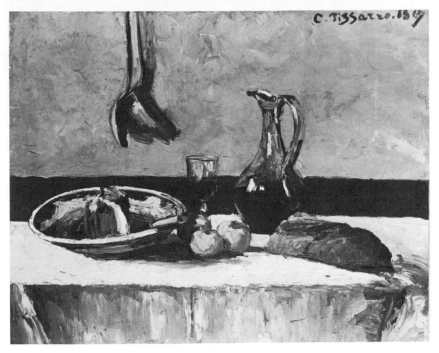

374. C. Pissarro, *Still Life*, 1867, Toledo (Ohio) Museum of Art, Gift of Edward Drummond Libbey (p. *403*)

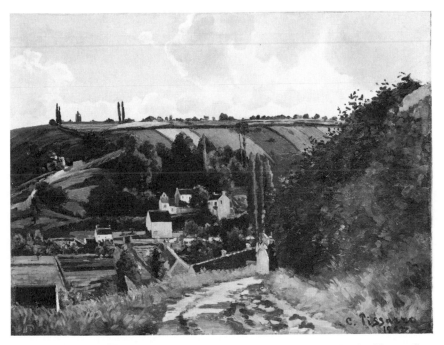

375. C. Pissarro, *The Jallais Hillside Near Pontoise*, 1867, New York, Metropolitan Museum of Art, Bequest of William Church Osborn (p. *403*)

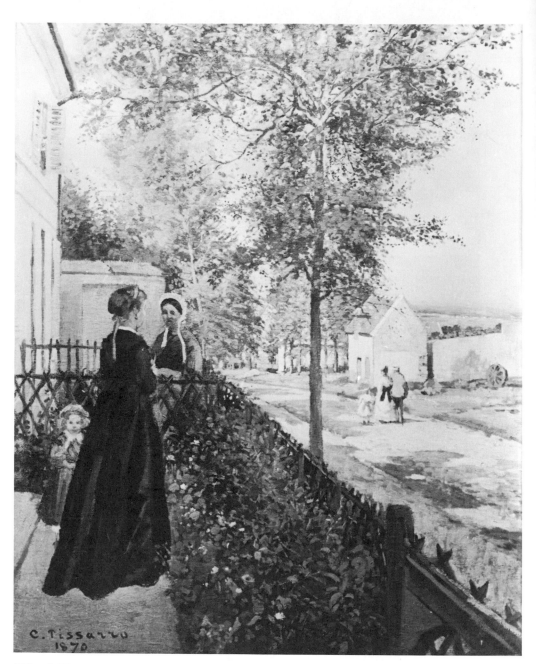

376. C. Pissarro, *Louveciennes, the Road to Versailles,* 1870, Zurich, E. G. Bührle Foundation (p. *404*)

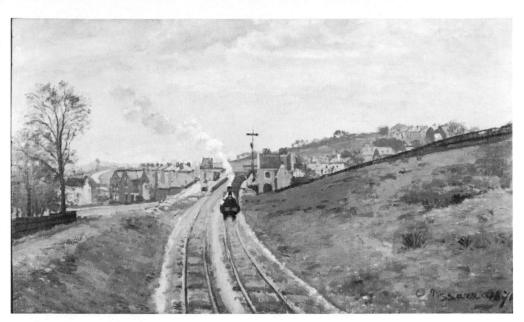

377. C. Pissarro, *Lordship Lane Station, Upper Norwood,* 1871, London, Courtauld Institute Galleries (p. *405*)

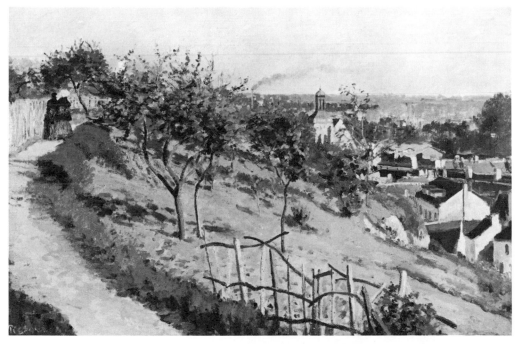

378. C. Pissarro, *The Sente de Justice,* ca. 1872, Memphis, Brooks Museum of Art, Gift of Mr. and Mrs. Hugo N. Dixon (p. *406*)

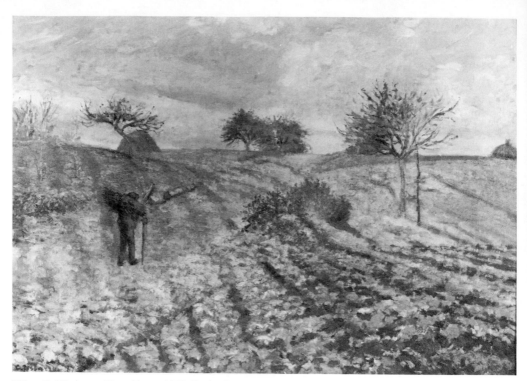

379. C. Pissarro, *Hoar Frost,* 1873, Paris, Louvre (Musée d'Orsay) (p. *406*)

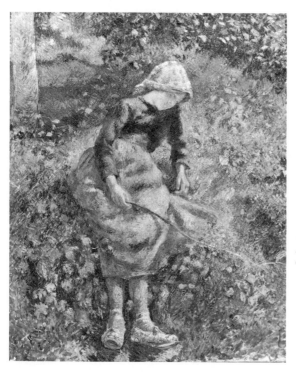

380. C. Pissarro, *The Shepherdess (Young Peasant Girl with a Stick),* 1881, Paris, Louvre (Musée d'Orsay) (p. *409*)

381. C. Pissarro, *Peasant Women Resting*, 1881, Toledo (Ohio) Museum of Art, Gift of Edward Drummond Libbey (p. *409*)

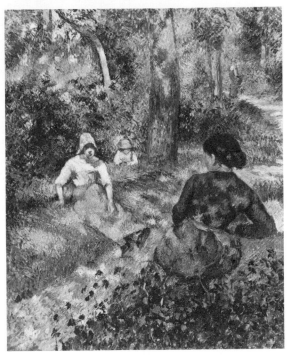

382. C. Pissarro, *View from My Window, Eragny*, 1886, Oxford, Ashmolean Museum (p. *411*)

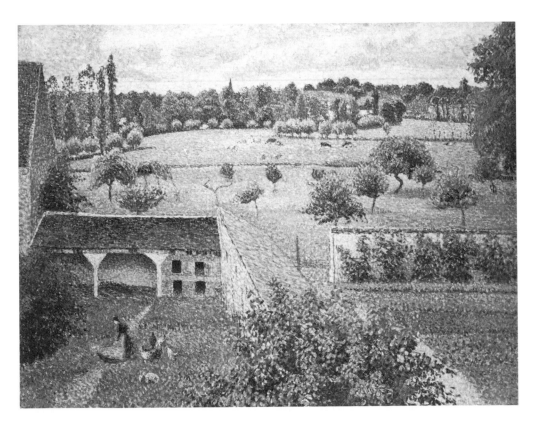

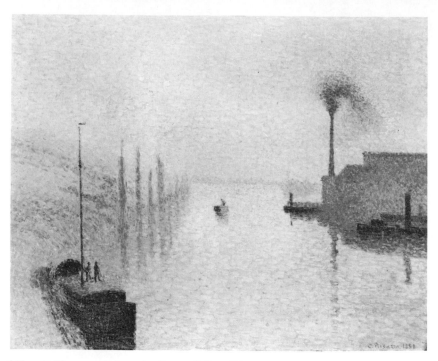

383.　C. Pissarro, *Ile Lacroix, Rouen, Effect of Fog,* 1888, Philadelphia Museum of Art, John G. Johnson Collection (p. *412*)

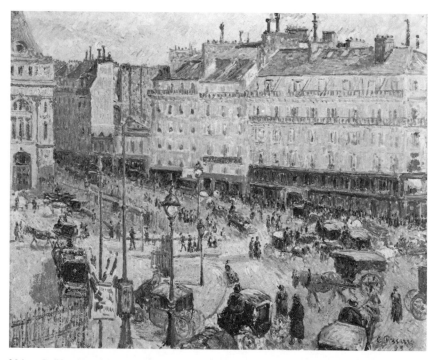

384.　C. Pissarro, *Place du Havre, Paris,* 1893, Art Institute of Chicago, Potter Palmer Collection (p. *413*)

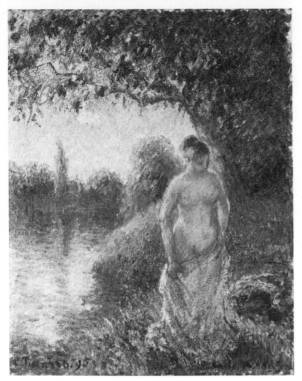

385. C. Pissarro, *Female Bather*, 1895, Washington, National Gallery of Art, Chester Dale Collection (p. *414*)

386. C. Pissarro, *Roofs of Old Rouen, Gray Weather*, 1896, Toledo (Ohio) Museum of Art, Gift of Edward Drummond Libbey (p. *415*)

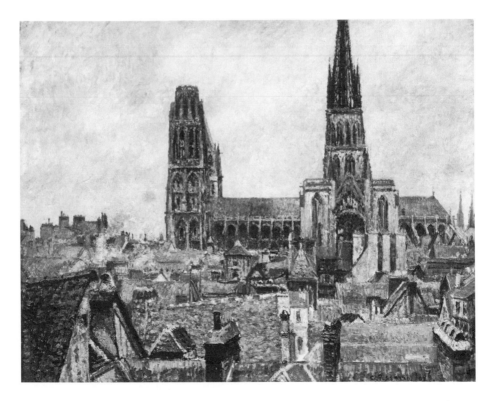

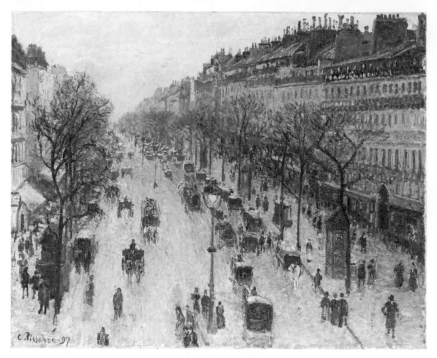

387. C. Pissarro, *Boulevard Montmartre, Winter Morning,* 1897, New York, Metropolitan Museum of Art, Gift of Katrin S. Vietro (p. *416*)

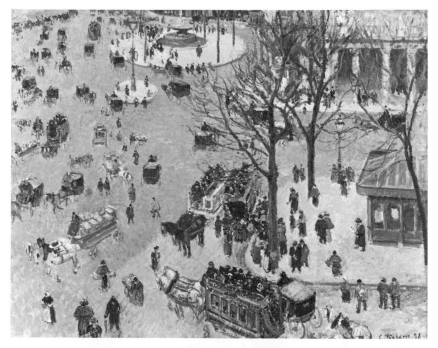

388. C. Pissarro, *Place du Théâtre Français,* 1898, Los Angeles County Museum of Art, Mr. and Mrs. G. G. De Sylva Collection (p. *416*)

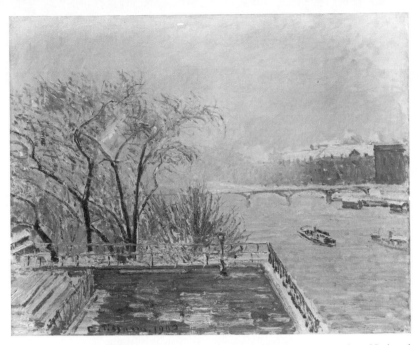

389. C. Pissarro, *The Louvre, Morning, Effect of Snow,* 1901, London, National Gallery (p. *417*)

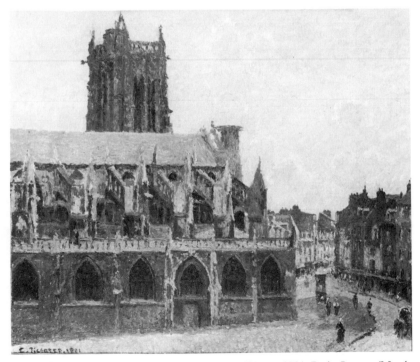

390. C. Pissarro, *The Church of Saint-Jacques, Dieppe,* 1901, Paris, Louvre (Musée d'Orsay) (p. *417*)

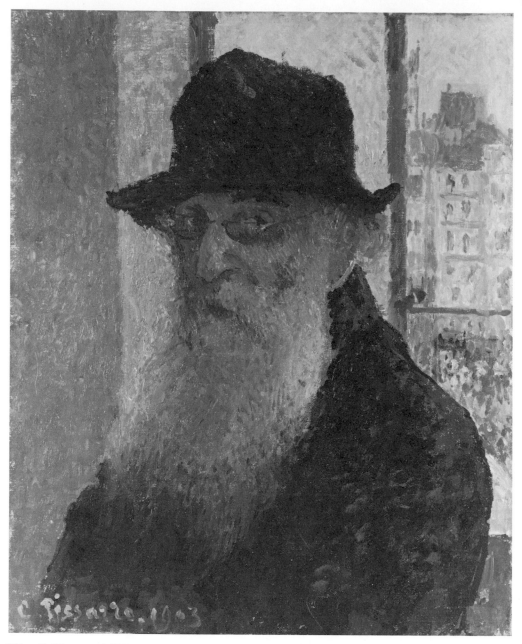

391. C. Pissarro, *Self-Portrait,* 1903, London, Tate Gallery (p. *417*)

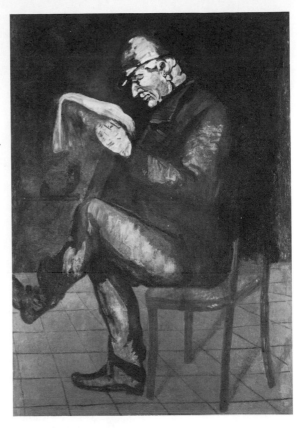

392. P. Cézanne, *Portrait of Louis-Auguste Cézanne,* ca. 1860, London, National Gallery (p. *422*)

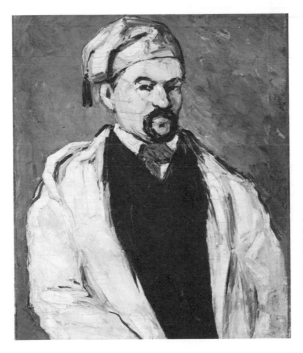

393. P. Cézanne, *Uncle Dominique,* ca. 1865–67, New York, Metropolitan Museum of Art, Wolfe Fund, 1951, from the Museum of Modern Art, Lillie P. Bliss Collection (p. *422*)

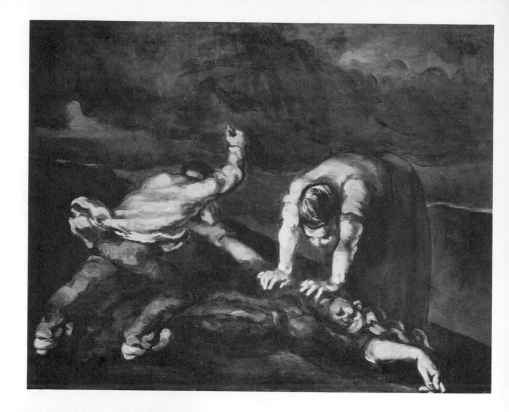

394. P. Cézanne, *The Murder,* 1867–70, Liverpool, Walker Art Gallery (p. *423*)

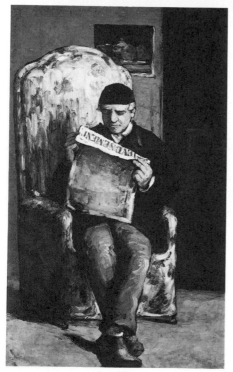

395. P. Cézanne, *Portrait of Cézanne's Father Reading L'Evénement,* 1868–70, Washington, National Gallery of Art, Collection of Mr. and Mrs. Paul Mellon (p. *424*)

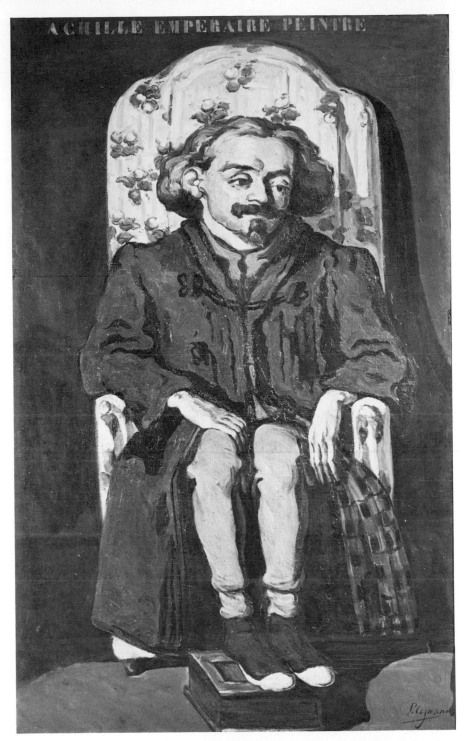

396. P. Cézanne, *Portrait of Achille Emperaire,* 1867–70, Paris, Louvre (Musée d'Orsay) (p. *424*)

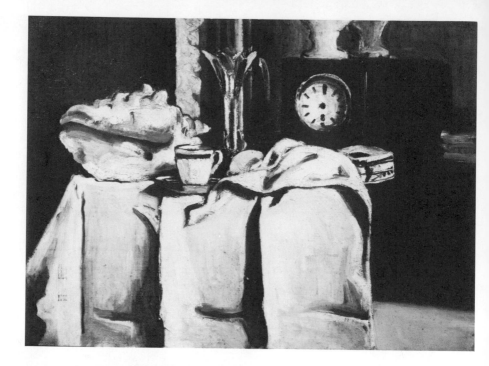

397. P. Cézanne, *The Black Clock,* ca. 1870, London, S. Niarchos Collection (p. *426*)

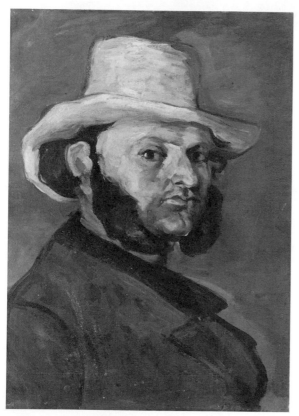

398. P. Cézanne, *Portrait of Boyer (Man with a Straw Hat),* 1870–71, New York, Metropolitan Museum of Art, Bequest of H. O. Havemeyer (p. *426*)

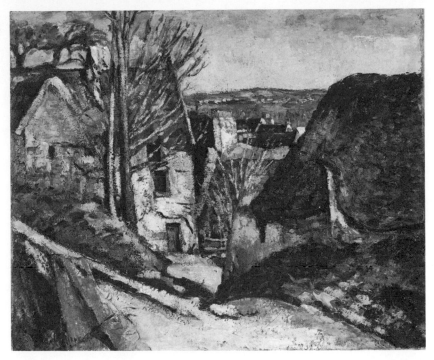

399. P. Cézanne, *The House of the Hanged Man,* ca. 1873, Paris, Louvre (Musée d'Orsay) (pp. *426;* 427, 433)

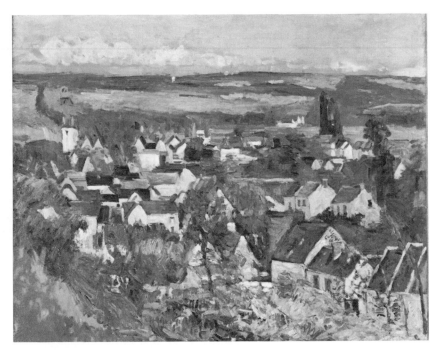

400. P. Cézanne, *View of Auvers,* ca. 1874, Art Institute of Chicago, Mr. and Mrs. Lewis Larned Coburn Memorial Collection (p. *427*)

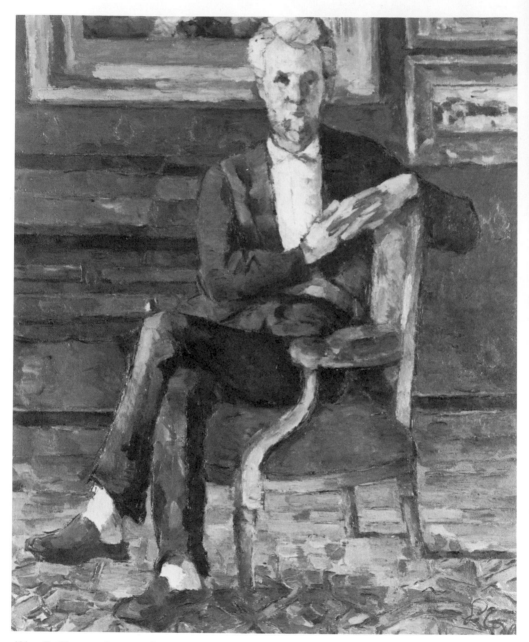

401. P. Cézanne, *Portrait of Victor Chocquet Seated,* ca. 1877, Columbus (Ohio) Museum of Art, Howald Fund (p. *427*)

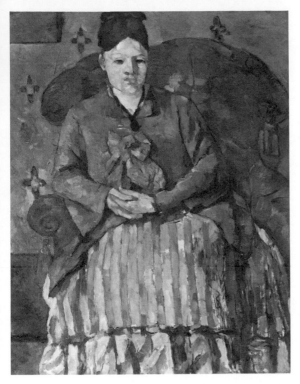

402. P. Cézanne, *Portrait of Madame Cézanne in a Red Armchair,* 1877, Boston, Museum of Fine Arts, Bequest of Robert Treat Paine, II (p. *428*)

403. P. Cézanne, *Love Play (Bacchanal),* ca. 1875–79, Washington, National Gallery of Art, Gift of the W. Averell Harriman Foundation in Memory of Marie N. Harriman (p. *428*)

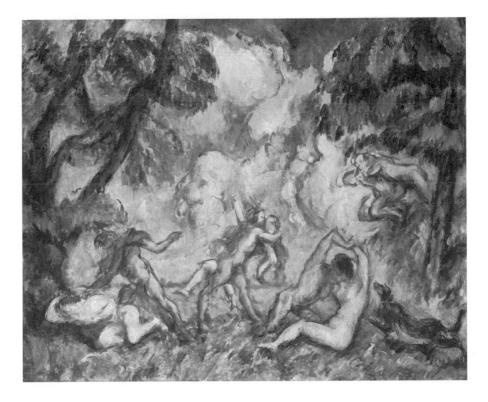

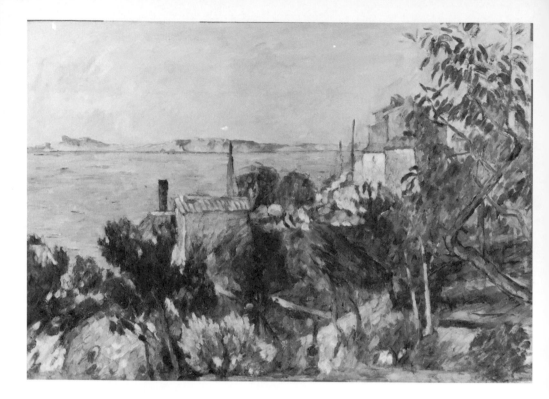

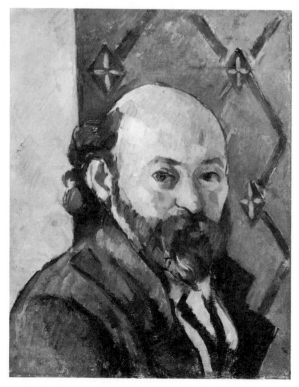

404. P. Cézanne, *L'Estaque,* ca. 1876, private collection, Switzerland (formerly Bernhard Foundation, New York) (p. *429*)

405. P. Cézanne, *Self-Portrait,* 1879–82, London, National Gallery (formerly Tate Gallery) (p. *430*)

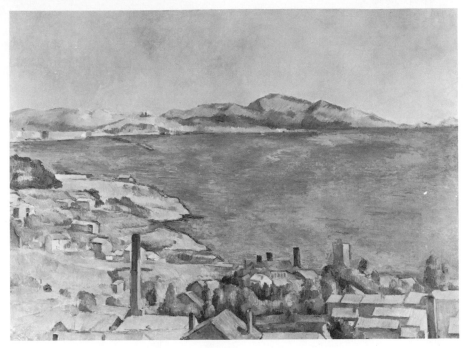

406.　P. Cézanne, *The Gulf of Marseilles Seen from L'Estaque,* 1883–85, New York, Metropolitan Museum of Art, Bequest of Mrs. H. O. Havemeyer (p. *431*)

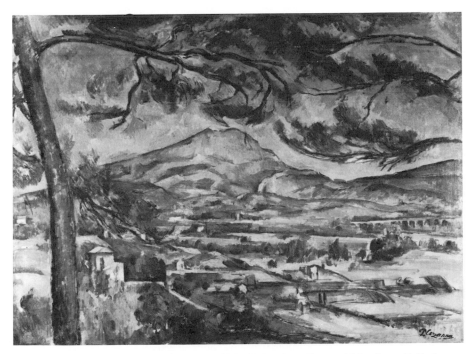

407.　P. Cézanne, *Mont Sainte-Victoire,* 1885–87, London, Courtauld Institute Galleries (p. *431*)

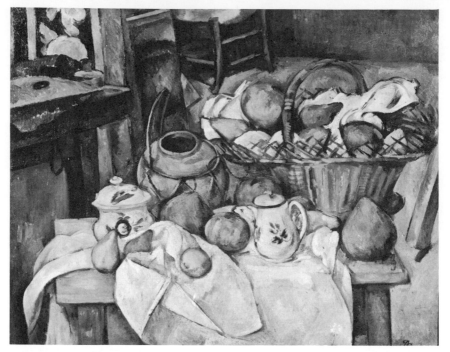

408. P. Cézanne, *Still Life with Fruit Basket,* 1888–90, Paris, Louvre (Musée d'Orsay) (p. *432*)

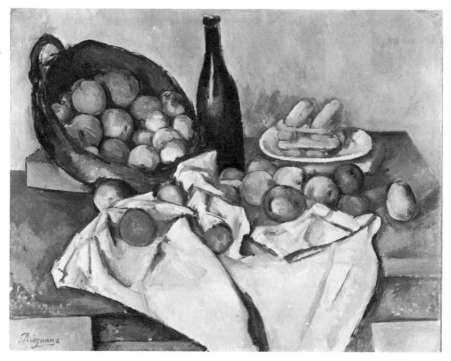

409. P. Cézanne, *Still Life with Basket of Apples,* 1890–94, Art Institute of Chicago, Helen Birch Bartlett Collection (p. *433*)

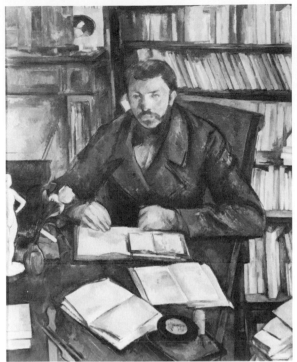

410. P. Cézanne, *Portrait of Gustave Geffroy,* 1895, Paris, Louvre (Musée d'Orsay) (p. *434*)

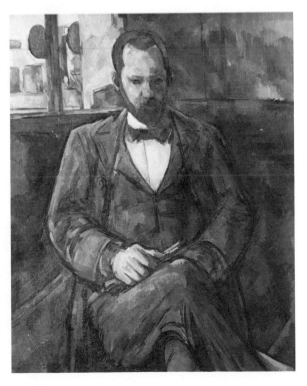

411. P. Cézanne, *Portrait of Ambroise Vollard,* 1899, Paris, Musée du Petit Palais (p. *434*)

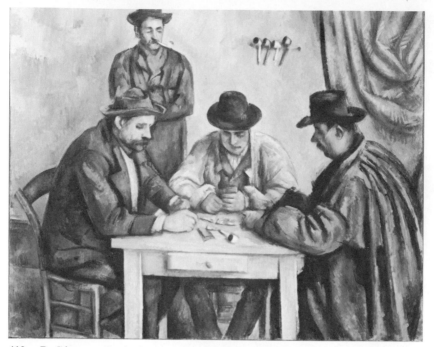

412. P. Cézanne, *Card Players*, 1890–92, New York, Metropolitan Museum of Art, Bequest of Stephen C. Clark (p. *435*)

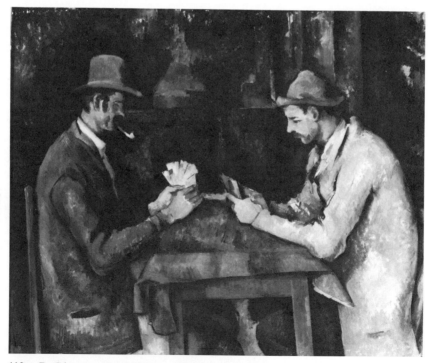

413. P. Cézanne, *Card Players*, 1890–92, London, Courtauld Institute Galleries (p. *435*)

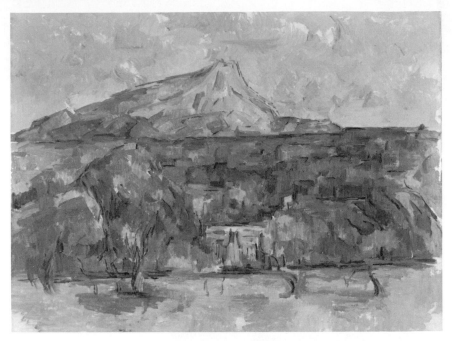

414. P. Cézanne, *Mont Sainte-Victoire*, 1904–6, Kansas City, Nelson-Atkins Museum of Art, Nelson Fund (p. *437*)

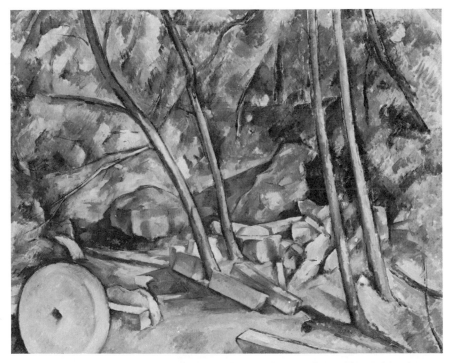

415. P. Cézanne, *Mill Stones in the Park of Château Noir*, ca. 1900, Philadelphia Museum of Art, Mr. and Mrs. Carroll S. Tyson, Jr., Collection (p. *437*)

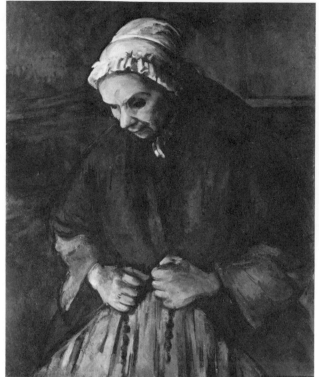

416. P. Cézanne, *Old Woman with Rosary*, ca. 1900–1904, London, National Gallery (p. *437*)

417. P. Cézanne, *Women Bathers*, ca. 1900–1905, London, National Gallery (p. *439*)

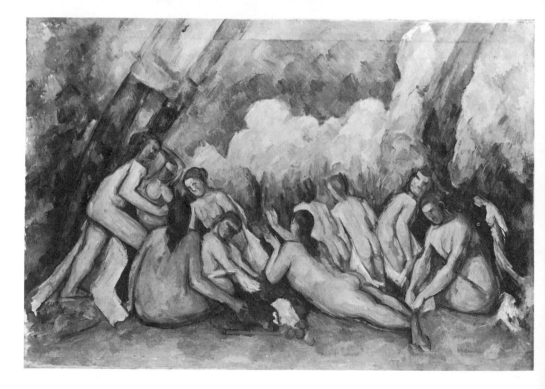

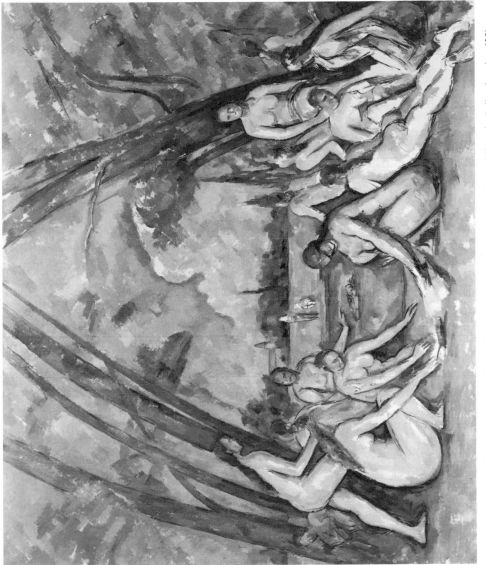

418. P. Cézanne, *Women Bathers*, 1904–6, Philadelphia Museum of Art, W. P. Wilstach Collection (p. *439*)

Photograph Credits
Numbers refer to plates.

Altadena, Calif., Robert N. Essick 75. *Baltimore,* Walters Art Gallery 159, 185. *Basel,* Kunstmuseum 138. *West Berlin,* Bildarchiv Preussischer Kunstbesitz (Foto Jörg P. Anders) 95, 96, 100, 282. *Birmingham,* England, Barber Institute of Fine Arts 254. *Boston,* Museum of Fine Arts 104, 135, 183, 197, 223, 227, 248, 261, 266, 289, 290, 293, 326, 327, 330, 335, 353, 365, 369, 402. *Bremen,* Kunsthalle 310. *Brussels,* Musées Royaux 11, 21, 204. *Cambridge,* Mass., Fogg Art Museum, Harvard University 149, 161, 286, 321, 346. Art Institute of *Chicago* 192, 271, 312, 325, 328, 361, 367, 373, 384, 400, 409. *Cincinnati* Art Museum 206. *Cleveland* Museum of Art 133, 337. *Cologne,* Wallraf-Richartz Museum 341. *Columbus* (Ohio) Museum of Art 401. *Copenhagen,* Ny Carlsberg Glyptotek 263, 366. *Corte di Mamiano,* Fondazione Magnani Rocca 44. *Dallas,* Meadows Museum 47. *Detroit* Institute of Arts 72, 319, 371. *Dresden,* Staatliche Kunstsammlungen 93, 94, 102. *Essen,* Folkwang Museum 97. *Fort Worth,* Kimbell Art Museum 307. *Frankfurt,* Staedelsches Kunstinstitut 313 (Foto Ursula Edelmann). *Ghent,* Musée des Beaux-Arts 168 (Photo P. Ysabie). *Hamburg,* Kunsthalle 86, 87, 88, 89, 90, 91, 92, 98, 101, 262, 281 (Foto R. Kleinhempel). *Indianapolis* Museum of Art 121. *Kansas City,* Nelson-Atkins Museum of Art 414. *Lille,* Musée des Beaux-Arts 239. *Liverpool,* Walker Art Gallery 394. *London,* Courtauld Institute Galleries 283, 344, 377, 407, 413. *London,* National Gallery 108, 111, 116, 122, 123, 127, 130, 131, 134, 137, 151, 184, 226, 268, 285, 316, 355, 389, 392, 405, 416, 417. *London,* Stavros Niarchos Collection 397. *London,* Royal Academy of Art 113. *London,* Royal Society of Arts 68. *London,* Tate Gallery 70, 79, 83, 85, 109, 114, 117, 118, 119, 120, 124, 125, 126, 129, 136, 391. *London,* Victoria and Albert Museum 69, 103, 106, 112. *London,* Wallace Collection 172. *Los Angeles* County Museum of Art 388. *Madrid,* Academia S. Fernando 58. *Madrid,* Prado 42, 43, 46, 52, 53, 56, 57, 61, 64. *Malibu,* J. P. Getty Museum 231. *Mannheim,* Kunsthalle 275. *Melbourne,* National Gallery of Victoria 370. *Memphis,* Brooks Museum of Art 378. *Minneapolis* Institute of Arts 27, 37, 62, 351. *Montpellier,* Musée Fabre 283, 243, 244, 245 (Photo C. O'Sughrue). *Montreal* Museum of Fine Arts 215. *Munich,* Bayerische Staatsgemäldesammlungen, Neue Pinakothek 220, 228, 276, 279. *New Haven,* Yale Center for British Art 77, 105, 115, 128, 132. *New Haven,* Yale University Art Gallery 66, 198 (Photo Geri Mancini). *New York,* Brooklyn Museum 80. *New York,* Frick Collection 110, 150, 210. *New York,* Hispanic Society of America 49. *New York,* Metropolitan Museum of Art 45, 54, 194, 242, 252, 264, 265, 274, 280, 287, 298, 300, 304, 305, 311, 314, 323, 329, 349, 375, 387, 393, 398, 406, 412. *Ottawa,* National Gallery of Canada 67, 225. *Oxford,* Ashmolean Museum 382. *Paris,* Bulloz 28, 29, 30, 153, 160, 162, 170, 175, 178, 182, 253, 269. *Paris,* Ecole Nationale Supérieure des Beaux-Arts 169. *Paris,* Giraudon 25, 27, 31, 34, 39, 139, 142, 174, 187. *Paris,* Musée Marmottan 318 (Photo Routhier). *Paris,* Service Photographique des Musées Nationaux, 1, 3, 9, 13, 14, 15, 16, 17, 19, 20, 22, 24, 40, 41, 48, 140, 143, 145, 147, 148, 152, 156, 157, 166, 167, 171, 176, 181, 188, 190, 191, 193, 199, 200, 201, 203, 205, 208, 209, 214, 229, 230, 232, 234, 235, 240, 246, 255, 258, 259, 260, 270, 273, 277, 284, 291, 294, 297, 299, 301, 310, 315, 324, 336, 347, 348, 354, 362, 363, 368, 379, 380, 390, 396, 399, 408, 410. *Paris,* Roger-Viollet 7, 23, 26, 35, 247, 251. *Paris,* Photothèque des Musées de la Ville de Paris 237, 411. *Pasadena,* Henry Huntington Library and Art Gallery 81. *Pasadena,* Norton Simon Foundation 256, 303, 306, 340. *Pau,* Musée des Beaux-Arts 295. *Philadelphia* Museum of Art 236, 272, 292, 320, 357, 383. *Princeton,* N.J., Art Museum, Princeton University, 334. *San Francisco* Fine Arts Museums 76, 189. *Stanford* University Museum 55, 63, 165, 211, 212, 213, 302, 360. *Stockholm,* National Museum 164, 338, 342. *Toledo* (Ohio) Museum of Art 207, 249, 374, 381, 386. *Upperville,* Va., Mr. and Mrs. Paul Mellon Collection 78, 82. *Vienna,* Oesterreichische Galerie 233, 359. *Warsaw,* National Museum 4. *Washington,* National Gallery of Art 107, 155, 186, 195, 202, 222, 250, 267, 278, 288, 296, 318, 322, 331, 332, 333, 339, 343, 345, 358, 372, 385, 396, 403. *Washington,* Phillips Collection 196, 350. *Williamstown,* Sterling and Francine Clark Art Institute 351, 356. *Winterthur,* Switzerland, Stiftung Oskar Reinhart 99, 364. *Zurich,* E. G. Bührle Foundation 376. *Zurich,* Kunsthaus 71, 257.